# ART EDUCATION: CONTENT AND PRACTICE IN A POSTMODERN ERA

Edited by James W. Hutchens and Marianne Stevens Suggs

1997

The National Art Education Association

## About NAEA

Founded in 1947, the National Art Education Association is the largest professional art education association in the world. Membership includes elementary and secondary teachers, art administrators, museum educators, arts council staff, and university professors from throughout the United States and 66 foreign countries. NAEA's mission is to advance art education through professional development, service, advancement of knowledge and leadership.

ISBN 0-937652-95-4

# CONTENTS

# ART EDUCATION: CONTENT AND PRACTICE IN A POSTMODERN ERA

Edited by

James W. Hutchens and Marianne Stevens Suggs

## About the Editors and Contributors

**Tom Anderson** is Professor of Art Education at The Florida State University. He has a particular interest in the social and philosophical foundations of art as a cultural phenomenon. His most recent foci have been cross-cultural, multicultural, and postmodern theory and practice in art education.

**Terry Barrett** is Professor of Art Education at The Ohio State University. He is the author of *Criticizing Photographs, Criticizing Art: Understanding the Contemporary*, editor of an anthology, *Lessons for Teaching Art Criticism*, and past senior editor of *Studies in Art Education*. His chapters and articles on teaching criticism have appeared in anthologies and journals such as the *Journal of Aesthetic Education, Studies in Art Education, Art Education, Visual Arts Research, Journal of Multicultural and Cross-Cultural Research in Art Education*, and *Canadian Review of Art Education*. He is the 1995-96 Visiting Scholar at the Getty Center for Education in the Arts.

**Robert Bersson** is Professor of Art at James Madison University in Harrisonburg, Virginia. The author of *Worlds of Art*, a college art appreciation text, he has written numerous articles in art education journals. Dr. Bersson is a founder of the Social Theory Caucus and the Student Chapter Affiliate groups of the National Art Education Association.

**Elizabeth Garber** is Assistant Professor of Art Education at The University of Arizona. Dr. Garber's research centers on feminist art theory and art criticism in art education and on Chicana art, literature, culture, and cultural theory. She has authored theoretical articles on feminist art criticism, multicultural issues, and feminist aesthetics in art education that have appeared in publications such as *Studies in Art Education*, the *Canadian Journal of Art Education*, the *Journal of Social Theory in Art Education*, and in anthologies. She is the 1993 recipient of the Mary Rouse Award, given by the Women's Caucus of the National Art Education Association.

**Yvonne Gaudelius** is Assistant Professor of Art Education and Women's Studies at The Pennsylvania State University. Her research interests focus on feminist issues relating to art education, including the representation of the body in the discourses of

visual art and contemporary critical theory, and in feminist pedagogy and its methodologies. Her publications have appeared in the *Journal of Social Theory in Art Education, The Pennsylvania Art Educator*, and the *Canadian Review of Art Education*.

**Betsy Gough-Dijulio** is a director of education at the Virginia Beach Center for the Arts in Virginia Beach, Virginia. She received her MA in art history from Vanderbilt University. Among the other positions she has held are Art History Lecturer at the Governor's Magnet School in Norfolk, Virginia, and museum educator/program coordinator at the Tennessee Botanical Gardens and Fine Arts Center at Cheekwood in Nashville, Tennessee. She has received numerous grant awards for her museum education programs, is a regular contributor to *The Docent Educator*, and is a frequent presenter on issues of art education at the local, state, and national levels.

**Karen Hamblen** is Professor of Art Education in the Department of Curriculum and Instruction at Louisana State University. She is past senior editor of *Studies in Art Education* and the recipient of the NAEA Manuel Barkan Award and the NAEA Women's Caucus Mary J. Rouse Award. Her publications have appeared in anthropology, sociology, curriculum theory, art education, and arts policy research journals.

**Jack A. Hobbs** is Professor Emeritus of Art at Illinois State University. He has exhibited prints and paintings in one-person and/or juried shows at regional and national levels. He has authored, co-authored, and revised books with Harcourt, Prentice-Hall, Bloomsbury Press, and Davis. Three of these are college-level texts in art appreciation and arts and humanities and one is a high-school level text in art appreciation. Currently he is co-authoring an art education text for Prentice-Hall. He has served twice on the editorial board for *Studies in Art Education*.

**James Hutchens** is Chair and Professor of Art Education at The Ohio State University. His articles on art education and arts management have appeared in the anthology *The Future of the Arts, Public Policy and Arts Research*, and journals *including The Journal of Arts Management and Law, Art Education, Visual Arts Research, Studies in Art Education*, and *Design for Arts Education*. He has served as Executive Secretary to the Council for Policy Studies in Art Education and as co-director of the National Art Education Association's Public Policy and Arts Administration Affiliate, an organization he co-founded.

**R. L. Jones, Jr.** is Dean of the College of Fine Arts, Stephen F. Austin State University. He is a former chair of the West Virginia Arts Commission and has served on special panels for the National Endowment for the Arts and the Mid-Atlantic Arts Consortia. He has authored numerous theoretical and critical essays related to visual arts and art education.

**Karen Keifer-Boyd** is Assistant Professor in art education in the Department of Art at Texas Tech University in Lubbock. Her research involves developing visual analytic techniques with digital video interactive technology to study nonverbal aspects of learning development in the arts. The National Art Education Association has honored her with the 1994 Pacific Region Supervision and Administration Art Educator award for "exemplary contribution, service, and achievement at the regional level."

Sally McRorie (formerly Hagaman) is Professor and Chair of Art Education at Florida StateUniversity. Her research interests include aesthetics, feminist inquiry, and contemporary art. She is currently senior editor of *Studies in Art Education* and has published widely in art education, education, and philosophy journals and anthologies. She has received the Mary J. Rouse Award and major grants from the National Endowment for the Arts and the Flora Roberts Foundation.

Harold Pearse is Professor of Art Education at Nova Scotia College of Art and Design. He has authored numerous articles on various aspects of art education for Canadian and American professional journals. He has served as editor of the *Journal of Social Theory and Art Education* and as national coordinator of the Social Theory Caucus, an affiliate of the National Art Education Association. He is currently a member of the Editorial Advisory Board of *Studies in Art Education*. He is also a practicing artist with numerous solo and group exhibitions behind him. His art is in public and private collections.

Marianne Stevens Suggs is Professor of Art at Appalachian State University and an exhibiting artist at regional and national exhibitions. Dr. Suggs has a strong interest in the contemporary women's movement in art. Her most recent focus has been multicultural theory and its practice in art education. She has received the NAEA's Women's Caucus Mary J. Rouse Award.

Sydney Walker is Assistant Professor of Art Education at The Ohio State University. She teaches art criticism, contemporary art, and classroom methodology for understanding artworks. Her publications on teaching and art criticism are found in *Studies in Art Education* and an anthology, *Lessons for Teaching Art Criticism*. She is currently engaged in a five-year project to develop curriculum materials with contemporary artists and artworks.

Anne G. Wolcott is the Fine Arts Coordinator for Virginia Beach City Public Schools in Virginia. Before taking this position, she was assistant professor of Art Education at East Carolina University. For ten years prior to receiving a Ph.D. from The Pennsylvania State University, she was a public school art teacher, primarily at the middle and secondary levels. She also served as an evaluator for the Getty Center for Arts in Education Discipline-based Art Education Summer Institutes for three years.

# PREFACE

"Contemporary art is in search of a truth, not the truth. Honestly created art, like democratic society, is always in search of...relative truths, not of absolute dogmas."
Frederick M. Logan, *Growth of Art in American Schools*

The decline of the modernist paradigm in the visual arts has been signaled by an array of critical, artistic, and educational responses from art world professionals who have repositioned themselves and their work within a postmodern climate. Postmodernists generally reject modernism's preoccupation with originality, creativity, pure abstraction, disinterested perception, and aesthetic experience; they embrace, among other things, art as expression of culture closely connected to and often critical of common human affairs and social conditions. This calls for a rethinking of paradigms of art education—the elements and principles of design, creative self-expression, art in daily living, discipline-based forms, and multicultural forms—in light of the discourse of our postmodern era.

Discipline-based art education and multicultural art education are the two most prominent themes promulgated in the professional literature of art education. In the schools, the studio-biased creative self-expression paradigm is, by all accounts, the most prominent. It is also the most prominent paradigm framing the education of preservice teachers in art, who themselves were attracted to art education programs from high school studios situated in modernist theory, centering, as Brent Wilson has said, "on the language of forms rather that the ideas their forms might disclose." (1992, p.111)

We asked authors to consider the effect of postmodern discourse on the content and practice of art in the schools and preservice education programs for art teachers. Our readers, we hope, will include students now matriculating through art and art education programs in our colleges and universities, and art and art education faculty who guide them. The format of this book is neither linear nor cumulative; there is no set of simple conclusions at the end. Our ultimate concern is that professors of art and art education—the teachers of teachers—and those issuing policy statements affecting educational programs for elementary, secondary, and postsecondary institutions will question why they do what they do.

We are grateful to our art and art education students whose questions led to this anthology. It seems they may be more cognizant of contemporary art than some of the faculty with whom they study. At the center of their queries was the question of relevance—"Why am I being asked to do these projects?" What do they have to do with art I read about and see?"

# STUDENT COMPLAINTS AND FACULTY MOANING: SOME ANTECEDENTS TO THE ESSAYS THAT FOLLOW

James W. Hutchens and Marianne Stevens Suggs

A new paradigm for thinking about art and art education has emerged to challenge ideas that arose during the modern era. Late modernist theory, shaped especially by Greenbergian formalism, is viewed by postmodernists as too narrow and restrictive to account for the range of objects contemporary philosophy and theory validates as art (Danto, 1981, 1992). What is obvious is a change in thinking about how art achieves meaning. Subject matter and content again are taking precedence over form and process.

The confluence of postmodern ideas and long-held modernist assumptions is unresolved in preservice programs for art teachers and in school classrooms, for, while contemporary art exhibitions and professional literature evidence postmodern ideas, teacher preparation programs remain entrenched in modernist ideology (Risatti, 1989, 1990, 1993).

As you read in the Preface to this text, students are questioning their curricula. "Why do I need to do the same projects in my college foundations courses that I did in my high school art classes?" "What do these foundations courses have to do with the art I see and read about?" Faculty are often mystified by these questions. "I'm so tired of students saying that my assigned art projects are irrelevant. I've used these projects for years without such challenges," complained a faculty member.

Students, of course, are challenging the value of their formalist-based studio-model training that emerged to support modernist ideology. More relevant for these students, claims the postmodernist, is an education that references and values the eclecticism of the artworld, and that places emphasis upon understanding the economic, political, social, and cultural factors inscribed upon it. This kind of preservice education will require a different approach from that of the modernist period. As Brent

Wilson has said, "if we are to meet the challenge of the postmodern era, those of us who work in higher education have the task of first transforming ourselves and then transforming art education" (Wilson, 1992, p. 99).

In the essays in this anthology, authors will add to the growing scholarship aimed at reforming art in the schools and preservice education programs for teachers. As a background for the essays, we will review formalist theory and some of its criticisms— especially the philosophical and theoretical basis of modernism. We will then turn to the feminist, multiculturalist, and social reconstructionist discourse that challenges modernism's basic tenets.

## Formalist Theory and Modernism: The Education of Art Teachers

The foundations programs through which most beginning art students (including intending teachers) must pass is based on modernism's formalist theory as are other studio courses following the foundations experience. A typical foundations program consists of courses in two- and three-dimensional design and drawing. Seldom is the study of art history, art criticism and aesthetics a part of the foundations program (Risatti, 1989, 1993).

The philosophical foundations of formalism are grounded in Immanuel Kant's 18th century argument that disinterested perception must be the basis for aesthetic judgment. Terry Barrett, in his essay in this text, will discuss Kant's influence, so we will only say that the concept of disinterested perception is seminal to modernist notions of disinterested aesthetic experience and art as a universal language so prevalent in art education. As Barrett has explained elsewhere, "an aesthetic judgment should be neither personal nor relative," and "the viewer should rise above time, place, and personal idiosyncrasies" (Barrett, 1993, p. 13).

Kant's idea about this detached or disinterested state of perception was further developed by critics Roger Fry and Clive Bell who gave us "significant form" as the content of art to be attended to in this detached state. "What quality is shared by all objects that provoke our esthetic emotions," they ask. "Significant form is the one quality common to all works of visual art...a combination of lines and colors...that moves me esthetically" (Bell, 1973, p. 228). This formalist theory and the resulting art criticism of Clement Greenberg in the 1940s and 1950s made possible the interpretation of modern art, especially abstract expressionism and postpainterly abstraction. Formalism became the basis of abstraction, the pursuit of form capable of evoking universal aesthetic experience.

The education of artists and art teachers in our colleges and universities, and following them, students in elementary and secondary schools, has been based on this "formalist preoccupation with abstract form as content" (Wilson, 1992, p. 101). Through disinterested contemplation of form, art refers to itself and not the outside world. Stylistic innovation as a result of original variations on form in a medium has defined art in the modernist period, art in the schools, and students' progress in the university classroom. Each of these principles is conveyed to students through foundations programs and studio training in many institutions of higher education. These formalist preoccupations entered the field of art education at the turn of this century to influence the content of K - 12 art education, later to be joined by creative expression as a rationale (Dow, 1899; Lowenfeld, 1952). One need only review state curriculum guides and college course syllabi to determine that formal problems and their resolution (called problem-solving) has been the content of art programs in schools and universities.

No doubt readers will be reminded at this point of their own foundations classes— 2-D and 3-D design— in which the elements and principles of design are assiduously studied and practiced. Knowledge of design and compositional effects was considered essential, or foundational, to making art to be experienced aesthetically because it communicated universals, thereby permitting one to interpret and evaluate art from any culture, any place, and any time (How often have you heard that art is a universal language?) And note that "quality art" exists to be contemplated aesthetically. That is, aesthetic contemplation is what art is for. Readers will also recognize that the studio curriculum in most art programs at all levels of education is organized around media, and art history courses around stylistic changes. Art criticism becomes talk of formal issues, and works of art are described in formal language. The focus of classroom criticism is often on how the object was made instead of on what the object means.

The ideological boundaries that separated modernism from postmodernism began to disintegrate with pop art. Minimalism of the 1960s "jettisoned space, illusionism, all suggestions of subject matter other than the apparent 'objectness' of the art... for an image that requires no information outside the boundaries of its own edges to function. Abstract expressionism had pushed the limits of art making almost to the edge. The last phase of modernism, minimalism, pushed it over" (Kissick, 1993, p. 410), and the succession of styles and "isms" that signaled modernism's beginnings with impressionism came to a close (Gablik, 1984).

Modernist theory became suspect as a younger generation of artists increasingly stopped believing in its most basic tenets. It had not brought us a better world as promised, but the Depression, two world wars, the potential of nuclear destruction, the Cold War, the Civil Rights Movement, the American Indian Movement, the Feminist Movement, and the rise of gay and lesbian issues. Modern art, especially post-World War II art, had significantly separated art from the masses. Pop artists sig-

naled a reconnection with the world beyond the boundaries of the work itself, as did other forms that came to signify a stylistically pluralist era in which, unlike the modernist period, no single style dominated the artworld. Economic, moral, political, and spiritual issues that marked post-World War II America became occasions for creation. Howard Risatti recently characterized this art that signals the rupture of values associated with modernism.

> The works of artists such as Hans Haacke, David Hammons, Jenny Holzer, Leon Golub, Anselm Kiefer, Adrian Piper, Mierle Laderman Ukeles—the list goes on and on—typify today's art world, an art world less involved with traditional aesthetic concerns than economic, psychological, environmental, social, and historical issues. This new art, recognized as "political" because these concerns often have a direct connection to legislative agendas, is part of what we now accept as the postmodern condition, a condition in which the cultural consensus that shaped the modern period has disappeared....It is clearly positioned as a backlash to Greenbergian formalism which, rightly or wrongly, came to represent modernism in the eyes of many people by the late 1960s. (1993, p. 12)

We should note here that some do not acknowledge that postmodernity is a new paradigm. Some see it as a continuing development in modernism. Howard Smagula, for example, claims that the "range of work we see about us is actually a result of the success of modernist thought, not its failure" (1989, p. 1).

## Postmodernism: The Rising Tide of Feminist, Multiculturalist and Social Reconstructionist Thought

A major challenge to modernism has been the discourse of feminists, multiculturalists and social revisionists—first in the humanities and now in the arts, who claim that, with the hegemony of Modernism, a minority of individuals had determined what quality art was and what quality art was not. Those whose art did not fit within modernism's formalist traditions were excluded from prominence in the art world.

Many postmodern artists are addressing issues of social and environmental responsibility (Gablick, 1991) and multiculturalism and parallel cultures (Lippard, 1990) rather than formal issues. What has regained prominence is art that references the world and often seeks the social reconstruction of society. While formalism may remain embedded in postmodernism, the investigation of formal issues and objectivist aesthetics is no longer central to art making or art criticism. This shift away from modernism is characterized by a way of thinking differently about knowledge and what art is for (Lather, 1991). Basic to this thought is that we are only one among others in a multicultural world, that perspective-free (universal) truth is not only impossible, but oppresses equally valid truth claims. It has become evident, says Ellen

Dissanayake, that there is "a pluralism of human possibility [and an] evident workability of numerous belief systems" in art (1988, p. 199).

Postmodernism is characterized by a reexamination or deconstruction of modernist claims. Deconstruction is not a rejection of modernism outright, "but rather seeing it from a different perspective and understanding it in terms of opposing forces" (Lovejoy, 1992, p. 91). Postmodern artists are breaking free of the hegemony of formalism and the centrality of the medium, from the aesthetic as the end of art, and from disinterested contemplation of form as the viewer's role. They undermine unicultural definitions of quality and claims of universal truth in order to refine our sensitivity to difference. Form and media become incidental to the idea and there is less concern with originality as evidenced by the appropriation and recycling of images created by other artists. These postmodern directions are prominent in the writings and art of feminists, people of color, and gays and lesbians.

## Feminism

Feminists were among the first to add to the construction of the postmodern paradigm in the visual arts. From their point of view, gender is a factor influencing what we think and believe, as are class, race, ethnicity, age, sexual orientation, etc. As Sally Hagaman notes, "feminist art critics have raised the issue of the inability of aesthetic theories based on a formalist criterion to provide...standards and definitions of art" (1990, p. 32). The point of view from which one acts is legitimate and to be valued for its difference. There is no single, objective truth, only human constructs that are biased and non-neutral. While there is always the presence of a point of view, the notion that a point of view is neutral and objective is vigorously denied by feminists. Recognition of different points of view, of communities of views, as opposed to the universal position of modernism, is one of the most significant aspects of postmodernism.

While early feminists sought to have art by women included side-by-side with men's art in the art historical canon, later feminists attempted to deconstruct the very nature and functions of art and the art world. Representatives of the latter orientation demonstrate how the production of art is tied to gender, power and ideological issues. Empowerment of artistically disenfranchised groups is a theme of much postmodern thought. This approach, notes John Kissick (1993), has proven itself fruitful not only for feminist critics but also for other underrepresented groups, such as African Americans and third-world artists, who have historically been excluded from consideration in art circles due to the incompatibility of their work with Western standards.

By the end of the 1960s, women were making the art world aware of their status as artists. Similar concerns of modernist hegemony were voiced by those who came to be labeled "others"—African Americans, Native Americans, and gay and lesbian artists.

We next consider these voices in the broad context of multiculturalism/social reconstruction.

## Multiculturalism and Social Reconstruction: The Art of Others

An eloquent statement of the impact of the growing realization of "others" in our midst was made by Paul Ricoeur (1965) in his discussion of the decline of the modern age. With the beginning of the postmodern age, he said, came the realization of the necessary coexistence of different cultures. Ricoeur foreshadowed the social upheavals of genderism, racism, and the gay and lesbian liberation movement of the 1970s and 1980s when he said the discovery that there are several cultures instead of just one in our midst, "is never a harmless experience" (p. 278). We must acknowledge, he argued, the end of a cultural monopoly and the value of community.

The rethinking of modernist assumptions by scholars whose studies are more broadly contextualized is beginning to enlarge our thinking about the art of "others." The Summer 1991 issue of the *Art Journal,* published by the College Art Association, was given over to feminist art criticism and the Fall 1992 issue to Native American art. The June 1994 issue of *Art in America* included interviews with 12 gay and lesbian artists, and a recent issue of *Studies in Art Education* (35 (3), 1994) was devoted solely to "The Social Reconstruction of Art Education." Inclusiveness is a general theme throughout these publications.

Multiculturalism and social reconstruction are additional threads of postmodernism which acknowledge and deconstruct modernism's monopoly maintained through narrow definitions of quality in art. "The ways in which quality has been used as a weapon of exclusion" (Minor, 1994, p. 203) have been at the center of this deconstruction. Lucy Lippard (1990) claims that this exclusion "is balanced on a notion of Quality...identifiable only by those in power [who claim] racism has nothing to do with art; Quality will prevail; so-called minorities just haven't got it yet. The notion of Quality has been the most effective bludgeon on the side of homogeneity in the modernist and postmodernist periods" (p. 7).

*Quality,* then, is a compromised term that reveals the biases of a Western, patriarchical, heterosexual art establishment. A central issue in the contemporary art of people of color and gays and lesbians has been inattention, or disempowerment, by the art establishment. Native Americans, for example, have argued for a more inclusive definition of art and quality in relation to Native American artists. Without more inclusive definitions, Kay WalkingStick warns, Native American art will continue to be relegated to "multicultural exhibitions...just another way to segregate artists" (1992, p. 15). While WalkingStick acknowledges that postmodern theory may provide for more inclusive critical viewpoints, others warn against categorizing the range of Native American art from any perspective other than that of the Native American.

Nomenclature such as *tribal art, crafts, folk art, fine art,* and other labels serves only to perpetuate cultural otherness and is an acquiescence to modernist aesthetic ideologies that value certain media more than others (Rushing, 1992).

What is needed is a new definition of quality that recognizes the current situation in the visual arts. "Just as the definition of quality had to be expanded to include Impressionism and Post-Impressionism...now the definition of quality needs to be further expanded...in order to include the best of the contemporary art defined by multiple...contexts" (Csarzar, 1994, p. 38).

Many African American artists describe their experience of otherness in mainstream society that marginalizes and represses them socially and professionally. For example, conceptual artist Adrian Piper (1990, p. 295), often mistaken for white, addresses racism in her "Calling (Card) No. 1" which reads:

Dear Friend,

I am black.

I am sure you did not realize this when you made/laughed at/agreed with that racist remark. In the past, I have attempted to alert white people to my racial identity in advance. Unfortunately, this invariably causes them to react to me as pushy, manipulative, or socially inappropriate. Therefore, my policy is to assume that white people do not make these remarks, even when they believe there are no black people present, and to distribute this card when they do. I regret any discomfort my presence is causing you, just as I am sure you regret the discomfort your racism is causing me.

Sincerely yours,

Adrian Margaret Smith Piper

The politics of sexuality and the dominant view that same sex relationships are obscene is a major component of the work of gay and lesbian artists in this time of AIDS and the Helms amendment. The late Marlon Riggs (1991), for example, was a gay African American media activist, film producer and director. Before his death from AIDS, he argued against the establishment that "squelches and negates...voices and visions...that threaten...American power and authority that is rigidly...white, male, and heterosexual" (p. 63).

Our readers will be familiar with the Cincinnati exhibition of Robert Mapplethorpe's photographs titled "The Perfect Moment." As a result of community outrage over homoerotic imagery, the director of the Contemporary Arts Center in Cincinnati was indicted on charges of pandering to obscenity (He was subsequently

acquitted) (Barrie, 1991). As Douglas Crimp (1993) argued, "the resulting Jessie Helms' amendment to the National Endowment for the Arts/National Endowment for the Humanities appropriations bill included language labeling homoeroticism obscene. Jesse Helms has made clear [that] difference, in our culture, is obscenity. And it is this with which postmodern theory must contend" (p. 161).

## Art Education for a Postmodern Climate

We have seen how formalism and other modernist ideas in foundations and studio courses have shaped the education of future artists and teachers. We have introduced some postmodern ideas that challenge the validity of these prevailing traditions. Foremost among these is that modernism as a style of art and a construct of Western culture has been relegated to history. It has been replaced by postmodernity, the characteristics of which include (1) a concern with art that references individual and group experiences of the world, particularized by class, race, gender, ethnicity, sexual orientation, etc., and that questions the aesthetic as the end of art; and (2) a recognition of the need for new definitions of quality inclusive of art defined by the heterogenity of multiple voices representing the current situation in the visual arts.

A discipline's epistemological character strongly influences methodology, pedagogy, and curriculum. The strength of modernism's pedagogical traditions now impede curricular reform in the schools and preservice teacher education programs. Although DBAE and multicultural/social reconstruction dominate the curriculum literature, and distance themselves from traditions of modernism such as creativity and self-expression (Hobbs in this volume), modernism's pedagogical traditions dominate art in the schools and teacher education programs. How can we enlarge the content of art and art education in a postmodern era? Can postmodern thinking be accommodated in art education theory and practice? The essays that follow address these questions. Barrett, Pearse, Hamblen, Anderson, and Hobbs address questions of content while Garber and Berrson emphasize the contextual and narrative dimensions of art. Jones reviews current teacher training and offers recommendations for its reform to accommodate postmodern directions. McRorie, Walker, Keifer-Boyd, Gaudelius, and Wolcott and Gough-Dijulio apply postmodern thinking at a variety of educational levels, including teacher training.

## References

Barrett, T. (1993). *Criticizing art. Understanding the contemporary.* Mountain View, CA: Mayfield Publishing Company.

Barrie, D. (1991). The scene of the crime. *Art Journal, 50* (3), 29 - 32.

Bell, C. (1973). Significant form. In M. Rader (Ed.), *A modern book of asthetics.* New York: Holt, Rinehart and Winston, Inc., 228 - 236.

Crimp, D. (1993). The boys in my bedroom. In R. Hertz (Ed.), *Theories of contemporary art.* Englewood Cliffs, NJ: Prentice Hall, 157 - 161.

Csarzar, T. (1994). Exchange & interrupt. Delay in praxis in the art of the '90s. *New Art Examiner,* Summer, 38 - 43.

Danto, A. (1981). *The transfiguration of the commonplace: A philosophy of art.* Cambridge, MA: Harvard University Press.

Danto, A. (1992). *Beyond the brillo box.* New York: Farrar, Straus, Giroux.

Dissanayake, E. (1988). *What is art for?* Seattle, WA: University of Washington Press.

Dow, A. (1899). *Composition.* New York: The Baker and Taylor Company.

Gablick, S. (1984). *Has modernism failed?* New York: Thames and Hudson.

Gablik, S. (1991). *The reenchantment of art.* New York: Thames and Hudson.

Hagaman, S. (1990). Feminist inquiry in art history, art criticism, and aesthetics: An overview for art education. *Studies in Art Education, 32* (1), 27 - 35.

Kissick, J. (1993). *Art. Context and criticism.* Dubuque, IA: Brown and Benchmark.

Lather, P. (1991). Deconstructing/deconstructive inquiry: The politics of knowing and being known. *Educational Theory, 41* (2), 153 - 173.

Lippard, L. (1990). *Mixed blessings. New art in a multicultural America.* New York: Pantheon Books.

Lovejoy, M. (1992). *Postmodern currents. Art and artists in the age of electronic media.* Englewood Cliffs, NJ: Prentice Hall.

Lowenfeld, V. (1952). *Creative and mental growth: Revised edition.* New York: The Macmillan Company.

Minor, V. H. (1994). *Art history's history.* Englewood Cliffs, NJ: Prentice Hall.

Piper, A. (1990). Xenophobia and the indexical present. In M. Obrien & C. Little (Eds.), *Reimaging America: The arts of social change.* Philadelphia: New Society, 285 - 295.

Ricoeur, P. (1965). *Civilization and national cultures, history and truth,* (C. A. Kelbley, trans.). Evanston, IL: Northwestern University Press.

Riggs, M. (1991). Notes of a signifyin' snap! queen. *Art Journal, 50* (3), 60 - 64.

Risatti, H. (1989). A failing curricula. *New Art Examiner,* September, 25 - 26.

Risatti, H. (1993). Formal education. *New Art Examiner,* February, 12 - 15.

Risatti, H. (1990). *Postmodern perspectives. Issues in contemporary art.* Englewood Cliffs, NJ: Prentice Hall.

Rushing, W. (1992). Editor's statement. Critical issues in recent Native American art. *Art Journal, 51* (3), 6.

Smagula, H. (1989). *Currents. Contemporary directions in the visual arts.* Englewood Cliffs, NJ: Prentice Hall.

WalkingStick, K. (1992). Editor's statement. Native America art in the postmodern era. *Art Journal, 51* (3), 15.

Wilson, B. (1992). Postmodernism and the challenge of content: Teaching teachers of art for the twenty-first century. In N. Yakel (ed.), *The future: Challenge of change.* Reston, VA: National Art Education Association, 99-113.

# MODERNISM AND POSTMODERNISM: AN OVERVIEW WITH ART EXAMPLES

Terry Barrett

Modernism and postmodernism in art are best understood in relation to modernity and postmodernity in general cultural history; and modernist and postmodernist art are most easily understood with art examples. The following offers cursory explanations of central themes in modernity and postmodernity, and modernist art and postmodernist art with descriptions of artworks that make the themes more understandable. The art examples are set in italics.

## Modernity and Postmodernity

The Age of Modernity is the epoch that began with the Enlightenment (about 1687 to 1789). Isaac Newton championed the belief that through science the world could be saved. René Descartes (1596-1650) and later, Immanuel Kant (1724-1804), shaped the age intellectually by their beliefs that through reason they could establish a foundation of universal truths. Political leaders of modernity also championed reason as the source of progress in social change, believing that with reason they could produce a just and egalitarian social order. Such beliefs fed the American and French democratic revolutions, the first and second World Wars, and the thinking of many today. The major movements and events of modernity are democracy, capitalism, industrialization, science, and urbanization. The rallying flags of modernity are freedom and the individual.

There is no unified theory of postmodernity. There are many contenders putting forth contentious ideas. Proponents of postmodernity symbolically date its birth with the riots in Paris in May 1968, when students, with the support of prominent scholars, demanded radical changes in a rigid, closed, and elitist European university system. Postmodernism does not merely chronologically follow modernism, it reacts against modernism, and might better be called anti-modernism.

Postmodernists criticize modernity by citing the suffering and misery of peasants under monarchies, and later the oppression of workers under capitalist industrialization, the exclusion of women from the public sphere, the colonization of other lands by imperialists and, ultimately, the destruction of indigenous peoples. Postmodernists claim that modernity leads to social practices and institutions that legitimate domination and control by a powerful few over the many, even though modernists promise equality and liberation of all people.

*Fred Wilson's exhibition "Mining the Museum" at the Maryland Historical Society in 1992, offers several postmodernist artistic strategies that address with critical bite social power in modernity. Among finely crafted and polished silver vessels that one would expect to see in a section of an historical museum labeled "Metalwork 1830-1880," Wilson placed steel shackles crudely forged and hammered for slaves. In a typical display of antique Victorian furniture, including a chair with the logo of the Baltimore Equitable Society, Wilson placed a whipping post. Based on Wilson's exhibition, museum educators prepared materials that asked visitors to consider any object in the museum by asking these questions, none of which would have been asked of an art object during the reign of modernism: For whom was it created? For whom does it exist? Who is represented? Who is doing the telling? The hearing?*

Whereas modernity is influenced by the rationalism of Newton, Descartes, Kant, and others, postmodernity is influenced by philosophers such as Friedrich Nietzsche, Martin Heidegger, Ludwig Wittgenstein, John Dewey, and more recently, Jacques Derrida, and Richard Rorty, who are skeptical about the modernist belief that theory can mirror reality. Karl Marx and Sigmund Freud also undermined the modernist belief that reason is the source of truth by identifying economic forces above the surface of society and psychological forces below it that are not bound by reason, yet are powerful shapers of society and individuals. Postmodernists embrace a more cautious and limited perspective on truth and knowledge than modernists. Postmodernists stress that facts are simply interpretations, that truth is not absolute but merely the construct of individual groups, and that all knowledge is mediated by culture and language.

*In a New York City gallery installation in 1994, postmodern artist Barbara Kruger offered an angry critique of how she understands religions to use cultural practices and language to control the psyche and society. In wall texts, photo graphics on the walls and the skylight and floor, and over loud speakers in the Mary Boone Gallery, Kruger made statements including these: "Think like us." "Believe like us." "Pray like us." "I mutilate you so you won't feel any pleasure. I want you to have my babies, because it shows how powerful and manly I am, and you want to do it because that is all you're good for."*

Structuralism and poststructuralism are two competing intellectual movements formative of postmodern thought. Structuralism emerged in France after World War II,

heavily influenced by the earlier semiotic theory of linguist Ferdinand de Saussure. De Saussure identified language as a system of signs consisting of signifiers (words) and signified (concepts) that are arbitrarily linked to each other in a way that is designated by a culture.

Claude Lévi-Strauss applied linguistic analysis to anthropology. Postmodernists build on the semiotic projects of Roland Barthes and others undertook semiotic projects studying the systems of signs in societies, believing that language, signs, images, and signifying systems organize the psyche, society, and everyday life.

Structuralists in various disciplines, including literature, attempted to explain phenomena by identifying hidden systems. They sought to discover unconscious codes or rules that underlie phenomena and to make visible systems that were previously invisible They especially differed from previous scholars who explained things through historical sequences of events rather than the structuralist method of explaining phenomena in relation to other synchronous phenomena. Structuralists, like modernists, believed they could with rigor attain coherence and objectivity, and they claimed scientific status for their theories, which they believed purged mere subjective understandings.

Poststructuralists, most influentially Jacques Derrida, criticize structuralists for their scientific pretensions, their search for universal truth, and their belief in an unchanging human nature. Both structuralists and poststructuralists reject the idea of the autonomous subject, insisting that no one can live outside of history, and poststructuralists especially emphasize the arbitrariness of signs. Postmodernists stress that language, culture, and society are arbitrary and conventionally agreed upon and should not be considered natural. Whereas modernists believe they can discover unified and coherent foundations of truth that are universally true and applicable, postmodernists accept the limitations of multiple views, fragmentation, and indeterminacy.

*Postmodern painter David Salle challenges closed meaning systems to expose their arbitrary construction by juxtaposing many diverse subjects on single canvases—for example, matadors, pop-culture images of Santa Claus and Donald Duck, iconic profiles of Abraham Lincoln and Christopher Columbus, with portions of nude and partially clothed female bodies. Some art critics decry Salle's pastiched paintings as sexist because of "their trademark girlie pinup images" (Rimanelli, 1991, p. 111) and his "crotch intensive perspective" (Cottingham, 1988, p. 104). However, with a postmodernist perspective that depends on the distinction between sign and meaning, Robert Storr (1988) denies that Salle's paintings represent women even though they depict them. Storr asserts contempt "for anyone who would insist that the subject represented might in some way have a proprietary interest in their representation" (p. 24).*

Postmodernist psychology also rejects the modernist notion that the individual is a unified rational being. Descartes's dictum, "I think, therefore I am," and Jean-Paul Sartre's dictum that "existence precedes essence" which defines the individual as free and undetermined, place the individual at the center of the universe. Postmodernists instead decenter the individual and claim that the self is merely an effect of language, social relations, and the unconscious; they downplay the ability of the individual to effect change or to be creative.

*Much of Cindy Sherman's art is photographs of herself which undermine notions of individuality. In "Untitled Film Stills," 1977-1980, she pictures herself, but as a woman in a wide variety of guises from hitchhiker to housewife. These pictures look like stills from old movies. They are pictures of Cindy Sherman, and pictures of Cindy Sherman disguised as others, and they are also pictures of women as women are represented in cultural artifacts such as movies and magazines and paintings, and especially as pictured by male producers, directors, editors, painters, and photographers. They are about "the cultural construction of femininity"* (Heartney, 1987, p. 18).

## Modernist Aesthetics and Criticism

Artistic modernism is more recent than philosophical modernity. Art critic Robert Atkins (1993) dates modernism "roughly from the 1860s through the 1970s" and writes that the term is used to identify both the styles and the ideologies of the art produced during those years (p. 139). Although modernism is now old, and some think finished, it was once very progressive, bringing a new art for a new age.

Modernism emerged amidst the social and political revolution sweeping Europe. Western European culture was becoming more urban and less rural, industrial rather than agrarian. The importance of organized religion in the daily lives of people was diminishing while secularism was expanding. Because the old system of artistic patronage had ended, artists were free to choose their own content. Their art no longer needed to glorify the wealthy individuals and powerful institutions of church and state that had previously commissioned their paintings and sculptures. Because it was not likely that their art would flourish in the new capitalist art market, artists felt free to experiment and made highly personal art. The slogan of the era, "Art for the sake of art," is apt.

Modernists signified their allegiance to the new by referring to themselves as "avant-garde," thinking they were ahead of their time and beyond historical limitations. Modern artists were especially rebellious against restrictions put on previous artists by the art academies of the 1700s, and later artists rebelled against the dominance of the art salons and their conservative juries in the late 1800s. Modern artists were often critical of the status quo and frequently challenged middle class values.

*Premodernists Jacques Louis David painted scenes from the French Revolution, and Francisco de Goya depicted Napoleon's invasion of Spain. Modernists Gustave Courbet and Edouard Manet turned their easels away from nobility and wealth to paint ordinary life around them. The impressionists and postimpressionists abandoned historical subject matter, and also turned away from the realism and illusionism artists had been refining in the West since the Renaissance. Some modernists, such as the futurists in Italy during the 1920s, celebrated in their work new technology, especially speed, while others, such as the constructivists in the Soviet Union, embraced scientific models of thinking. Abstractionists Wassily Kandinsky and Piet Mondrian embraced spiritualism to offset the secularism of modern society. Paul Gaugin, and later Pablo Picasso and Henri Matisse sought solace and inspiration in non-Western cultures, while Paul Klee and Joan Miró "employed childlike imagery that embodies the yearning to escape adulthood and all its responsibility"* (Atkins, 1993, p. 176).

In 1770, Immanuel Kant laid the philosophic foundation for artistic modernism. Kant developed a theory of aesthetic response which held that viewers could and should arrive at similar interpretations and judgments of an artwork if they experienced the work in and of itself. When viewing art, according to Kant, people should put themselves in a supra state of sensory awareness, give up their personal interests and associational responses, and consider art independently of any purpose or utility other than the aesthetic. An aesthetic judgment should be neither personal nor relative. The viewer should rise above the time, place, and personal idiosyncrasies, reaching aesthetic judgments of art with which all reasonable people would agree. In 1913, Edward Bullough, an aesthetician, added the concept of "psychic distancing," reinforcing Kant's idea that the viewer should contemplate a work of art with detachment.

In the 1920s, modernist art theory received a big boost from two British critics, Clive Bell and Roger Fry, who introduced what is now known as formalism. Formalism and modernism are inextricably linked, although the former is an outgrowth of the latter. Bell and Fry sought to ignore as irrelevant the artist's intent in making a work of art and any social or ideological function the artist may have wanted the work to have. Instead, the "significant form" of the artwork was what was to be exclusively attended to. Atkins (1990) credits Bell and Fry's critical purpose as being responsible in part for the early 20th century interest in Japanese prints and Oceanic and African artifacts. Their critical method of attending to art was meant to allow a cross-cultural interpretation and evaluation of any art from any place or any time. Form was paramount, and attention to the other aspects of the work—such as its subject matter or narrative content or uses in rituals or references to the ordinary world—were considered distractions and, worse, detriments to a proper consideration of art.

During the 1930s, in the area of literary criticism, T. S. Eliot, I. A. Richards, and other writers developed "New Criticism," a formalist approach to literature that paralleled formalism in art. These literature critics wanted more interpretive emphasis on

the work itself—on the poem rather than the poet, for instance—and they wanted the work to be analyzed according to its use of language, imagery, and metaphor. They were attempting to correct the then-current practice of critics placing too much emphasis on information outside of a literary work—for example, on a poet's biography and particular psychology, rather than on the actual text. After World War II, formalist art criticism became extremely important in the United States because of the work of Clement Greenberg, the most influential American art critic of this century.

*With formalist principles, Greenberg championed the Abstract Expressionism of Mark Rothko, Willem De Kooning, and Jackson Pollock in the mid-1940s through the 1950s. Greenberg particularly championed the work of Pollock, and the artist and critic in tandem are generally credited with moving the center of the high art world from Paris to New York. While regionalist painters such as Thomas Hart Benton and Grant Wood were painting the American scene, and while Social Realists depicted class struggles, the Abstract Expressionists championed the existential ideal of individual freedom, and committed themselves to psychic self-expression through abstraction.*

Shape, size, structure, scale, and composition were of utmost importance, and styles evolved out of enthusiasm for particular properties of paint. Abstract Expressionism gets much of its effect "from how paint in various thicknesses, applied by a variety of means, behaves differently and affects the finished work in different ways. Blobs of paint mean something different from drips or thin veils" (Yenawine, 1991, p. 20).

With the backing of Greenberg and, later, fellow critic Harold Rosenberg, Abstract Expressionists and Color Field Painters and Hard-Edged Abstractionists flattened their paintings under the formalist principle that painting is two-dimensional by nature and that it ought not attempt three-dimensional illusions. Rosenberg declared that "a painting is not a picture of a thing; it's the thing itself" (Singerman, 1989, p. 156). He wanted artists "just TO PAINT." *Barnett Newman, who painted huge minimally abstract paintings in the 1950s, wrote that the canvas should not be a "space in which to reproduce, redesign, analyze or express," and he rejected "props and crutches that evoke associations, and resisted the impediments of memory, association, nostalgia, legend, myth" (p. 156). Frank Stella wrote, "My painting is based on the fact that only what can be seen there is there" (p. 157). Minimalists, with their emphasis on reducing painting and sculpture to its bare essentials, were heavily influenced by the work of Newman, Ad Reinhardt, and David Smith.* During the 1960s, critic Michael Fried wrote extensively on formalism, concentrating especially on minimalist sculpture.

However, as social forces in the 1960s sought to obliterate social boundaries, so art movements erased aesthetic boundaries. Joseph Beuys, the German Process Artist, was claiming that everyone was an artist, while Andy Warhol was claiming that everything was art. Movements such as Pop Art eventually rendered formalism ineffective.

*Warhol's renditions of Brillo boxes and Campbell's soup cans demanded social and cultural interpretations rather than meditations on the significance of their form. Pop Art also relied on everyday life, a subject that was anathema to formalists, and Pop artists such as Roy Lichtenstein used comic book imagery to make art with narrative content, content that formalists wanted banished from painting. Pop artists erased the boundaries between high art and low art, and between an elite and a popular audience, by placing their versions of comic strips, soup cans, and cheeseburgers in galleries and art museums.*

Negative criticism of modernism, its slogan of "art for art's sake," and its push toward minimal abstraction was growing. Tom Wolfe attempted to discredit Greenberg and Rosenberg and their abstract and minimalist movements with sarcastic wit in *The Painted Word* (1975). Wolfe mocked as a trivial idea the formalists' insistence on the "flatness" of a canvas. In 1982, Wolfe wrote *From Bauhaus to Our House*, concentrating on the glass box architectural principles and buildings of Mies Van Der Rohe, Le Corbusier, and the Bauhaus school. Wolfe's book on architecture followed another influential critique of modernist architecture by Charles Jencks, *The Language of Post-modern Architecture* (1977). Jencks pointed out that the utopian dreams of modernist architects like Le Corbusier resulted in sterile skyscrapers and condemned public housing projects. Jencks called for a new architectural style based on eclecticism and popular appeal.

Arthur Danto (1992) credits Warhol with bringing about "the end of art," by which phrase he refers to the logical end of a certain strain of art, namely, modernism. Danto describes modernism as an internally driven sequence of "erasures" that took place over the course of decades and ended in 1964 with the exhibition of Warhol's *Brillo Box*. According to Danto, the history of modernism since 1900 is "a history of the dismantling of a concept of art which had been evolving for over half of a millennium. Art did not have to be beautiful; it need make no effort to furnish the eye with an array of sensations equivalent to what the real world would furnish it with; need not be the magical product of the artist's touch" (p. 4).

*Modernists abandoned beauty as the ideal of art—Picasso's Cubist rendering of women in* Les Demoiselles d'Avignon, 1907. *They dropped subject matter as essential—Jackson Pollock's "drip paintings." They stopped rendering three-dimensional forms on two-dimensional surfaces—Franz Kline's* Mahoning, 1956, *an approximately 6' x 8' oil on canvas, black-on-white linear abstraction. They eliminated the artist's touch—Don Judd's* Untitled, 1967, *consisting of eight cubes, made by commercial fabricators, of steel and car paint. They eliminated the need to have an art object itself. For conceptual artists of the mid-1960s and 1970s, the idea was more important than the finished work. John Baldessari, for example, exhibited only the documentation of a piece he made by placing the letters C-A-L-I-F-O-R-N-I-A in the actual landscape according to where these letters appeared on a map of California (Atkins, 1990, p. 56). They eliminated the need to have*

*an artwork be different from ordinary objects—soft sculptures of hamburgers and fries by*
*Claes Oldenburg, and Andy Warhol's* Brillo Boxes, *1964.*

Danto specifically credits *Brillo Boxes* with the end of modernism because with it
Warhol made the philosophical statement that one could no longer tell the difference
between an ordinary object and an art object just by looking at it. To know that
Warhol's *Brillo Box* was art and a Brillo box in the grocery store was not, one had to
know something of the history of art, the history of the erasures that lead to Warhol's
ultimate erasure (or "death of art"). One had to participate in a *conceptual atmosphere*
and be familiar with some of the *discourse of reasons* afloat in *an art world.*

Despite Danto's proclamation of the end of art, there obviously were and are many
artists, with much energy, still making art, but it is the art of a new pluralism rather
than art made under the dictates of mainstream modernism. Danto sees the "end of
art" as a liberation: "Once art ended, you could be an abstractionist, a realist, an alle-
gorist, a metaphysical painter, a surrealist, a landscapist, or a painter of still lifes and
nudes. You could be a decorative artist, a literary artist, an anecdotalist, a religious
painter, a pornographer. Everything was permitted since nothing was historically
mandated" (1992, p. 9).

This is roughly the way that Danto and other mainstream critics and aestheticians
write the history of modern art. One art scholar may judge some artists to be major
influences; another may see these same artists as less important. Fried, for instance,
stresses the importance of minimalist sculptors such as Judd and Robert Morris, while
Danto finds the Pop artists, especially Warhol, to be most influential.

Others, notably Douglas Crimp (1990), write a different history of modernism,
arguing that its demise was brought about by the invention of photography.
Photography allowed the mechanical reproduction of images, including art images,
thus eventually stripping away from the work of art its properties of uniqueness, origi-
nality, and location or place of origin. In reproduction, the artwork can be enlarged,
cropped, and recombined with other artworks and images. That the artwork once was
"original and authentic" is considered much less important. What is considered
important by Crimp and others is that any artwork made in any place in the world at
any time can now be seen over and over again in a myriad of contexts.

The significance of the reproducibility of artworks by photographic means was
noted by Walter Benjamin in the 1930s. Benjamin was a member of the Frankfurt
School, which included Theodore Adorno, Herbert Marcuse, and other European
scholars fleeing Hitler. These scholars, and more recently, Jurgen Habermas, devel-
oped critical theory, a form of neo-Marxism challenging dominant capitalist ideology,
practice, and culture. Habermas particularly supports art that contributes to critical
social discourse. Marxists accept modernists' search for foundational truths, but are

hostile to artistic modernists' separation of art from life. The "neo" in neo-Marxism is a rejection of strict and unwavering historical determinism and belief in the collapse of capitalism that Marxists once held, and a new acceptance that culture influences history and that people can affect the future.

In postmodernist terms, Danto's and other writers' renditions of modernism are thought of as "stories." According to Derrida, all explanations of the world, including scientific explanations, are merely stories or "discourses" fabricated by people. Derrida holds that we never get to reality, only to what we say about reality; there is no truth, there is only discourse. Nevertheless, Danto's theory is compelling. It makes sense of a myriad of stylistic changes that have taken place in art over the past 100 years, making these changes seem logical and linear in order. Like all stories, however, it draws our attention to certain characters and events and ignores thousands of other people who could have been written as major or minor characters. Danto's story of recent art is set in Paris and New York. The rest of the world would be distracting. Danto's story ignores all aesthetic traditions except those of Western Europe and the United States. It is a story about modern Western culture, and it overlooks artists and artworks that do not fit its plot. Frida Kahlo is not a character for his story, nor is Romare Bearden. The art of most women is omitted, as is the work of artists of color, and indeed anyone who was making art with different intentions from those recognized by mainstream critics and aestheticians.

We might have inherited a very different history of recent art than modernism and others are now being written. We inherited modernism as an influential but limited explanation of art of the past century. The predominant characteristics of modernism are an optimism regarding technology; belief in the uniqueness of the individual, creativity, originality, and artistic genius; a respect for the original and authentic work of art and the masterpiece; a favoring of abstract modes of expression over narrative, historical, or political content in art; a disdain for kitsch in culture and a general disdain for middle-class sensibilities and values; and an awareness of the art market.

## Postmodernist Aesthetics and Criticism

Postmodernists set themselves apart from all or most modernist beliefs, attitudes, and commitments. *Postmodern artists present the art world with diverse aesthetic forms that break with modernism like the architecture of Robert Venturi and Philip Johnson; the radical musical practices of John Cage; the novels of Thomas Pynchon; films like Blue Velvet; performances like Laurie Anderson's; and the use of electronic signage by Jenny Holzer to make socially oppositional art in popular culture.*

Postmodernists flout the modernists' reverence for originality. A central postmodernist strategy is known by the term "appropriation." By appropriating or borrowing or plagiarizing or stealing, postmodernists remind us that the notion of originality is

absent in most traditions of art, in the West and throughout the world. Throughout time most cultures felt no need to identify artists personally, even if they were especially gifted.

*Sherrie Levine is most famous for appropriating artworks from the past, most often so-called masterpieces by such white male modern painters as Piet Mondrian and photographers Walker Evans and Edward Weston, two of the most influential mentors of modernist art photography. Levine copied (appropriated) an Evans's photograph and exhibited it as her own under the title* After Walker Evans #7, *1981.*

Levine's *After Walker Evans #7* also reinforces Crimp's point, and Benjamin's before him, that the invention of photography has created havoc for modernism. The original photograph, or any artwork, is not important. The reproduction brings the image to millions who otherwise would not see it at all because they would not travel to wherever Evans's photograph might hang. By using a camera to rephotograph a photograph, Levine is also eschewing the reverence previously given to painting, always considered the essential medium of modernism, even though minimalist sculptors attempted to challenge the primacy of paint on canvas. By selecting the work of male artists, Levine questions the place of women in the history of art. By copying certain subjects of male artists, such as a photograph by Edward Weston of his son Brett Weston as a nude young boy, she also questions the role of the artist's gender when the audience views the work: If the nude torso of a young boy had originally been made by a woman artist, the implications would have been different than they are.

As should be expected, not everyone is enamored with postmodernists' appropriations such as those by Levine. In one biting rejection, Mario Cutajar (1992) dismisses the practices of Levine and fellow postmodernists like Jeff Koons, who appropriates crass three-dimensional commercial artifacts such as bunnies, has them made into stainless-steel replicas, and exhibits them as high art sculptures. Cutajar writes: "The typical product of envy and resentment, postmodernism has extracted its vitality from parasitic critiques of far greater achievement, rationalizing the shabbiness of its own product by devaluing (deconstructing) the greatness of what is beyond the reach of its own adherents" (p. 61). He interprets the strategy of appropriation to be the strategy of adolescents trying to emerge from under the shadow of their formidable parents.

## Summary Distinctions Between Modernist and Postmodernist Art

Postmodernists do not merely follow modernists chronologically, they critique them. Modernists throw off the past and strive for individual innovations in their art making: Postmodernists are generally content to borrow from the past and are challenged by putting old information into new contexts creating new meaning. Critics

and theorists who support modernism ignore the art of artists who are not working within the sanctioned theory of modernism. Postmodernist critics and artists embrace a much wider array of art-making activities and projects. Modernists attempt to be pure in their use of a medium; postmodernists tend to be eclectic regarding media, and freely gather imagery, techniques, and inspiration from a wide variety of sources. Although modernists are often enthusiastic about the times during which they work, they think themselves and their art apart from and above the ordinary events of the day. Postmodernists are skeptical and critical of their times, and some postmodernist artists are socially and politically active by means of their art. Modernists believe in the possibility of universal communication; postmodernists do not.

Whereas modernists search for universals, postmodernists identify differences. Difference, according to Cornel West (in Golden, 1993), is concerned with issues of "exterminism, empire, class, race, gender, sexual orientation, age, nation, nature, region" (p. 27). West writes that a new cultural politics of difference is determined to "trash the monolithic and homogenous in the name of diversity, multiplicity and heterogeneity; to reject the abstract, general and universal in light of the concrete, specific and particular; and to historicize, contextualize and pluralize by highlighting the contingent, provisional, variable, tentative, shifting, and changing" (p. 27).

*Hachivi Edgar Heap of Birds uses some postmodernist strategies to show historical information that the dominant culture would like to suppress. In a 1990 piece on government property along the Mississippi River in downtown Minneapolis, Heap of Birds erected 40 white aluminum signs with the names in blood red of 40 Dakota Indians—first in Dakota, then in English—who were hanged after the 1862 United States-Dakota war. Thirty-eight of the execution orders were signed by President Abraham Lincoln, two by President Andrew Jackson. With his use of traditional media—oil, pastels, and ink—for pieces that hang on gallery walls, he "subverts any attempt to characterize the Native American artist as noble spirit, dangerous savage, or ravaged victim. Instead, Heap of Birds represents himself as a complex and fully dimensional individual working as an artist within a tribal community"* (Lydia Matthews,1990, p. 1).

Karen Hamblen (1991) provides an overtview of problems inherent in beliefs in the possibility of universal communication through art. She explains that most scholars no longer believe that art objects can communicate without viewers having access to knowledge about the times in which they were made and the places in which they originated. Most critics no longer believe that they can interpret, let alone judge, art from societies other than their own without considerable anthropological knowledge of those societies. Most critics now believe that artworks possess characteristics and meanings based on their sociocultural contexts, and acknowledge that artworks have been interpreted differently in various times and places. Critics are now likely to consider personality differences, socioeconomic backgrounds, genders, and religious affiliations of artists and their audiences, whereas modernist critics are much more likely to

concentrate solely on the art object itself and believe that they can gain consensual agreement about their individual responses.

With the influence of postmodernism, critics are much more attuned to viewers of art and how they respond to it, and they prize variable understandings of the same work of art. Wanda May (1992) asserts that the postmodernist goal is to "keep things open to demystify the realities we create" (p. 238). Rigid categories of modernists "tend to make us more static than we are or wish to be" (p. 239). May adds that a postmodern work is "evocative rather than didactic, inviting possibilities rather than closure" (p. 239). Postmodernist critics hold that an artwork is "a text that is a permutational field of citations and correspondences in which multiple voices blend and clash" (Owens, 1991, p. 121) written by many people, providing viewers with many possible readings.

Lucy Lippard (1988) gives a clear and strong objection to the tendency of modernists to withdraw from the world and ordinary viewers in their art making: "God forbid, the [modernist] taboo seems to be saying, that the content of art be accessible to its audience. And God forbid that content mean something in social terms. Because if it did, that audience might expand, and art itself might escape from the ivory tower, from the clutches of the ruling/corporate class that releases and interprets it to the rest of the world" (p. 184). She rails against what she calls the still-current modernist taboo against what modernists derogatorily refer to as "literary art," which encompasses virtually all art with political intentions. Critics and artists still influenced by modernism are likely to denigrate social art as too "obvious, heavy handed, crowd pleasing, sloganeering" (p. 184).

Barbara Kruger (1990), who writes criticism as well as makes postmodernist art, rejects modernists' fixations with distinguishing, in a hierarchical manner, high culture from low culture. The title of her article is telling: "What's High, What's Low— and Who Cares?" In the article she denounces such categories in general for their false authority, pat answers, and easy systems. In a related thought about modernists' penchants for dogmatic distinctions, Robert Storr (1989) writes: "Indeed if postmodernism means anything, it is an end to terminal arguments and the historical mystifications and omissions necessary to maintaining millennial beliefs of all kinds" (p. 213).

Harold Pearse (1992) succinctly draws significant summary distinctions among premodern, modern, and postmodern tendencies: "By dispossessing itself of the *premodern* tendency to repress human creativity to avoid usurping the supremacy of a divine creator, and the *modern* tendency to over-emphasize the originative power of the autonomous individual, the *postmodern* imagination can explore alternative modes of inventing alternative modes of existence" (p. 249). Pearse explains that the model of the modernist image of the artist as a productive inventor has been replaced by that of

the bricoleur, or collagist, who finds and arranges fragments of meaning. The post-modern artist is the "postman delivering multiple images and signs which he has not created and over which he has no control" (p. 249).

## Concluding Implications for Art Education

Artists and critics are informed by and contribute to the thought of their times. The many examples of uses of postmodernist strategies by theorists and artists are sketchily drawn in this essay to make postmodernist art and criticism, in all its complexity, clearer. No one-to-one correspondence between a theory and an artwork are given, however. That would be a miseducational oversimplification. The more perspectieves we can gain on a work of art, the richer and deeper will be our experience of that work. Thoughts offered here are aimed at helping our students view new art and old art through new intellectual strategies, and read recent criticism with more confidence because of having introductory knowledge of the underpinnings of recent ideas and practices.

## References

Atkins, R. (1990). *Art speak: A guide to contemporary ideas, movements, and buzzwords.* New York: Abbeville Press.

Atkins, R. (1993). *Art spoke: A guide to modern ideas, movements, and buzzwords, 1848-1944.* New York: Abbeville Press.

Cottingham, L. (1988, May June). David Salle. *Flash Art,* p. 104.

Crimp, D., & Rolston, A. (1990). *AIDS demographics.* Seattle, WA: Bay Press.

Cutajar, M. (1992, July August). Good-bye to all that. *Artspace,* p. 61.

Derrida, J. (1974). *Of grammatology.* Baltimore: The John Hopkins University Press.

Danto, A. (1992). *Beyond the Brillo box: The visual arts in post-historical perspective.* New York: Farrar, Straus, & Giroux.

Fried, M. (1967). Art and objecthood. In Gregory Battock (Ed.), *Minimal art,* 116-147. New York: E. P. Dutton & Co., 1968.

Golden, T. (1993). What's white? In 1993 *Biennial Exhibition Catalog.* New York: Whitney Museum of Art.

Hamblen, K. (1991). Beyond universalism in art criticism. In D. Blandy & K. Congdon (Eds.), *Pluralistic approaches to art education* (pp. 9-25). Bowling Green, OH: Bowling Green State University Popular Press.

Heartney, E. (1987, October). Cindy Sherman. *Afterimage,* p. 18.

Jencks, C. (1977). *The language of postmodern architecture.* New York: Pantheon.

Kruger, B. (1990, September 9). What's high, what's low? and who cares? *New York Times,* p. 43.

Lippard, L. (1988). Some propaganda for propaganda. In H. Robinson (Ed.), *Visibly female: Feminism and art today,* (p. 184). New York: Universe.

Matthews, L. (1990, December 6). Fighting language with language. *Artweek,* p. 1.

May, W. (1992). Philosopher as researcher and/or begging the question(s). *Studies in Art Education, 33*(4), 226-243.

Owens, C. (1991, March). Amplifications: Laurie Anderson. *Art in America,* p. 121.

Pearse, H. (1992). Beyond paradigms: Art education theory in a postparadigmatic world. *Studies in Art Education, 33*(4), 249.

Riddle, M. (1990, September). Hachivi Edgar Heap of Birds. *New Art Examiner,* p. 52.

Rimanelli, D. (1991, Summer). David Salle. *Artforum,* p. 110.

Singerman, H. (1989). In the text. In C. Gudis (Ed.), *A forest of signs: Art in the crisis of representation* (p. 157). Cambridge, MA: MIT Press.

Storr, R. (1989). Shape shifter, *Art in America,* April, 213.

Storr, R. (1988). Salle's gender machine, *Art in America,* June, 24-25.

Wolfe, T. (1982). *From Bauhaus to our house.* New York: Farrar, Straus & Giroux.

Wolfe, T. (1975). *The painted word.* New York: Farrar, Straus & Giroux.

Yenawine, P. (1991). *How to look at modern art.* New York: Abrams.

# DOING OTHERWISE: ART EDUCATION PRAXIS IN A POSTPARADIGMATIC WORLD

Harold Pearse

## Introduction

One of the seminal ideas of the late 20th century is Thomas Kuhn's notion of "paradigm shift," articulated in *The Structure of Scientific Revolutions* (1962). To Kuhn, significant progress in science proceeds not in incremental steps, but as the result of the changing of competing notions of what is possible. Shifts arise from a sense of malfunction or crisis that necessitates a different way of viewing and responding to the world, that is, a different paradigm. In the human sciences, a useful paradigmatic structure was proposed by Jurgen Habermas (1971) to portray three distinct orientations to human interests and values. While derived from the history of philosophy, they are not aligned with any one philosophic position. Instead, they underscore three separate knowledge claims: prediction, understanding, and emancipation.

The first of Habermas's paradigms, (1971) the empirical-analytic, describes a world ruled by positivism in which efficiency, certainty, and predictability are valued and knowledge—in the form of facts, generalizations, theories, and cause and effects laws—is sought. In educational terms the approach is essentially subject centered. The second and third paradigms are postpositive in their approaches to generating and legitimating knowledge. The *interpretive-hermeneutic*, the second, originates in the philosophical stance of existential phenomenology with its interest in experientially meaningful, authentic, intersubjective understanding. The valued knowledge form is situational knowing. In its broadest sense the approach is student centered, yet essentially, the educational process is seen as a dialogue with others and with oneself in a world of things, people, and ideas. Habermas's third paradigm, the critical-theoretic orientation, rooted in reflection aimed at transformation of oneself and one's social world, is grounded in a fundamental interest in emancipation and improvement of the human condition. Critical knowing is valued as it aims to render transparent tacit and

hidden assumptions by initiating a process of transformation designed to liberate and empower people. It views education as firmly centered in society.

# Along Came Postmodernism

Approaches to art education theory and practice during much of the 20th century can be framed by Habermas's tri-paradigmatic structure (Pearse, 1983). Art education which concerns itself with products, facts, skills, techniques, accountability, and is subject-centered is situated in the first paradigm. Approaches which emphasize dialogue and the subjective and intersubjective meanings artworks and activities have for the student affiliate with the second. The third paradigm encompasses art education approaches informed by the impact of popular culture, critical social theory, feminism, and cultural pluralism. While such recent developments in art education as discipline-based art education (DBAE) and multiculturalism exist comfortably in the tri-paradigmatic structure (Pearse, 1992), a significant influence, postmodernism, which seeped into art education's collective consciousness around 1990, is an entirely different matter. In 1984, Gablik noted that "postmodernism is the somewhat weasel word now being used to describe the garbled situation of art in the '80s" (p. 73). By 1991, Lather uses postmodernism as "the code name for the crisis of confidence in western conceptual systems...borne out of the uprising of the marginalized, the revolution in communication technology, the fissures of global multinational hyper-capitalism, and our growing sense of the limits of enlightenment rationality" (1991a, pp. 163-164). She elaborates:

> Postmodernisms are responses across disciplines to the contemporary crisis of representation, the—rofound uncertainty about what constitutes an adequate depiction of social "reality." Philosophically speaking, the essence of the post-modern argument is that the dualisms which continue to dominate western thought are inadequate for understanding a world of multiple causes and effects interacting in complex and non-linear ways, all of which are rooted in a limitless array of historical and cultural specificities. (Lather, 1991b, p. 21)

Conversations about postmodernism among artists, educators and others contain words like *disturbing, unsettling, discomforting*. It sounds like Habermas's critical theoretic paradigm, but with some twists and without the emancipatory fervor and without the center. Is postmodernism a breakthrough or an endgame? Even if it could be adequately defined, postmodernism cannot be easily accommodated within any existing paradigmatic structure. We are hearing the rumblings not only of paradigms shifting, but also of the very existence of overarching paradigms being undermined.

## Another Perspective

A new paradigm requires a new paradigmatic structure. Can one be found to explain postmodernism? A reasonable place to begin would be to juxtapose the postmodern with a construct of the modern and the premodern, viewing these paradigmatically rather than strictly historically. Kearny (1988) presents just such a framework with each paradigm embodying a root activity and graphic metaphor and being exemplified in the changing Western conceptions of the artist. Kearny calls the premodern the *mimetic* paradigm and attributes as its metaphor the referential figure of the *mirror*. The artist is construed "primarily as a *craftsman* who, at best, models his activity on the 'original' activity of a divine Creator" (Kearny, p. 12). This theocentric view of the craftsman describes the artists of antiquity and the medieval period "when the work of the icon maker, painter, scribe or cathedral designer was generally evaluated in terms of its capacity to obediently serve and imitate the transcendent plan for creation" (p. 12).

The premodern artist-as-craftsman was replaced in the modern movements of Renaissance, romantic, and existentialist humanism with the paradigm of the artist as "the original *inventor*" (Kearny, 1988, p. 12). This is the modernist anthropomorphic or humanist aesthetic which "promotes the idea of the artist as one who not only emulates but actually replaces God" (p. 12). The modern is the *productive* paradigm and the metaphor is the expressive figure of the *lamp*, the light that leads the way. An aim of modernity was emancipation, the creation of a society emancipated from poverty, despotism and ignorance. Emancipation is, of course, a key goal of the critical theoretic paradigm. Not coincidentally, paradigm building itself is a modernist trait. Postmodernists like Jean-Francois Lyotard point out that these dreams of emancipation have proven to be illusory. Indeed, the whole anthropocentric paradigm is overturned by postmodern culture.

Postmodernity questions the modernist cult of creative originality as well as the notion of artistic progress and the possibility of perpetual newness. The central message of postmodern philosophers (especially Foucault, Derrida, Lacan) is the denial of the very idea of "origin." In their work language consists of an open-ended play of "signifiers" and "meaning is deconstructed into an endless play of linguistic signs, each one of which relates to the other in a parodic circle" (Kearney, 1988, p. 253). There is no possibility of a single founding reference or "transcendental signified" external to language that can be called truth or human subjectivity. Truth is replaced by endless parody with imitations reflecting imitations.

### Deeper Into The Labyrinth

With postmodernism then, the model of the productive inventor is replaced by that of "the bricoleur" (Kearney, 1988, p. 13) or collagist who finds and rearranges

fragments of meaning. The postmodern is the *parodic* paradigm with the reflective fig-
ure of a *labyrinth of looking-glasses* as defining metaphor. Mimesis and the mirror
metaphor have returned, but with a difference. What is reflected is not the outer
world of nature or the inner world of subjectivity, but a complex maze of associated
meanings—the mirror's reflection of itself into infinity. The artist has become a fun-
house mirror anonymously parodying, simulating or reproducing images. Or to mix
metaphors and drop a typically postmodern pun, the postmodern artist is like a post-
man, delivering multiple images and signs which he has not created himself and over
which he has no control (Kearney, p. 14). And to further extend the parody, the post-
man is now a postperson!

    While postmodernism can be seen as an ending and a denial of the extremes of pre-
modernism and modernism, its end need not be futility or nihilism. Habermas him-
self refutes the nihilistic postmoderns, epitomized by Foucault and Derrida, and
argues that modernism's emancipatory project is still unfinished business (Habermas,
1983; Lather, 1991b; Turner, 1990). What is being challenged, is "not modernism
per se, but a compromised version" (Smart, 1990, p. 23). By dispossessing itself of the
premodern tendency to repress human creativity to avoid usurping the supremacy of a
divine creator and the modern tendency to over-emphasize the originative power of
the autonomous individual, the postmodern imagination can, says Kearney, explore
"possibilities of another kind of poiesis—alternative modes of inventing alternative
modes of existence" (1988, p. 33). The end of modernity requires re-examination of
modernist ideals and recovery of humanitarian intentions with the possibility of re-
beginning through re-inventing our ways of being. Perhaps this ontological path will
lead us out of the labyrinth.

## Postparadigms

    A skeptic might say that what is being called postmodernism is a cluster of varied
and unstable tendencies and conditions that are too unstable to be called a paradigm.
A postmodernist would say that this state of flux is not something transitional—it is
exactly the point. Postmodernism's stance of being oppositional, being radically unset-
tling, making problematic, captures a kind of truth, albeit a paradoxical truth which
denies claims to certainty and totality. The possibility of totalizing, universalizing
"grand narratives" is questioned. Postmodernism goes beyond the bounds of conven-
tional paradigms. It is "postparadigmatic." Moreover, since Habermas's construct is
essentially modernist, whatever goes beyond it could be said to be postmodernist or
postparadigmatic. Nevertheless, "old" or earlier paradigms continue to exist as both
historical artifacts and governing perspectives for many people. Premodern and mod-
ern art remains in our museums and works in these modes may even be newly created.
Paradigms may co-exist, but it is the dominant one that exemplifies the zeitgeist. The
current zeitgeist, call it postmodernism, is pushing the boundaries of notions of para-
digms. Yet as is the case when a new paradigm replaces other ones, it still has to con-

tend with the old ones being somewhere on the landscape—sometimes as competition, sometimes just as clutter. It is, of course, messiness and contingency on which postmodernism thrives.

## Doing Art Education Otherwise

It appears that we have embarked on a postparadigmatic era, one in a constant state of flux, a kind of perpetual pluralism. Kearney's paradigmatic structure gives a framework on which to hang a discussion of postmodernism and its implications for theory and practice in art education. When considered as a kind of paradigm, or at least a world view, postmodernism can be juxtaposed to the familiar world view that has dominated art education for most of the twentieth century: modernism. Art education has embraced modernist ideas such as the artist as creative genius; the child as having the potential for creative self-actualization; the notion that art transcends real life and can be an end in itself; that art involves aesthetic sensing and that anyone sufficiently sensitive and experienced will perceive aesthetic quality (Webb, 1989). DBAE, with its desire to train students in the techniques of formalist art criticism and to expose them to masterworks that exemplify historical styles, and its totalizing tendencies, reflects modernist views. Indeed, Apple (1988) sees DBAE as part of a "conservative restoration" and a desperate attempt to revive modernism. However, with postmodernism, the modernist pillars of self-expression, authenticity, originality, and the masterpiece are no longer sacrosanct, or even relevant. As hard as some might try to make the case (Greer, 1993; Moore, 1991), DBAE cannot accommodate postmodernism, although postmodernism can accommodate (perhaps "absorb" is a better word) DBAE. Postmodernism can absorb everything.

The work of postmodernism, says Lather (1991b), is cultural change work. It is a question of *praxis*, the reciprocity of thought and action. The requirements of *praxis* "are theory relevant to the world and nurtured by actions in it, and an action component in its own theorizing process that grows out of practical political grounding" (p. 11-12). Just as "postmodernism offers feminists ways to work within and yet challenge dominant discourses" (p. 39), it can offer art educators ways of working in and around and beyond DBAE yet challenging its orthodoxies. Considering postmodernism in art education is a way of grounding postmodernism in a specific cultural practice, thus giving postmodernism vitality and art education relevance.

In her approach to feminist research and pedagogy within the postmodern, Lather talks about an effort "to do science otherwise" (1991b, p. 101). Similarly, art educators must think in terms of doing art education otherwise—in ways that are more open, less intrusive, less authoritative and that are more responsive to individual differences and competing conceptions of how knowledge is situated. Sullivan (1993) suggests classroom strategies that art educators can adopt involving "cooperative learning, peer learning and reciprocal learning" wherein "teachers and students become co-

participants in learning, and content is approached and acted upon in different ways and from various viewpoints" (p. 8). We cannot operate in the same old ways in a world revolutionized by communication technology and depersonalized consumerism in which we are inundated by the products of the mass media that cause us to constantly question what is real. Sophisticated television and computer graphic devices can create "virtual reality." Photographic and computerized reproduction techniques make indistinguishable, and irrelevant, what is original. The point is that curricular knowledge must be contextualized so that the aim of teaching is understanding. The postmodern perspective helps art educators to move away from an oversimplified, monolithic, "one-size-fits-all" mode of presentation.

## Putting Our Money Where Our Praxis

Whether or not postmodernism is a paradigm, the real challenge for art teachers is to understand postmodernism as a way of being in the world and the implications it has for professional practice. Contemporary students, part of the electronic, plugged-in generation, are attuned to postmodernism. Both Webb (1989) and jagodzinski (1991) have noted that art educators have been slow to embrace postmodernism or even to enter the debate.

Taking the lead from jagodzinski (1991), we can imagine some ways that art educators might operate under postmodernist tenets. The first step is to see art as a social process, students and children as cultural workers (no less patronizing a concept than children as little artists), and to rename the activity "cultural production." Cultural production easily subsumes the images and visual language of the mass media and popular arts as well as those of so called "high arts." By replacing creation with production, we can begin to get at the social and cultural conditions informing the process; if we talk about the consumption of aesthetic images we can begin to politicize the act of seeing. The entire syllabus changes, says jagodzinski, "when we see art as a form of *social practice*" (p. 149). Art in this sense is one way people participate with the world, how people read its images and signs and how their participation is read.

To teach students to critically examine the mass media, and other visual languages, a postmodern art educator needs to be versed in semiotics and methods of decoding (viewing/reading) sign systems of various modalities as well as in methods of deconstructing social meaning. We should examine cultural practices, as well as the artifacts of culture, as signifying systems, as practices of representation, not as the production of beautiful things evoking beautiful feelings. Art educators should begin to understand the rhetoric of the image and how it persuades and positions the viewer/reader (jagodzinski, 1991, p. 149). Such are the requisites for literacy in contemporary media that push dimensions and boundaries and have radically transformed modes of representation.

## Identity-Based Art Education

As we examine the language of public images, from those in museums to those in magazines, television, and computer monitors, the boundaries between high culture and popular culture become blurred and the arena of participation, what constitutes culture, becomes extended and particularized. Tensions that may exist between high and popular culture, local and global culture, are to be exploited. The art and culture of the local community, of "the folk," of those groups marginalized and disenfranchised by virtue of gender, race or ethnicity, should be seen as valid subjects for study and emulation in the postmodern classroom. The rich and diverse elements of the cultural landscape need to be seen through an ecological consciousness. Perhaps in the future, what has been heralded as multiculturalism will give way to polyculturalism, the vertical harmony of polyphony, "the intertwining of independent elements in a relationship of integrated balance which results in a whole that is more than the sum of its parts" (Carlin, 1994), rather than the cacophony associated with sheer multiplicity. Again, the results may be messy, but if one listens in the right way, the effect is not discordant.

Since a postmodern art curriculum is neither subject centered, student centered, nor strictly society centered, it is, in effect, "decentered." Paradoxically, there is no center, yet every self is his or her own center. This is not self-centeredness as unbridled relativism or egocentrism, but rather a view of the self as the locus of the quest for identity. In a curriculum concerned with identity, the quest is manifested in many ways. It is essentially a journey through the maze of one's multiple identities and sense of self as individual filtered through membership in various groups, be they family, peer, gender, race, neighborhood, region, or nation. The community is a global one including not only human communities, but also "the biologic, geologic and celestial worlds that permeate and surround them" (Blandy & Hoffman, 1993, p. 26). In an identity based curriculum, one's own cultural makeup provides a focus, but the substance of other individuals' cultural identities, the art from other times and places, is equally valid content. Aspects of identity provide rich sources for visual imagery. Whether the concern is with producing art, criticizing it, or studying its historical, political, social or environmental contexts or its philosophical or psychological dimensions, the center slides from self to others, to groups, to the community, to the environment; from the mainstream to the margins; from the outside world back to the self. Interconnectedness is key. An identity-based curriculum involves processes that go beyond formal concerns and requires materials that allow for multiple, multifaceted responses. Narrative and storytelling opportunities abound. Student art work with mazes, labyrinths, and illusions takes on new meaning in such a classroom. Not only the art teacher, but also the art teacher educator and the art education researcher will need to develop methods that are culturally and environmentally responsive and identity sensitive. Again, what grounds the work is *praxis*, the conviction that theory and action are symbiotic and situate in specific cultural practices.

## Jettisoning Postmodernism

The postmodern view has features which generate both optimistic and pessimistic responses just as there are positive, affirmative, progressive as well as negative, nihilistic types of postmodernism (Smart, 1990). As we approach the 21st century, the optimistic view would envision an art education in which local cultural practices are valued, the differences of those historically marginalized by virtue of gender, race, ethnicity, or class, are celebrated, and the cultural artifacts of all places and times are valid "texts" for study by art educators and students. The pessimistic perspective would see an aimless, fragmented, relativistic art education, cut off from standards of excellence. A "paradigmologist" would remind each that it is one's world view and the visions it can accommodate that guides how one acts in it. A "postparadigmologist" would revel in the absurdity not only of the name, but the conceit that such totalization could be constructed in the first place. The irony for art educators is that the pluralist, decentered perspective engendered through postmodernism can serve to reconnect art and life in ways that can be meaningful to students while fostering critical and reflective attitudes. Perhaps we can now jettison the term "postmodernism" and simply speak of the time and place where we live. Nevertheless, the lesson for all is that nothing can be taken for granted.

## References

Apple, M. (1988). The politics of pedagogy and the building of community. *Journal of Curriculum Theorizing, 8*(4), 7-22.

Blandy, D., & Hoffman, E. (1993). Toward an art education of place. *Studies in Art Education, 35*(1), 22-33.

Carlin, J. (1994). Education in the arts: A polyphonic model. *Canadian Music Educator, 35*(5), 29-32.

Gablik, S. (1984). *Has modernism failed?* New York: Thames and Hudson.

Greer, W. D. (1993). Developments in discipline-based art education (DBAE): From art education toward arts education. *Studies in Art Education, 34*(2), 91-101.

Habermas, J. (1971). *Knowledge and human interests.* Boston: Beacon.

Habermas, J. (1983). Modernity—An incomplete project. In *The anti-aesthetic: Essays on postmodern culture.* Hal Foster, (ed.) 3-15. Washington: Bay Press.

jagodzinski, J. (1991). A para-critical/sitical/sightical reading of Ralph Smith's Excellence in art education. *Journal of Social Theory in Art Education, 11*, 119-159.

Kearney, R. (1988). *The wake of imagination: Toward a postmodern culture.* Minneapolis: University of Minnesota Press.

Kuhn, T. S. (1962). *The structure of scientific revolutions.* Chicago: University of Chicago Press.

Lather, P. (1991a). Deconstructing/Deconstructive inquiry: The politics of knowing and being known. *Educational Theory, 41*(2), 153-173.

Lather, P. (1991b). *Getting smart: Feminist research and pedagogy with/in the postmodern.* New York: Routledge.

Moore, J. (1991). Post-modernism and DBAE: A contextual analysis. *Art Education, 44*(6), 34-39.

Pearse, H. (1983). Brother can you spare a paradigm? The theory beneath the practice. *Studies in Art Education, 31*(4), 195-197.

Pearse, H. (1992). Beyond paradigms: Art Education theory and practice in a postparadigmatic world. *Studies in Art Education, 33*(4), 244-252.

Sullivan, G. (1993). Art-based art education. *Studies in Art Education. 35*(1), 5-21.

Smart, B. (1990). Modernity, postmodernity and the present. In *Theories of modernity and postmodernity.* B. S. Turner (Ed), London: Sage.

Turner, B. S. (1990). Periodization and politics in the postmodern. In *Theories of modernity and postmodernity.* B. S. Turner (Ed), London: Sage.

Webb, N. (1989). Postmodernism—Threats and promises. *Canadian Review of Art Education: Research and Issues, 16*(1), 13-20.

# THE EMERGENCE OF NEO-DBAE

## Karen A. Hamblen

The proposal of discipline-based art education in the 1980s heralded a major shift in art education theory and practice. As could be expected, discipline-based art education (hereafter referred to as DBAE) also elicited more scrutiny and criticism than other movements in the field of art education. Unfortunately, much that was proposed, implemented, reacted to, and criticized concerning DBAE in the 1980s remains as established ideas. In this paper it is proposed that the theory and practice of DBAE of the 1980s are undergoing significant changes—and that *Neo-DBAE* is emerging in the 1990s. Changes in original DBAE theory and practice are discussed, and reasons for such changes are proposed. Some identified changes are more encompassing curriculum content, integration of art with other subject areas, and variable forms of assessment. It is suggested that Neo-DBAE is a response to postmodern developments, reform movements, multiculturalism, and teacher proactivism. Neo-DBAE is also the result of criticisms of original DBAE theory and practice in the 1980s.

DBAE theory and practice have dominated the concerns of many art educators (both supporters and critics) for almost a decade. Given the sociopolitical climate of the 1980s, the conservative aspects of DBAE in the 1980s were understandable—as well as the criticisms DBAE elicited. However, recent changes in DBAE theory and practice have been less predictable. Moreover, many of these changes have been overlooked by art education researchers. Although new developments in DBAE are part of policy statements, ongoing programs, publications, and conference topics, these new (neo) DBAE characteristics are not specifically identified or discussed in art education literature. Considering the influence DBAE has had, and continues to have, on the field of art education, it is important for art educators to be aware of changes in DBAE, to participate in DBAE's ongoing construction and/or criticism, and to understand the extent to which postmodern factors and critical input have influenced and fostered change in DBAE theory and practice. Toward those ends, this study consists of a discussion of the following: (a) DBAE theory and practice in the 1980s, (b) theo-

ry and practice in the 1990s that suggest the development of Neo-DBAE, (c) characteristics of Neo-DBAE, and (d) factors contributing to the emergence of Neo-DBAE.

# Background

Through publications and policy statements put forth by the Getty Center for Education in the Arts, DBAE was initiated as a theory of art instruction that emphasized the disciplinary character of art and the study of art for its own sake (The J.Paul Getty Trust, 1985; Greer, 1984). DBAE proponents proposed that art study consist of studio production, art criticism, art history, and aesthetics. Curricula should be in written form, and the content of the four areas of study sequenced within and between grades and implemented district-wide. In a DBAE program, learning outcomes would be identifiable and assessed through formal measures.

## Criticisms of DBAE

DBAE evolved from theory to implemented practice broadly supported by ideas presented at conferences and symposia, through numerous publications, and through programs supported by the Getty Center for Education in the Arts (The Getty Center, 1990). As DBAE theory was implemented and its operational characteristics became visible, criticisms and reactions to those criticisms also emerged. It is not my intent to weigh the merits of criticisms of DBAE or the adequacy of the rebuttals. Rather, my purpose is to indicate the ways DBAE theory and practice were often perceived and ways in which DBAE characteristics (that elicited criticisms) may ·have changed and can now be interpreted as a new form of DBAE, i.e., Neo-DBAE.

In theory and implemented practice, DBAE represented a drastic change from previous instruction which had tended to emphasize freedom of expression, creative responses, and studio production (The J. Paul Getty Trust, 1985). Proponents of child-centered instruction objected to DBAE on the grounds that it ignored individuality, possibilities for idiosyncratic artistic responses, and the holistic nature of art learning (Burton, Lederman, & London, 1988). Other critics suggested that DBAE too closely resembled the rest of education in its emphasis on sequenced instruction, predictable outcomes, and testable learning (Hamblen, 1988). A DBAE emphasis on Western fine art, artistic exemplars, and formalistic lessons in selected curriculum series also received criticism (Blandy & Congdon, 1987).

Dobbs (1988) identified many of these criticisms as myths that had developed in response to a perceived threat to the status quo of studio production, child-centered instruction, and so on. For example, he pointed out that DBAE was a theory, not a curriculum or any one prespecified program. However, DBAE had become linked with specific curricula, such as the Southwest Regional Laboratory series for the elementary grades (SWRL, 1975). SWRL was implemented in the Los Angeles School

District in the first Institute supported by the Getty Center. Since SWRL can be broadly classified as a teacher-proof curriculum with a strong focus on technical skills and design principles, it more or less follows that DBAE was open to criticisms that DBAE programs fostered a formalistic study of Western fine art with prespecified content and easily identified outcomes. Although Neo-DBAE may not, according to critics of DBAE, adequately address all of the criticisms cited in this section, Neo-DBAE characteristics do represent major differences from DBAE of the 1980s.

## DBAE Assumptions and Characteristics

DBAE theory and the ways theory was put into practice had certain basic assumptions and characteristics throughout much of the 1980s (see The J. Paul Getty Trust, 1985; Greer, 1984; *The Journal of Aesthetic Education*, 1987). The emphasis was on the disciplinary status of art with indications that the areas of studio production, art criticism, art history, and aesthetics could be integrated. However, the integration of art with other subject areas was not promoted. Art criticism was often discussed in terms of aesthetic scanning; as such, art criticism dealt with primarily sensory and formal characteristics. The focus was on the art object per se rather than the social functions of art or interpretations by different cultures. Due to limited time for art in school schedules, it was deemed that DBAE study should focus on art identified by experts as important and significant. This came to mean, as evidenced in curricula and policy statements, the study of Western fine art exemplars (Chapman, 1985; *The Journal of Aesthetic Education*, 1987; SWRL, 1975). Aesthetics, perhaps the most problematic of the four areas of study, was presented in the literature as consisting of aesthetic inquiry rather than study for purposes of aesthetic experiences, cross-cultural aesthetic awareness, etc. Finally learning outcomes were to be tested in the manner in which other subject areas are tested; this meant pencil-and-paper objective testing with the hope such measurements would standardize learning activities and curriculum content (Greer & Hoepfner, 1986).

DBAE characteristics identified in this paper are presented in bold brush strokes and are certainly open to debate. In fact, who has actually been responsible for presenting "official" DBAE theory and guidelines for practice has never been clear and in itself indicates a basic delimma that is starting to work itself out in Neo-DBAE. Information on DBAE has been mainly presented by the Getty Center for Education in the Arts, as well as by individuals closely associated with the Getty Center but writing and presenting ideas independently. To a much lesser degree, some individuals with no association with the Getty Center presented their own interpretations as they criticized or implemented DBAE programs along their own lines of interpretation.

In 1987 Clark, Day, and Greer discussed possibilities that DBAE theory would be refined and further articulated in the future. Writing in 1993, Dunn considered DBAE open to definition, interpretation, and implementation by the field of art edu-

cation at large. This perspective on "who is in charge" itself indicates a major shift toward Neo-DBAE. In the 1980s, there were constellations of greater and lesser "ownerships" of DBAE, with most art educators looking (or being directed to look) for direction on DBAE matters from the Getty Center. In the 1980s, art educators were *reacting to* statements made about the character of DBAE by the Getty Center; in the 1990s, more art educators, who are not necessarily associated with the Getty Center, are interpreting and adding their ideas to DBAE (Chalmers, 1992, 1993). The acknowledgment that DBAE "belongs to us and it is up to those of us in the field to explore every variation of DBAE we can conceive" (Dunn, 1993, n.p.) suggests major directional changes in policy-making and in ideas on what "qualifies" as a DBAE program of study. I am proposing that this shift in ownership is just one of the changes that heralds Neo-DBAE in the 1990s. In the following section of this paper, DBAE changes will be presented in the general categories of: (a) curriculum content, (b) the integration of art with other subjects, and (c) the assessment of learning outcomes.

## Toward Neo-DBAE

### Curriculum Content

Throughout the literature on DBAE presented by the Getty Center and by DBAE proponents, new and more encompassing curriculum content is discussed as appropriate or desirable for DBAE (Dunn, 1993; Greer, 1992). In particular, non-Western art forms and art forms that go beyond traditionally designated fine art are included. Multicultural art forms are part of curriculum materials, conferences and symposia have been held on multiculturalism, and publications are available on how to implement a multicultural DBAE program (Chalmers, 1992, 1993; *Newsletter*, 1993).

In an apparent response to criticisms that DBAE-designated curricula tended to over-emphasize technical skills and formal qualities, there have also been attempts to be more inclusive of art that is socially critical and of instruction that examines controversial issues in art (Greer, 1992). Although some types of art—such as feminist, folk, domestic, commercial, craft—are not included in DBAE curricula to the extent some might wish, their presence represents a major deviation from the fine art "look" of the 1980s and is a strong indication that Neo-DBAE has postmodern leanings.

In the category of curriculum content, perhaps the most powerful change has occurred within the general area of teacher-initiated curricula. In the late 1980s, grants were awarded to six regional institutes throughout the United States by the Getty Center. Consisting of a consortium of universities, museums, school districts, and other institutes, each institute implemented DBAE within the schools in its respective area (Davis, 1992). Although there is little published information on the institutes, from conference presentations, personal communication, and newsletters it appears that each has developed its own interpretation of DBAE and that variable

instructional practices among, and within, the institutes are common (see *ARTiculator*, 1990, 1992; Dunn, 1993). For example, in the Florida institute, teachers include content that relates to the built environment, to student interests in popular and commercial art, and to the rest of the elementary curriculum (*ARTiculator*, 1990, 1992). Teachers originated curriculum content, shared ideas with each other, and suggested ways the program can adjust to the needs of diverse student populations. The institutes, I believe, represent ways in which a rather modernistic and pre-ordered DBAE theory of the 1980s has changed and adjusted to the real life, practical classroom needs of practicing teachers and their students. It should also be noted that such changes via the institutes are apparently supported by the Getty Center in light of renewal of institute status into the 1990s.

## Integration and Instrumental Outcomes

Original DBAE theory offered art educators an alternative to the many instrumental rationales commonly used to justify art instruction, e.g., art to improve reading scores, develop creativity, and foster positive self-concepts. In a DBAE curriculum art would no longer be the servant of other subject areas, at the beck-and-call of general education, and as the answer to deficiencies experienced in other subject areas. However, as indicated above, in some programs, art is taught separately as well as with strong linkages to other subject areas for purposes of enhancing learning in those subjects.

In the initial offical DBAE publication *Beyond Creating* (The J. Paul Getty Trust, 1985) and later in Eisner's (1987) *The Role of Discipline-Based Art Education in America's Schools*, the cognitive benefits of art study were presented. Art was discussed as promoting imaginative thinking, abilities to hypothesize, and predispositions to tolerate ambiguity. However, in these publications, cognitive benefits were specific to, and stayed within, the study of art. In contrast, in recent publications supported by the Getty Center (together with the National School Boards Association, the National PTA, and the National Conference of State Legislatures) artistic cognitive benefits are aligned to learning in other subject areas (Loyacono, 1992; *NAEA News*, 1993). Art is cited as important to learning in general by promoting the following: "Problem solving. Critical reasoning. Curiosity. Higher test scores. Creative thinking. Interpersonal skills. Resourcefulness. Self-esteem. Risk taking." (*NAEA News*, 1993, p. 12). These are familiar claims, commonly cited by instrumentalists. As such, Neo-DBAE of the 1990s indicates a softening of the stand on the disciplinary, self-focused integrity of art study. A discussion of whether Neo-DBAE is actually still *discipline-based* is beyond the scope of this paper.

## Assessment

The assessment of learning outcomes in a consistent and focused manner has been an important part of DBAE since its inception. Although Day (1985) cited a range of ways in which art might be assessed, in the 1980s the assessment focus was on objective testing. Statements were made that art should be assessed as other subject areas are (Greer & Hoepfner, 1986). And work was begun in some state departments to develop multiple choice test item banks (Hamblen, 1988; R. Higgins, personal communication, 1990). Recently, however, spokespersons for the Getty Center have indicated that objective testing in its many forms does not adequately relate to art learning, and more qualitative forms of assessment, such as portfolio reviews, should be used (Stankiewicz, 1992). In a study of approaches to art assessment, Davis (1992) also found a range of options, much as Day (1985) suggested earlier.

## Characteristics of and Reasons for Neo-DBAE

To summarize, Neo-DBAE is characterized as somewhat postmodern in that it incorporates aspects of multiculturalism and collective decision-making. It is contextually responsive to the needs of teachers and students and allows for variable learning outcomes. Art learning is considered holistic and may be integrated with, or used to enhance, learning in other subject areas. Assessment encompasses qualitative approaches, and curriculum content is developed within the needs of given contexts and circumstances.

In this paper it is proposed that DBAE developed toward Neo-DBAE due to two major groups of factors: (a) developments of postmodernism and educational reform and (b) specific actions taken by individuals or institutions to effect DBAE changes. Neo-DBAE is in many respects a response to postmodern manifestations of multiculturalism, proactivism, contextualism, and so on. Neo-DBAE is also the result of criticisms and actions taken directly against the modernist values of original DBAE theory and practice in the 1980s.

Neo-DBAE is part of the larger education reform movement in terms of acquiring the legitimating characteristics of general education at a time when, ironically, general educators were highly disillusioned with their own modernistic practices (Hamblen, 1988). Neo-DBAE is actually more aligned with the general education reforms proposed in the 1980s, e.g., the empowerment of teachers, assessment that goes beyond standardized testing, and programs responsible to diverse student populations.

Neo-DBAE is also the outcome of a tremendous amount of critical imput from art educators. As noted earlier, criticisms of DBAE emanated from numerous directions, and Neo-DBAE represents an amalgam of perspectives. There appears to be an acknowledgment that DBAE "must evolve to remain educationally relevant" (Dunn,

1993, n.p.) and that there are many possible directions that DBAE can take. Ownership of theory and practice extends to the field in general and "belongs to us and it is up to those of us in the field to explore every variation of DBAE we can conceive" (Dunn, 1993, n.p.). In this sense, the Neo-DBAE characteristics identified in this paper are only the beginning.

# References

*The ARTiculator.* (1990, January).

*The ARTiculator.* (1992, March).

Blandy, D., & Congdon, K. (Eds.). (1987). *Art in a democracy.* New York: Teachers College Press.

Burton, J., Lederman, A., & London, P. (Eds.). (1988). *Beyond DBAE: The case for multiple visions of art education.* North Dartmouth, MS: Peter London.

Chalmers, F. G. (1992). D.B.A.E. as multicultural education. *Art Education, 45*(3), 16-24.

Chalmers, F. G. (1993). *Arts education as a catalyst to reform: Cultural diversity and arts education.* Unpublished manuscript.

Chapman, L. H. (1985). *Discover art.* vols. 1-5. Worcester, MA: Davis.

Clark, G., Day, M., & Greer, D. (1987). Discipline-based art education: Becoming students of art. *The Journal of Aesthetic Education, 21*(2), 129-193.

Davis, D. J. (1992). Art education in the 1990s: Meeting the challenges of accountability. *Studies in Art Education, 34*(2), 82 - 90.

Day, M. (1985). Evaluating student achievement in discipline-based art programs *Studies in Art Education, 26*(4), 232-240.

Dobbs, S. (1988). *Perceptions of discipline-based art education and the Getty Center for Education in the Arts.* Los Angeles: The Getty Center of Education in the Arts.

Dunn, P. C. (1993). *The evolution of discipline-based art education.* Unpublished manuscript.

Eisner, E. W. (1987). *The role of discipline-based art education in America's schools.* Los Angeles: The Getty Center for Education in the Arts.

The Getty Center for Education in the Arts. (1990). *Getty Center for Education in the Arts publications.* Los Angeles: Author.

The J. Paul Getty Trust. (1985). *Beyond creating: The place for art in America's schools.* Los Angeles: Author.

Greer, W. D. (1984). A discipline-based view of art education. *Studies in Art Education, 25*(4), 212-218.

Greer, W. D. (1992). Developments in discipline-based art education (DBAE): From art education toward arts education. *Studies in Art Education, 34*(2), 91-101.

Greer, W. D., & Hoepfner, R. (1986). Achievement testing in the visual arts. *Design for Arts in Education, 88*(1), 43-47.

Hamblen, K. A. (1988). What does DBAE teach? *Art Education, 41*(2), 23-24, 33-35.

*The Journal of Aesthetic Education.* (1987). *21*(2).

Loyacono, L. L. (1992). *Reinventing the wheel: A design for student achievement in the 21st century.* Denver: National Conference of State Legislatures and The Getty Center for Education in the Arts.

*NAEA News.* (1993, April). *36*(2), pp. 12-13.

*Newsletter, Getty Center for Education in the Arts.* (1993, Spring). Discipline-based art education and cultural diversity, pp. 3-5.

Stankiewicz, M. A. (1992). Beyond multiple choice. *The J. Paul Getty Trust Bulletin, 7*(3), 12-13.

*SWRL elementary art program.* (1975). Los Alamitos, CA: Phi Delta Kappa.

# THE INTERACTION BETWEEN ART
# EDUCATION AND THEORIES OF ART

## Jack A. Hobbs

## Our Fin de Siecle

The previous turn-of-the-century (sometimes called *fin de siecle*) was apparently a heady time for visual culture. Among other developments, it saw the triumph of the Impressionists, the emergence of several new avant-gardes, and the popularity of a radical applied arts movement called *Art Nouveau*. In this country, the first skyscrapers were altering the Chicago loop in ways that anticipated the commercial centers of future cities. Meanwhile in 1893, springing up on the swamps east of the loop, was the neoclassical "White City" of the Columbian Exposition world's fair. While its retrograde architecture may have contradicted that of the loop, the fair's other features heralded the 20th century in many ways—among which were several "congresses" on the subject of education. Art educators at the time were little aware of the meeting of the Congress on Experimental Psychology whose agenda on child study had much to do with setting the direction of their field (Logan, 1955, pp. 103-4).

As we know, the impact of these developments did not become fully apparent until the next century: Cezanne and Van Gogh came into their own by the first decade, but innovations of the Chicago School of architecture were not appreciated until mid-century. Likewise the importance of the child study movement's investigations of children's drawings was not realized until the second decade, while its implications for child-centeredness were not completely realized until even later decades.

I bring up this history because of the obvious parallel with our own fin de siecle, or perhaps I should call it *fin du millenaire*, the end of the millennium. Such an auspicious turn of the calendar should bring even greater excitement. Indeed, in the field of art education at least, there does seem to be a significant change of mood—evidence of which is the publication of the series of articles in this book. We should acknowledge, however, that the developments that are occurring now, like those of a century

earlier, may not even be recognized, let alone be completely understood, until well into the next century.

At the risk of being perceived as shortsighted by colleagues in the next century notwithstanding, I'm going to venture some observations about the present state of art education. Currently, the two most prominent directions appear to be: 1) discipline-based art education (DBAE; also known as "comprehensive art education") and 2) multiculturalism/social reconstruction.

Of the two, DBAE has received the most attention. Its pros and cons have been debated by scholars for almost a decade; by now this discourse has reached teachers in the field. Although DBAE exponents may disagree, they are united enough to be able to promulgate an agenda of basic, understandable principles. The National Art Education Association pays homage to these principles as do new mandates for arts education in state offices of education (National Art Education Association, 1990; Illinois State Board of Education, 1985). Because DBAE principles are so well known and are discussed elsewhere in this text, I will not reiterate them here except to say that, in the context of this review, they are ostensibly based on Western concepts of art, emphasizing role models—artist, art historian, critic, and aesthetician—peculiar to the Western art world.

Multiculturalism as a term speaks of itself; social reconstruction is borrowed from the label applied to a series of papers given at the 1993 annual meeting (and reported in *Studies* [Freedman, 1994]). I combined the two terms to identify the second direction because the contents to which they refer overlap and each represents one end of a continuum of a broad array of concerns and advocacies. Unlike DBAE, multiculturalism/social reconstruction does not as yet manifest a defining set of common principles, let alone possess an easy-to-remember set of initials. Its perspective is not reflected in the official policies and mandates at the national and state levels of art education. While the discourse of this orientation may be less cohesive than that of DBAE, it is nevertheless pervasive. Social reconstruction in art education can be dated to the Great Depression and the Owatonna Project of the 1930s, although in the interim between then and now it had been relatively dormant. Multiculturalism dates to the writings of McFee (1966-1970, 1988) who began to use anthropological models in the 1960s as an alternative to the narrowly-based psychological models of Lowenfeld (1952). Since then, what was initially a body of insights about art and child development in the context of culture has broadened into a mini-movement (Bersson, 1983) and deepened to include the concerns and political agendas of feminists, minorities, and other disenfranchised groups (Clark, 1990). The thread of active advocacy runs through all these concerns. Art education is exhorted to intervene in, or at least witness to, the problems of race, neocolonialism, sexism, homophobia, AIDS, etc. that divide or trouble society today. Multiculturalism/reconstruction draws its models from such sources as anthropology, sociology, semiotics, Marxism, deconstructionism,

and mass media studies (Chalmers, 1988) and varies between exponents who call for more sensitivity within art education to cultural, ethnic, gender, and ability diversity to those who would call for radical reconstruction of the system.

Both directions—DBAE and multiculturalism/reconstruction—agree in their desire to distance themselves from the themes of the past—i.e., creativity, self-expression, personality development, etc.—but for different reasons. DBAE perceives that these basically child-centered themes have led to the marginalization of art and that in order for art to become a part of the school curriculum, it must join other school subjects as a substantive discipline in its own right. Because of its cultural focus, multiculturalism-reconstruction finds itself at odds with psychologically-based analyses, particularly those that, like Lowenfeld's, imply universal explanations of art and creativity. Further, multiculturalism perhaps tends to perceive art education's preoccupation with self-expression as simply catering to one of Western culture's most self-indulgent values, individualism.

If DBAE and multiculturalism/reconstruction can agree on what they disvalue in art education, they cannot seem to agree on what they value. Of the two, multiculturalism-reconstruction is the most critical, accusing DBAE of elitism (its preoccupation with excellence), gender inequity, being committed to a canon of art that omits women and minorities, and, worst of all, Eurocentrism. DBAE defends elitism as democratic, that is, "access to the best should be the right of all." And it accuses the other side of cultural relativism and taking cheap shots.

I choose not to side with DBAE over multiculturalism/reconstruction or vice-versa. I find some fault with both. While some of DBAE's positions are grounded in what I consider to be anachronistic theories of art, multiculturalist positions seem not to be grounded in any philosophy of art. On the other hand, I find a great deal of value in both and believe that both are needed for art education to move forward. The problem, then, is to reconcile the two. While proposing a solution to that problem is too daunting for now, I might suggest a first step: examining our conventional thinking about art and how this affects our beliefs and decisions in art education—regardless of which side we are on in the debate between DBAE and multiculturalism/reconstruction. In this article I will attempt to do this by analyzing: 1) the culture of higher education art departments, 2) art education literature with regard to theories of art, and 3) some alternative theories of art.

## The Culture of University Art Departments

In an article written over a decade ago (Hobbs, 1983), I made the point that art teachers were not so much the products of their art education training as they were of the regular art curriculum, a curriculum that was heavily biased in favor of studio experiences. In essence, art students (including art education majors) were encouraged

to manipulate forms rather than ideas. And, since in the art education curriculum, the goal was to train teachers to teach creativity, art education majors were encouraged to manipulate media—thereby confirming and reinforcing the studio bias.

There is some evidence to show that art education programs are changing. Supposedly they are spending less time on media exploration and doing more with methods of teaching art history and criticism (*NAEA News*, 1990; Willis-Fisher, 1991), but the degree of this change, not to mention the true depth of commitment to this change, is as yet unknown. Still, if this is the case, there is no evidence to suggest that art programs themselves are relinquishing their partiality toward studio. The National Association of Schools of Art and Design (NASAD), the principal accrediting body for art departments, recommends a minimum of 72 hours in studio for the Bachelor of Fine Arts (BFA). As the premier degree offered in art, the BFA and what it stands for are the model of excellence in art at the undergraduate level. This, of course, bears on the value system and even the self-esteem of all majors, including art education majors (whether or not they elect to pursue that degree).

My belief is that in the 1990s the studio bias is even more counter-productive for art education majors than it was in the 1980s. Indeed, in the current postmodern era of art, it may be just as counter-productive for BFA students. In a recent analysis of art curricula, Risatti (1989) lamented the fact that, because of the studio emphasis, "art students are more limited in the range of subjects they can take than are students in other humanities areas" (p. 24). He recommended that BFA programs include a substantial number of hours in the humanities, "as a way of complementing and undergirding current emphasis in studio practice" (p. 25). Risatti's proposal, in other words, would be more attuned to the concerns and practices of artists today.

In addition to the studio emphasis, the art department culture is encumbered by a lingering doctrine of art loosely referred to as formalism. Formalism's antecedents go back to Bell who developed a theory called "significant form" to explain to the English-speaking world in the early part of this century the art of Cezanne and other postimpressionists (1914-1949). I will say more about this later. Formalism received increased credibility and became *the* standard in the 1950s and early 1960s due largely to the influential writings of Greenberg who did for postwar abstraction what Bell did for postimpressionism (Greenberg, 1977). Formalism's counterpart in the educational realm dates to the design and materials curriculum of the Bauhaus as organized by, among others, Gropius, Itten, and Albers. Later, Arnheim's translation of Gestalt theories into structural principles of design (Arnheim, 1954/1974) gave formalism the imprimatur of science, specifically, the psychology of perception.

Studio curricula typically include required courses in "foundations," that is, two-dimensional and three-dimensional design. Most foundations instruction, even now, tends to reflect the practices of the Bauhaus and/or the theories of Arnheim. Risatti

(1989) argued that, whereas a few decades ago, such an emphasis "could be defended because it echoed one aspect of artistic practice," it is now out of date, given the current practices of artists (p. 25) Lee (1990), writing for the journal of the professional organization for teachers of foundations courses, characterized formalism as consisting of "disciplinary repetitions of drills and exercises labeled 'problem solving'"(p. 25). He indicted the doctrine not so much for being out of date as for its historical assumptions of privilege and detachment: "A culturally vacant and positivistic formalism...survives despite a continuing critique by multicultural studies and feminism" (p. 25).

The heritage of formalism in art education is even older than Bell, if one considers the influence of turn-of-the-century art educator Dow (Efland, 1990). As early as 1899 Dow published *Composition*, a book that introduced the values of Japanese art and the notion of basing artistic creativity on the principles of design. This was well before the publication of Bell's book or even the Armory Show which marked the introduction of modernism to the American art world. Dow's prescient book remained in print for over one-third of a century. It spawned a popular art education text in 1924 that was organized entirely around the elements and principles of design and dedicated to Dow (Boas, 1924). Either because of decades of reification or because they are so teachable, the principles of design are always invoked whenever an art educator is prevailed upon to explain an artwork. In a 1977 article I criticized their use (Hobbs, 1977). But at that time there was little talk about the need to teach aesthetics or criticism in the classroom; therefore, supposedly, there was no urgency to reconsider the design principles' relevancy. Now, there is talk about teaching aesthetics, and criticism, so there is no longer any reason not to consider their relevancy.

## Theories of Art in Art Education Literature

Presently, as we all know, there is a great deal of talk in art education circles about aesthetics and criticism, particularly in literature promulgated by advocates of DBAE. But discussion of any theories upon which these disciplines are to be grounded is often lacking or underdeveloped in much of that same literature. Sometimes the issue is studiously avoided: "The definition of the nature of art and whether or not there can be a definition at all are moot considerations" (Greer, 1987, p. 229). Sometimes the issue is broached but only implicitly and mostly in reference to Broudy's technique of "aesthetic scanning," i.e., attending to sensory, formal and technical properties in an artwork. Broudy (1972), whose Enlightened Cherishing has become a sort of holy writ among aesthetic educators, embraced the factors of imagination, metaphor, history, language, and culture in his theories. But aesthetic scanning, the most formalistic aspects of his ideas, has tended to receive the most notice.

There is one body of DBAE literature, however, in which the issue of art theory is forcefully joined. Smith, the person responsible for the literature, is one of the out-

standing leaders in aesthetic education. Throughout his monograph, *Excellence in Art Education: Ideas and Initiatives,* Smith (1986) paid homage to a philosophy of art that is basically formalistic. In addition to his own claims, he cited critics like Greenberg and Kramer and aestheticians like Beardlsey and Osborne, all associated with a formalistic point of view. In two articles (Hobbs, 1988, 1993), I challenged that point of view, particularly his identifying excellence with works drawn from a canon of fine art that excluded not only examples of popular art but also examples of non-Western and very recent art. More recently, Smith edited a series of volumes published with the assistance of the Getty Center which as a whole is less exclusive than the excellence monograph. *Aesthetics and Education* (Parsons & Blocker, 1993), in particular, contains illuminating, and very readable, overviews of a wide spectrum of theories of art. The "flagship" volume, *Art Education: A Critical Necessity* (Levi & Smith, 1991), overviews the contributions of a number of writers on art from Berenson to Jencks and from Fry to Osborne; it is essentially a collection of meditations on art and culture. While not as monocular in its analysis as Smith's earlier book, this one, nevertheless, views these subjects primarily through formalist-modernist lenses.

According to anthropologist Dissanayake, these very lenses have contributed to a sort of Western myopia, particularly with regard to the role of art across time and place. In an address before the 31st annual NAEA convention, she traced the evolution of two uniquely Western concepts—fine art and the aesthetic attitude—from the 18th century to the postmodern present (Dissanayake, 1991). By the mid-20th century, she explained, critics like Greenberg and Rosenberg were impelled to create "more elaborate and abstract formalistic standards" in order to justify the "skeins" and "blobs" of postwar abstract painting. Still, according to Dissanayake:

> Never in question was the 'high' art assumption that works of art—no matter how strange they looked or unskilled they seemed to be—were conduits of transcendent meaning, of truths from the unconscious, expressions or revelations of universal human concerns that the artist was uniquely endowed to apprehend and transmit. (p. 18)

The above quote turns 20th-century aesthetics on its head. In the whole address, Dissanayake turned almost every cherished concept about art on its head. Because her views are in accord with those of multiculturalism, I am using her address as the example of art education literature in the multicultural/reconstructionist vein. Unlike Smith's, Dissanayake's viewpoint is grounded not in philosophical aesthetics but in cultural anthropology or, as she puts it, palaeoanthropsychobiology.

## Alternative Theories of Art for a New Art Education

An advocate of multiculturalism might dismiss any theory of art as being a Western invention, hence biased from the start. But indeed, multiculturalism is also a Western

invention. Just as multiculturalism prompts serious discourse on the recognition of, and respect for, cultural diversity, a good theory of art is intended to prompt discourse on the nature of art. Without such discourse, it seems that teachers will be at a disadvantage in grounding their pedagogical theories, particularly with regard to the teaching of aesthetics and art criticism. Aesthetics is about raising questions. Will art educators be prepared, for example, to mediate articulate discussions around such questions as: What is art? What are the differences between art objects and ordinary objects? How does one interpret an artwork? Apropos of multicultural concerns, will art educators be prepared to mediate discussions about non-Western art: What is the difference between an artwork and an artifact? Who decides? How does one interpret a non-Western object? Can standards of taste be applied across cultures? Without intelligent, probing discourse on the nature of art, conventional—and often inadequate—thinking about art, Western or non-Western, will fill the vacuum.

One theory of art is to declare that there is no one theory of art—at least no viable one. In a classic article on the subject, Weitz (1956/1962) called theories of art vain attempts "to define what cannot be defined" (p. 52). He recommended that art be considered an "open concept" comparing it to games (which include everything from solitaire to soccer). Just as it is futile to look for common properties in games, so it is in today's art. In summarizing several extant theories (including formalist theory), Weitz dismissed all as inadequate but went on to say that each, in its time, had the virtue of "emphasizing or centering upon some particular feature of art which has been neglected or 'perverted' (p. 59). But Weitz, knowing or not, implied a theory of art, particularly with regard to dealing with "new cases." He called for a decision (presumably to be made by "a professional") "as to whether the work under examination is similar in certain respects to other works...and consequently warrants the extension of the concept to cover the new case" (p. 54). Such a decision occurs, perhaps, when a judge of a juried show is confronted with an especially novel work, when a gallery director risks booking a new performance piece, when a museum curator decides an object made by a tribal culture is an artwork rather than an archeological artifact, and when an art historian discovers a trove of work by a forgotten 19th-century photographer and brings it to the attention of the public as art.

The process of determining what is art or not by the means illustrated above was articulated by Dickie (1974) in his controversial institutional theory of art. To Dickie an artwork was a status conferred on an artifact by the network of people and conventions involved in the "art world"—thereby treating the work as "a candidate for appreciation." What this theory does is remove the argument over definition from the realms of perception and metaphysics and places it in a social context. The context in this case includes not only the art world, i.e., various institutions (galleries, museums, the art press, universities) and authorities (artists, curators, museum directors, art critics), but also the public which, consciously or not, accepts the social convention of an art world. This theory helps to account not only for the novel products of recent art

but also for a vast body of objects from medieval, ancient, and tribal cultures which were intended by their original makers to be ceremonial or utilitarian objects instead of art objects (whereas, today, the art world "intends" them as art objects).

The institutional theory also breaks the link between art and aesthetic experience as a defining principle. Bell (mentioned earlier) was the first to link the two when he claimed that an aesthetic emotion was prompted by the presence of significant form. He never defined significant form beyond describing it as "lines and colours combined in a particular way" (Bell 1914/1949, p. 8-9). Although formalists today probably would not explain the relationship between art and aesthetic experience so simplistically, they do nevertheless tend to link the perception of art (particularly, good art) to some sort of refined experience. Smith (1986), for example, identified a special kind of "percipience" or "detached affect" (p. 22). Dickie (1974) argued against the idea of a special kind of aesthetic consciousness, attention, or perception; the term appreciation in his definition is meant to regard something as worthy or valuable. He also stated that this appreciation "applies quite generally both inside and outside the domain of art" (pp. 40-41). In other words, an encounter with an ordinary object—say a rare and beautiful rock—can elicit this special kind of appreciation.

Despite its advantages in helping to clarify some of the puzzling situations in today's world of art, Dickie's theory has been challenged. As Blocker (1979) explained: "At most, Dickie provides us with a de facto criterion after the decision has already been made" (p 210). In other words, his theory is more of an art world tautology than a true definition. On the other hand, if "appreciability" is seen as a kind of test to determine an object's eligibility, it may not be tautological. Although Dickie (1974) did not require that a work of art actually be appreciated ("The fact is that many, perhaps most, works of art go unappreciated" [p. 39]), he will allow that "The possibility of appreciation is one constraint on the definition: if something cannot be appreciated, it cannot become art" (p. 41). Dickie, however, never clearly illustrated how an object met the test of appreciability. The "candidate for appreciation" feature, which has been challenged by more than one aesthetician, is perhaps the weakest part of Dickie's definition. When forced to defend this aspect of his theory, he relied on identifying appreciation with perceptual qualities. For example, Duchamp's *Fountain*, "its gleaming white surface, the depth revealed when it reflects images of surrounding objects, its pleasing oval shape," was compared in these respects to works by Brancusi and Moore (Dickie, 1974).

Another who challenged Dickie was Danto, one of the most discussed aestheticians today and one that will be discussed here at some length. While Danto agreed that Duchamp's urinal, like all porcelain urinals, shares some properties with, for example, Brancusi's *Bird in Flight*, the relevant properties of *Fountain*, the artwork, are contextual, not perceptual. Throughout the *Transfiguration of the Commonplace*, Danto (1981) presented paradigm cases of art objects and literary works that were "indis-

cernible" in all outward respects. Some of these were hypothetical, as for example, an art show consisting of a number of perceptually identical red squares. Some were art, some were not; each had a different meaning, and each had a different history. And this is the important point. Danto linked content and causation inasmuch as two works may appear the same but have wholly different meanings, even classifications, due to their respective provenances. One of Danto's squares, made in the 16th century, was a canvas covered with red ground and thus not an artwork (at least not by 16th-century standards). The rest, all made in the 20th century, were submitted as paintings and thus, by institutional standards, were art. But although the rest of the squares were classified art and were indiscernible, they had different meanings. One was titled *Red Square* by a minimal artist (who probably claimed the meaning was self-referential). Another, titled *Nirvana*, was by a Buddhist convert (who probably wished to exemplify nothingness, the goal of Buddhism). Another titled *Red Square* was a witty reference to a piece of Moscow real estate by a Russian artist converted to modernism. And so it went.

In at least one respect Danto's theory resembled Bell's but is symmetrically opposite. Bell stated that to know something is an artwork one must experience an aesthetic emotion. Danto held that to respond aesthetically, "one must first know that the object is an artwork" (p. 94). In a de facto way, Danto's theory acknowledges Dickie's institutional theory. Indeed it was Danto's insights about the workings of the art world that led Dickie to develop the theory in the first place (Danto, 1964/1977).

One of Danto's paradigms (Danto, 1981) that was particularly instructive referred to Lichtenstein's *Portrait of Madame Cezanne* in which the artist imitated so closely a diagram by Loran (an art critic) that the latter brought charges of plagiarism. The Loran diagram was intended simply to reveal the compositional directions and proportions of a Cezanne portrait of his wife. Legal issues aside, it is clear that while the two works are virtually indiscernibile, the Loran is not an artwork and the Lichtenstein (at least by institutional standards) is. One would respond to the Loran as one would to any diagram—the issue in this case being its adequacy of mapping the relevant volumes and contours of the Cezanne. The response to the Lichtenstein, although identical to the Loran, is of a completely different order.

By Danto's thesis, the structure of an artwork does not just, or even necessarily, entail the arrangement of its lines, volumes, and colors. Rather, it resembles the structure of a metaphor, consisting of the complex relationships among artistic intention, the work, and the viewer. To unpack the Lichtenstein, to recognize the diagram as a witty and insightful commentary not only on the art of Cezanne but also on the critical apparatus surrounding Post-Impressionism and early modernism, the viewer obviously needs a knowledge base above and beyond visual elements and principles of design. Danto (1981) referred to this process as "transfiguration": "In order for the

viewer to collaborate in the transfiguration, he[/she] must infuse the portrait with those connotations" (p. 172).

Danto (1981) claimed that his theory applies to all art; "every artwork is an example of the theory if it is correct" (p. 172) Yet with the exception of Hiroshige's woodcuts, all the examples in *Transfiguration of the Commonplace* are Western. Of those, very few are pre-modern (Michelangelo, Breugel, Rembrandt, and Gainsborough); the vast majority, in particular those used to illustrate his theory, are modern and postmodern. Further, nowhere is the status of the crafts, applied arts, or popular arts addressed.

In a recent book, *Beyond the Brillo Box* (Danto, 1992), Danto rectified these omissions to some extent. To illustrate the application of his theory in a non-Western context, he developed another paradigm: two African tribes known, respectively, as the "Basket Folk" and the "Pot People" (1992, pp. 96-7). Both groups produced baskets and pots, thereby creating four subsets of products. Two of the subsets—Basket Folk baskets and Pot People pots—were art; the other two—Basket Folk pots and Pot People baskets—were artifacts. Yet because both subsets of baskets and both subsets of pots were indiscernible, there was no way of determining which was which on the basis of appearance. To do this one had to know the special relationship that existed between each group and its respective products. To the Basket Folk a single basket— the way in which it was organized and held together—was an occasion for reflecting on the power and magic of the universe. Men, women, and animals were thought to be made in the image of baskets, etc. But a pot was simply a pot, very useful but not transcendent. On the other hand, to the Pot People a single pot was a revelation of creation, since it was said by wise persons that God, the eternal pot maker, shaped the universe out of primal unformed clay. Meanwhile a basket was simply a basket, another artifact. Acknowledging that he is a "born again Hegelian," Danto often referred to Hegel, in this case with regard to the German philosopher's distinction between artifacts ("the Prose of the World") and art ("Absolute Spirit"):

> That is what Hegel meant in saying that, as art, an object is not part of the Prose of the World but belongs instead to the realm of Absolute Spirit. This is as true of artworks in primitive cultures as of those in our own. It is only, perhaps, that we lack the robust sense of Absolute Spirit that Hegel and Wise Persons of primitive cultures share. (1992, p. 107)

Here, I believe, is where multiculturalists and Danto (and Hegel) find common cause. Dissanayake identified art as "behavior to 'make special,' particularly things that one cares deeply about" (Dissanayake, 1991, p. 22). Danto might add that "something is special" in virtue of the intentions of the people involved, not in virtue of the way it looks. Hart (1991), who insisted that non-Western art must be considered "in

its cultural context, specifically in terms of the categories and intentions of its producers and consumers" (p. 150), would agree.

In his chapter on "High Art, Low Art" (1992), Danto posited three relationships between art and applied arts: 1) the actual entry by artists into the field of public relations—for example, Toulouse Lautrec making advertisements for the Moulin Rouge, 2) the advertising profession appropriating high art imagery "to give a certain inflection to their messages"—as in the use of Mondrian's style in advertising layouts during the 1950s (p. 152), and 3) "..erasing the boundary between high and low from the other side" (p. 154)—as in Warhol's imitation of Brillo boxes or Oldenburg's mockery of fast food. Beyond these relationships, the book makes no reference to other aspects of popular culture such as films or comics (an exception being a discussion of a provocative German play that may have been made into a film). Architecture is mentioned only in passing.

I find Danto's attitude toward the applied arts vis-a-vis the fine arts disappointing. Each of the relationships he described entails either the intervention or influence of an acknowledged fine artist—as though low art, in order to have substance, needs the endorsement of high art. Danto did not enlighten us on, or even address, the issue of where one draws the line between art and non-art with regard to film, comics, or architectue (Philip Johnson is discussed but not his architecture). Many things, now considered high art, were originally considered applied art or public entertainment. Mozart's Don Giovanni, to some critics, a singular masterpiece of Western music, was first performed as a piece of opera buffa or musical comedy. Rome's Colosseum and Nimes' Pont du Gard, monuments of architecture found in every art book, were, respectively, a stadium for public spectacle and a piece of urban plumbing. Hogarth's etchings, Daumier's cartoons, Japanese woodcuts, Constructivist posters, Charlie Chaplin films, and Dorothea Lange photographs were at one time considered mere entertainment, propaganda, or documentation. What are the dynamics involved in something changing its status from artifact to art? Does it over time don the structure of metaphor? Or was metaphor there at the start, only to be discovered by later generations? Can items of current popular art be submitted to Danto's metaphorical analysis? The humorous vignettes of Charlie, Lucy, Linus, and Snoopy chronicled in Peanuts, it seems to me, can easily be read as insightful homilies on the anxieties or interpersonal relationships. Indeed, they have even been seriously interpreted as metaphors on the major themes of Christianity (Short, 1968).

I am not much more satisfied with Danto's Pot People/Basket Folk explanation of the distinction between art and artifact in a non-Western context. In effect he has told us that any object involved in ritual, magic, myth, religion, or "Absolute Spirit" is art, while a utilitarian object is an artifact, involved in the "Prose of the World." Whether or not this rationale would be taken seriously by museum curators is not my concern here. What I do miss is Danto's explanation of the ways in which a Basket Folk basket

functions as a metaphor to the Basket Folk. What if Basket Folk do not frame metaphors as Europeans do? What if they believe their baskets are literally endowed with magical powers? What if they view their creation myths not as poetry but inherent revelations of historical fact? I would have appreciated, aside from offering us the paradigm, if Danto had provided a concrete example or two of real tribal art—just as he did with numerous Western modern and postmodern examples in his *The Transfiguration of the Commonplace* (1981). Danto did not give us all the answers, but he certainly left us with a lot of interesting questions.

## Conclusion

As we approach the end of the century art educators seem united in their desire to distance themselves from the old themes of creative and mental growth, yet are divided over what new direction the field should take. Of the many proposals for new directions, two stand out: discipline-based-art-education (DBAE) and multiculturalism/social reconstruction. DBAE is not only the best known of the two, it and its principles have already affected practice and are becoming, increasingly, the official position of the field. Nevertheless, the opposing view is not to be denied as its proponents are quite active in the national association and visible in the literature. I say "opposing" because they tend to brand DBAE as Western-oriented and overly academic in addition to being Philistine about social concerns.

The problem, then, is to reconcile the two camps, so that art education can move forward into the next century. A first step in such a reconciliation might be to examine art educators' assumptions about the nature of art itself. If DBAE followers want to bring "art" into art education, they must be clear about what it is; multiculturalists must be clear about the nature of art in different places; social reconstructionists must be clear about the ways in which art relates to society. To undertake this examination, I reviewed 1) the culture of higher education art departments, 2) art education literature with regard to theories of art, and 3) some alternative theories of art.

Given either direction for the field, future teachers of art will need to be well grounded in aesthetics, criticism, and art history (both non-Western and Western), yet attempts to increase hours in these subjects are thwarted by the continuing, and possibly increasing, emphasis on studio. Another problem is the pervasiveness of the doctrine of formalism in the foundations curricula. (Although this may be changing in many departments, the current crop of art educators was nevertheless raised on the doctrine). While formalism was appropriate for analyzing certain kinds of early modern art and postwar abstract painting, it is inadequate for non-Western art and even for most recent Western art.

Much of the DBAE or DBAE-related literature either ignores the subject of art theory or implicitly accepts formalism. One body of literature, promulgated by Smith,

is very engaged in the subject. While not gainsaying the contribution of this literature, one must acknowledge that, overall, it is biased in favor of modernist-formalist concepts. Multicultural-reconstructionist literature, while recognizing the limitations of modernist aesthetics, offers sociologically-based, rather than philosophically-based theories of art.

Of recent writers on art theory, two deserve mention: Dickie and Danto. The first is responsible for the "institutional theory" in which art is defined by the behavior and conventions of an "art world." Danto's theory, while not denying the importance of the art world, goes beyond Dickie's in claiming that the structure of an artwork is metaphorical rather than perceptual. His theory was most thoroughly developed in *The Transfiguration of the Commonplace* (1981), but by use of Western, mostly postmodern, examples. In a recent volume, *Beyond the Brillo Box* (1992), Danto attempted to relate his theory to non-Western art. Still, in my judgment, he leaves many questions unanswered.

I see no necessary conflict between the theories of Dickie and Danto and the agenda of DBAE. It is not just that these theories are more appropriate than formalism in accounting for the real world of art. More importantly, they would force art educators to consider artworks as socio-historical objects rather that just repositories of visual elements and design principles. For art teachers, this means having to be well grounded in a broad range of subjects, rather than just in studio. In the art classroom, this means that art teachers, wherever and whenever practical, should integrate art with other subjects, i.e., art history with history and social studies, art criticism with language arts, and aesthetics with critical thinking. Such integration would not only enrich learnings in art but also learnings in the other subjects.

Also, I see no conflict between multicultural concerns and the theories of Dickie and Danto. I say this not because of any overt regard for multiculturalism on the part of either writer but, rather, because of their emphasis on provenance and cultural context—respecting the intentions, conventions, and categories of the people by whom and for whom art objects are (were) made. Dickie's and Danto's analyses are, therefore, better able to accommodate encounters with art outside the Western or modern canon.

Finally, I see no necessary conflict between the agenda of DBAE and that of multiculturalism/social reconstruction. In this regard, the theories of Dickie and Danto could perhaps help to dissolve the division between the two. But that may be wishful thinking.

## References

Arnheim, R. (1954/1974). *Art and visual perception: A psychology of the creative eye* (new version). Berkeley: University of California Press.

Bell, C. (1914/1949). *Art*. London: Ghatto and Windus.

Bersson, R. (1983). For cultural democracy: A critique of elitism in art education. *Bulletin of the Caucus on Social Theory and Art Education, 3,* 25-32.

Blocker, G. H. (1979). *Philosophy of art*. New York: Charles Scribner's Sons.

Boas, B. (1924). *Art in the school*. Garden City, NY: Country Life Press.

Broudy, H. S. (1972). *Enlightened cherishing: An essay on aesthetic education*. Urbana, IL: University of Illinois Press.

Chalmers, F. G. (1988, Winter). A response to Ron MacGregor's paper. *Viewpoints: Dialogue in Art Education,* 26-30.

Clark, G. (1990). Art in the schizophrenic fast lane: A response. *Art Education, 43*(6), 8-23.

Danto, A. C. (1977). The artistic enfranchisement of real objects: The artworld. In G. Dickie, and R. J. Sclafani (Eds.), *Aesthetics: A critical anthology*. New York: St. Martin's Press. (Original work published 1964)

Danto, A. C. (1981). *The transfiguration of the commonplace: A philosophy of art*. Cambridge, MA: Harvard University Press.

Danto, A. C. (1992). *Beyond the brillo box*. New York: Farrar, Straus, Giroux.

Dickie, G. (1974). *Art and the aesthetic: An institutional analysis*. Ithaca, NY: Cornell University Press.

Dissanayake, E. (1991). *Art for life's sake*. Keynote Addresses. 31st Annual Convention. Reston, VA: The National Art Education Association, (pp. 15-26).

Efland, A. D. (1990). *A history of art education: Intellectual and social currents in teaching the visual arts*. New York: Teachers College Press.

Freedman, K. (1994). About this issue: The social reconstruction of art education. *Studies in Art Education, 35* (3), 131-134.

Greenberg, C. (1977). After abstract expressionism. In G. Dickie,and R. J. Sclafani (Eds.), *Aesthetics: A critical anthology*. New York: St. Martin's Press. (Original published 1962), pp. 424-437.

Greer, W. D. (1987). A structure of discipline concepts for DBAE. *Studies in Art Education, 28*(4), 227-233.

Hart, L. M. (1991). Aesthetic pluralism and multicultural art education. *Studies in Art Education, 32*(3), 145-159.

Hobbs, J. A. (1977). Is aesthetic education possible? *Art Education, 30*(1), 30-32.

Hobbs, J. A. (1983). Who are we, where did we come from, where are we going? *Art Education, 36*(1), 30-35.

Hobbs, J. A. (1988). Is beneficial elitism beneficial? *Studies in Art Education, 26*(3), 176-180.

Hobbs, J. A. (1993). In defense of a theory of art for art education. *Studies in Art Education, 34*(2), 102-113.

Illinois State Board of Education. (1985). *State goals for learning in the fine arts*. Springfield, IL: Department of School Improvement Services.

Lee, C. (1990). The cultural and historical redefinition of foundations education. *F.A.T.E. in Review, 13,* 30-31.

Levi, A. W., & Smith, R. A. (1991). *Art education: A critical necessity*. Urbana, IL: University of Illinois Press.

Logan, F. (1955). *Growth of art in American schools*. New York: Harper & Brothers.

Lowenfeld, V. (1952). *Creative and mental growth* (revised edition). New York: The Macmillan Company.

McFee, J. K. (1988). Cultural dimensions in the teaching of art. In F. H. Farley & R. W. Neperud (Eds.), *The foundations of aesthetics, art and art education* . New York: Praeger, 225 - 272.

McFee, J. K. (1970). Society, art, and education. In G. Pappas (Ed.), *Concepts in art education.* New York: Macmillan, (Original work published 1966), 71 - 90.

Parsons, M. J., & Blocker, G. H. (1993). *Aesthetics and education.* Urbana, IL: University of Illinois Press.

Risatti, H. (1989). A failing curricula. *New Art Examiner, 17*(6), 24-26.

Short, R. L. (1968). *The parables of Peanuts.* New York: Harper and Row.

Smith R. A. (1986). *Excellence in art education: Ideas and initiatives.* Reston, VA: The National Art Education Association.

The National Art Education Association. (1990). *Quality art education: Goals for schools.* Reston, VA: Author.

Weitz, M. (1962). The role of theory in aesthetics. In J. Margolis (Ed.), *Philosophy looks at the arts* (pp. 48-60). New York: Charles Scribner's Sons. (Original work published 1956).

Willis-Fisher, L. (1991). *A survey of the inclusion of aesthetics, art criticism, art history, and art production in art teacher preparation programs.* Normal, IL: Illinois State University Press.

# TOWARD A POSTMODERN APPROACH TO ART EDUCATION

## Tom Anderson

## The Liberal Tradition and Modern Art

The *liberal tradition* arose in the Age of Enlightenment in the 18th century. The foundational assumptions of Marxism, neo-romanticism, behaviorism, scientism/technologism, and humanism are all rooted in the liberal tradition (Bowers, 1989) and, when combined, define it as a tradition. In simplified form, liberal assumptions are that 1) time is progressive (that change is good, that so-called progress is desirable, and that technological advancement is progress); 2) the ultimate authority for regulating life's affairs lies within the individual's rational consciousness; 3) human nature is basically good when left to its own devices, or at least amenable to shaping toward goodness; and 4) humans do or should seek to act autonomously in relation to society, seeking to modify or overcome it through rational intelligence, the assumption being that society is inherently restrictive and repressive.

Embedded within these assumptions are modes of understanding that have shaped Western thought and education. These are that 1) education should contribute to "progressive" social change, 2) the power and authority of the individual are to be progressively strengthened through the development of skills and consciousness, and 3) critical rational thought is more valued and valid than other (traditional) forms of cultural authority and is to be the primary goal of the individual student's development.

The centrally empowered (neutral), unquestioned assumptions of the liberal tradition, by their nature and focus, either negatively frame or ignore other conceptual possibilities. Of particular significance, according to Bowers (1989), are assumptions about freedom, progress, individualism, literacy, technology, and especially tradition. Liberalism's assumptions and course of action lie in direct opposition to tradition. Tradition is seen as something to be overcome, something inherently repressive, often dehumanizing in its oppression of the human spirit, something the enlightened indi-

vidual strives to rise above, to escape, or at least to reform. Liberal education's largely unexamined role is to help the individual in this quest. The question arises, however: is such escape truly possible? And if it is possible, is it even desirable? The ideals of emancipation through individual freedom and authority devalue, ignore, and obscure the concept of the individual as the bearer of collective values, mores, institutions, and ways of doing things. They fail to acknowledge the individual as the bearer of tradition. They also obscure the fact that while tradition is in many ways restrictive, it is enabling and supporting in others.

Tradition provides patterns that make communication and collective living possible. The culture in which one is immersed to a large extent determines how one thinks, what one thinks about, and in what ways. Language and communication structures and ideologies built upon them shape the consciousness of those embedded within them by facilitating particular beliefs and propensities, and restricting or disallowing for others either through framing them negatively or ignoring them completely. Certainly, as Foucault (Sarup, 1989) claims, neutral status is given to the driving assumptions of a culture's central ideology, making them unquestioned, giving them the status of *truth*, rather than, more correctly, just one of many conceptual possibilities. These given truths and their supporting conceptions comprise the playing field which circumscribes a culture's definition of reality. This mapping, framing, and naming of reality, in including some concepts, must necessarily exclude others. In this lies the power axis of ideology and the reason for mortal combat between modernism, which has arisen within the liberal tradition, and traditionalism in the premodern sense. The driving assumptions of each do not match up comfortably with the other. Being modern means rising above and rejecting tradition.

The notion of rejecting then rising above tradition—what has come before—is the life blood of modern art and aesthetics. (See also Barrett in this volume.) Creativity is the supreme good. Modern art has been a progressive series of avant garde movements, one rising from and rejecting the one before through creative originality. The positive spin on rising above and/or rejecting tradition through creative expression naturally implies that the converse, adhering to tradition—copying—is bad. Copying in the modern tradition, in fact, is suspect as "art" at all. Placing creativity at the pinnacle also necessarily demotes other traditional values and qualities of art to secondary status thus replication, skill and craftsmanship are all less important than creativity.

A second root assumption of modernist theory is that art is inherently aesthetic in both form and function. That is, the highest purpose of art is to evoke the so-called aesthetic response. This is done through the presentation of what has been called "significant form" (Bell, 1981/1913; Fry, 1920; Collingwood, 1958). (See also Hutchens and Suggs in this volume). If form is truly significant it needs no explanation nor does it have purpose beyond the aesthetic. Significant form is believed in modernist theory to be universal, stimulating similar aesthetic responses in Africans, Arabians,

Americans and all others, regardless of culture or background. Whether it is a Persian rug, a painting by DeKooning, or a Ukiyo-e print, the value of a work is based on the power of its forms to evoke response. Conversely, then, artifacts and artworks that have functions extrinsic to the aesthetic, that are analogous, for example, or narrative, or that hold things or are sat upon, are less universal, less significant, and even sometimes not framed as art works at all (Collingwood, 1958), no matter how aesthetically dynamic. In late modernism, in fact, the so-called "fine arts" or "high arts" were claimed to be a bastion of good taste, of fine and high ideals articulated in some significant aesthetic form, holding out against the rabble and degradation of popular culture (Greenberg, 1961).

It thus becomes very apparent how modernism in art reflects the larger liberal tradition. The autonomy of the individual acting alone to rise above an inherently repressive society is the very core fiber of the creative fine artist, seeking through aesthetic means to progressively overcome a tasteless and degraded popular culture through the creation of beauty, and through beauty, significance.

## Postmodernism: Deconstruction, and Recontextualization

The past 30 years, or so, have seen the advent of the postmodern era in Western civilization. Central to postmodern theory have been the French poststructuralists. Poststructuralists do not define themselves as philosophers at all, preferring to see what they do as critiques of philosophy. The most influential poststructuralists, Lacan, Derrida, and Foucault, share the idea that the human subject is structured by language and therefore deny the Cartesian/liberal self as a unified consciousness, and as the ultimate authority for meaning or truth (Sarup, 1989). In this sense, a primary agenda of poststructuralism, which pervades the larger postmodern movement, is the de-centering of the individual. A human subject structured by language cannot have a unified individual consciousness outside the context of that (socially-defined) language structure.

The focus on language rather than individual consciousness as the primary reality construction device began to come into focus with Saussure's (1974) development of linguistic structuralism in the early 20th century. In Saussure's schema, linguistic "signs" are what make up language. The sign consists of both a signifier (a word or visual symbol) and a signified (that to which the signifier refers). For example, the word *dog* or a picture of a dog refers to the actual animal in three-dimensional space. The sign, consisting of the signifier/signified relationship is totally arbitrary. However, there is, still truth behind or within the text/the language system, because signs are ultimately stable.

In poststructuralism, however, meaning exists not in the relation between signifiers and signifieds, but in the interrelationship of signifiers themselves (Derrida, 1978).

For example, looking up the word *dog* in a dictionary, leads not to a dog but to other words such as *canine*, *domestic*, and *carnivore*. Looking up one of these words, i.e. *canine*, leads to further words, one of which is *dog*, others of which are *tooth*, *jackal*, and *wolf*. Looking up any one of these words leads to further words, and so on, ad infinitum. In this sense the signifier only takes on meaning in relation to other signifiers in a web of meaning that is intertextual, interdependent, and socially defined. The argument is thus made by many poststructuralists that symbols/signs (signifiers) do not refer to anything beyond the communication structure in which they are embedded. This meaning is produced in the interaction between the reader/viewer and the text. Therefore meaning does not passively pre-exist, contrary to what a liberal tradition positivist would claim. Further, signs, since they are context-dependent, are not stable. Meanings change. Thus there is no such thing as final truth.

It could be argued that the poststructural stance is ultimately nihilistic, or at least not productive for educational purposes, if not in fact anti-educational. Based on the logic of an endless chain of signifiers the meanings of which are constantly slipping and changing in meaning, Poststructuralists deconstruct systems of meaning. They are, in fact, antiphilosophical in the sense that they deconstruct systems theory, believing that no philosophical system (i.e., marxism, humanism, romanticism) is adequate as a conceptual framework for action in the contemporary world. Ultimately the poststructural critique of philosophy attempts to deconstruct the philosophies and assumptions of the liberal tradition, offering very little in their place but bleak and meaningless relativism. The effect of this, by definition, is neoconservative. Offering no theoretical position better than the one they are deconstructing, poststructuralists, in effect, take away our impulse or drive to move, to go forward, to progress.

Other postmodern thinkers, however, have integrated aspects of structuralism and poststructuralism without abandoning systems theory to the antiphilosophical critique. Neo-Marxism, feminism, environmentalism, and multiple forms of social reconstructionism are representative of this postmodern tendency. Sarup (1989), sees this tendency as Hegelian in spirit. Rather than anti-systematic, undermining, and negatively relativistic, these postmodern philosophical movements, while seeking to deconstruct the older Cartesian/liberal framework, also attempt to reconstruct other belief structures in its place. This is done through a process of recontextualization. Neo-Hegelian postmodernists recontextualize reality through challenging accepted beliefs and structures, decentering previously dominant beliefs and assumptions, and centering previously peripheralized assumptions and beliefs through dialectic activity. Through this, they believe that a new synthesis can be achieved, grounding new systems and new philosophies which holistically reflect new ways of being. Of particular interest, for my purposes, here, is the tendency of reconstructive postmodernists to borrow from traditional or indigenous societies, including pre-Enlightenment Europe, in rediscovering alternatives to modernism.

## Tradition and Traditional Art

Tradition is doing something the way it has "always" been done. As such, tradition is an inherited pattern of thought and action, passed from one generation to another. Tradition normally is transmitted by example or orally rather than through written means. It is, therefore, heavily context dependent, rather than abstract or rational (Bowers, 1989). Tradition gives us, as social animals, rules to live by through a reliance on the collective wisdom of the ages. It is a human survival tool.

Naturally, as an inherited intergenerational pattern, tradition fosters and values continuity. It does not consequently value creativity, which stimulates change, what in the liberal tradition would be called progress. Change, for its own sake, viewed from a traditional point of view is not necessarily good. It is tampering with what has always worked before. If it works, the question is, why should it be changed? The altering of an inherited pattern of belief or action is often viewed as at least a mistake and frequently as downright heretical. It is not an individual's right or place to usurp the patterns of the group without some very good reason. To do so can be a grave offense.

It becomes obvious, then, that unlike the liberal tradition, which centers the free and rational individual, traditional cultures center the social group as the source of wisdom and authority. Traditional societies do not hold the liberal assumption that all individuals are good and will act well, given their individual freedom. Rather, they assume that social control is a necessary and positive facet of culture and that a system of social checks and balances is necessary to moderate individual drives. Traditional societies assume that a shared moral code is necessary for non-perfect human beings, and that this codification should rely on collective experience as its centering device rather than on individuals' abstract rationality and logic (Bowers, 1989). They do not automatically assume technology to be good and value-free. Instead they are suspicious of technology separated from context. Finally, in traditional societies, the individual is always placed in relation to the community and the common good. When there is conflict between the individual's rights and society's rights, society comes first.

It follows, then, that traditional education is prescriptive. Traditional education's role is to transmit the cultural values, mores, and ways of doing things, as given, in an orthodox manner (Eisner, 1994). Critical analysis of the given mores and structures of the society is discouraged. The agenda is conservative, in the literal sense. The goal is to inculcate a sense of ownership, social obligation, and responsibility in the culture's central doctrine, which is seen as the truth.

Like traditional education, the art of traditional/indigenous societies is conservative, having a primary purpose of reinforcing and transmitting core cultural values and beliefs. In fact, traditional arts are so deeply embedded in the web of culture that normally they are known and judged for their functions in society rather than as works of

art, frequently not even being defined as artworks in their own right. In fact, many languages do not even have a word for *art* which corresponds with the Western conception. Instead what Westerners tend to call "primitive" art is known by indigenous peoples as artfully executed artifacts or performances which serve some larger function extrinsic to the aesthetic dimension. These functions are spiritual, sacramental, idealistic, and above all, social. Art symbolizes goodness, energy, masculinity, femininity, beauty, and other ideal states in its forms and uses. It serves as a means of influence, both secular (as in trappings of power) and spiritual (as in being a messenger or influencing agent for spirits or gods). Richard Anderson (1990) says art is the use of symbol and icon through which people populate a cold and indifferent universe with spirits and forces that make it have meaning for us.

Dissanayake (1988) takes the functionalist argument even further, suggesting that art serves a basic survival function in the biological sense. In short, her argument is that people need social cohesion to survive, that instead of sharp teeth and claws or camouflage, we have the ability to work in groups. Art facilitates this social cohesion by displaying and making concrete core values and beliefs through ritual, ceremony, and other public display. In this sense the arts are defined as collective and interdependent; i.e. dance, music, masks and so on all designed to be used together for the benefit of ritual display reflecting core cultural beliefs, whether that be a Christmas mass or the Gelede Festival.

The aesthetic element in all of this is obviously not for its own sake. Dissanayake argues that the skill and craft that go into making something beautiful or aesthetically appealing—the compositional make-up—are designed to make the object or performance "special," thus causing them to be something of focus. Through being the object of attention, artworks (artful artifacts and performances) draw attention to the extrinsic functions they serve, carrying messages about values and beliefs from one person and one generation to another. Traditional arts normally serve religion in this capacity, but also communicate the philosophical, political, social, psychological, and even prosaic concerns of the group.

Richard Anderson (1990) defines art as "culturally significant meaning encoded in an affecting sensuous medium" (p. 238). Analyzing this statement, it is immediately clear that culturally significant meaning implies a logico-meaningful system of symbolic communication which is defined, structured, and understood in the group context. Symbolic meanings as Saussure (1974) first alerted us, are not natural or given but assigned through social agreement.

If the primary function of art in traditional societies is, as Dissanayake says, to focus group attention and energy on those qualities which cause the group to be cohesive—mutual beliefs and values—it follows that the forms and the style of these forms must be understood broadly and specifically. Style, then, becomes a critical incitement

of meaning, but not in the modernist, universalist sense. As a cohesion device, art must maintain a consistently understandable style within a specific social context. Everyone in the group must know what is being communicated from person to person and generation to generation. The message of a style, whether it be a Yoruban mask or a Cimabue crucifix can only be read by those who are culturally literate, who are embedded in the cultural web of which that style is a part. This selects against innovation or originality in traditional art and selects for skill as a valuable artistic quality: particularly skill in reproduction. Changing the given pattern changes the meaning of a work of art, not a desirable trait in traditional cultures. If you change the mask maybe the god will not recognize it and deny your request. The power of the work relies on its continuity with tradition, and thereby an emphasis on skilled reproduction. The English word *art*, in fact, originates from the Greek *artes*, meaning useful skill (R. Anderson, 1990). Artists in medieval Europe were artisans. Art was construction, not expression, and the most skilled artisans, members of stone masons guilds or metal workers guilds, received the most culturally significant tasks, i.e., the *Gates of Paradise* (Eco, 1986; R. Anderson, 1990). This role of the artisan artist is very much like the Yoruban carver who creates the Gelede Ritual mask or the Tglingit carver of totem poles.

In short traditional art is conventional and orthodox, communicating through forms and styles accessible and understandable to all, through aesthetic means, about those core values and beliefs that define a culture. Its function is social cohesion, presenting frequently ritualized "special" displays that foster a collective spirit. As a bearer of tradition, indigenous art is not innovative. Rather the emphasis is on beauty or specialness and the skill that makes that so. Functional objects are to be enhanced artfully, but not changed so they no longer "work." The most important point is that the beauty, the skill, the affective sensuous medium must be understood to be the vehicle only, serving meaning which lies beyond the work itself. Art's most important function is the transmission of socially encoded meaning, which in traditional societies everyone is embedded in, and believes, and understands.

## A Synthesis of Liberal and Traditional Ideals for Postmodern Art Education

Modernism's forward-looking emphasis on progress and on individual emancipation from society is reflected in art education's focus on individual creativity. But looking forward and constantly innovating as the highest good de-emphasizes the conservation of what is worthwhile in a society's traditions. There is a great potential for loss of cultural continuity. Conversely tradition's focus on orthodox thinking and acting de-emphasizes critical thinking, individual authority, and thus the individual's right or motivation to move forward, to change or improve what exists. Modern artists recognized this in their revolt against academicism. The individual authority

invested in the artist as creative spirit, however, reflects an embedded assumption that individual consciousness raising always is done for inherently good ends and has positive results. A consequent lack of social constraints, then, ultimately allows for unbridled relativism in which all expressions must be seen as equally valid, from *Piss Christ* to *Tilted Arc*, both of which are greatly offensive to the larger society in differing ways. On the other hand, traditionalism does not automatically assume all human actions to be for the good and sets standards for the greater good of the group. In a strictly traditional context neither the *Tilted Arc* nor *Piss Christ* would exist. Yet a modernist ethos giving equal credence to both, from a traditional perspective, indicates total relativity and disintegration of community. It is apparent that neither a traditional nor a modernist perspective is sufficiently comprehensive.

What I hope to construct is a conceptual approach to art education which deconstructs the modernist model and recontextualizes components of the liberal tradition and pre-Enlightenment traditionalism into a synthesis which holds equal respect for the individual and the community. Bowers' view of postliberal education informs this effort. Four qualities he believes are essential to postliberal education are: 1) a shared stock of tacit knowledge through models and modeling, 2) a knowledge of tradition/a community of memory, 3) understanding of self as a social being, and 4) shared conceptual foundations through which to exercise communication.

Looking first at the notion of understanding self as a social being, the decentering of the subject—of the individual "I"—is a central aspect of poststructuralism. The argument is that the group is in the individual. Lacan (Sarup, 1989), argues that in taking on language the individual is socialized, taking on group norms and understandings in spite of him/herself. There is no "I" apart from the group. In the most extreme versions this implies an absence of center, no "I" at all, thus no free will, thus no creativity or innovation by an individual who is merely an extension of group consciousness. In one sense this is very similar to the traditional repression of the individual by group needs, demands, and consciousness.

As Barrett pointed out earlier in this text, artist Sherrie Levine takes the postmodern decentering of the subject as her content in her appropriations of work by artist-geniuses. Appropriating these works denies ownership of ideas and forms by the individuals who first created them. In essence it denies the originality of expression, claiming the works for and as an extension of everyone. Yet Levine cannot take us back to the days when anonymous artisans crafted Indian temples or Gothic altarpieces, even if she wants to. In fact, her act of denying originality is a very original act which has established her as a very famous artist—maybe even the individual artist-genius she has set out to deny (and become). So, buried within the postmodern critique as exemplified by Levine, the liberal tradition of the individual creative artist lives on and enjoys good health. The value of the critique, then, is not so much in the deconstruct-

ing of the notion of the individual subject as in the refocusing of art on group concerns. Decentering the subject ("I") socializes artistic activity.

A vehicle well suited to instigating this social focus may be content-based art education, first framed as discipline-based art education (DBAE). DBAE has been roundly criticized in some circles as being too traditional in its academic focus on history, criticism, and aesthetics at the expense of creative self-expression. It may, in fact, have been true that DBAE was somewhat narrow and elitist in its initial phases. However, its advocates have steadfastly maintained that it is not a curriculum (with content), but a structure on which to build curriculum (Lovano-Kerr, 1990). And since its general introduction to the field (Greer, 1984) it has undergone considerable modification. On the other hand, it can be argued, that chosen structures as much as content indicate value and belief patterns. For example, limitations are set simply in restricting approaches to the study of art to four disciplines as defined within a Western philosophical context. This automatically selects against traditional understandings and strategies such as ritual, storytelling, and performance, thus somewhat invalidating them. Likewise, labeling the fourth discipline "aesthetics" implies the aesthetic, non-functional, Western disciplinary point of view in approaching works of art or artful artifacts. *Philosophy of the arts* may be a more comprehensive term since it encompasses valuing and defining activities from both the Western (intrinsic) perspective and the larger world view in which much art is defined and valued based on extrinsic/functional properties. Nevertheless, DBAE was the first, is the best known, and, as Hamblen argued earlier in this volume, is an evolving form of content-based art education, and must be credited with opening the door to a postmodern approach that refocused art educators on the historical, contextual, evaluative, and definitive *content* in art as well as on individual expression. Further, there are now multiple versions of content-based art education, so choices of structure and are available, all of which focus on art content rather than on art for art's sake.

This expanded focus on art for meaning and extrinsic societal understandings reflects an important postmodern trend in the art world. Very early, authors such as Cockcroft, Weber and Cockcroft (1977), and later Lippard (1990), Gablik (1991), and Dissanayake (1988), have focused on art's connection and meaning in life — what it does beyond the realm of the aesthetic. Content-based art education provides an ideal vehicle for moving beyond the aesthetic in art education.

Still, it is important not to throw out the baby with the bath water. It is, after all, the aesthetic quality of art that originally distinguished it from other forms of social communication. And in spite of the fact that early in the century Duchamp introduced us to the fact that art may be totally conceptual (non-aesthetic), still, the aesthetic is the rule in art rather than the exception. Defining, understanding and using the aesthetic, then, must continue to be a primary concern of postmodern art education. As tools for production, analysis, and appreciation, the elements and principals

of design and other compositional and stylistic tools are not to be discarded. It is these very elements that draw our attention to artful artifacts and performances, that cause us to focus, that engage our emotions and attention, that make artworks special enough to point us to their contextual and extrinsic value. So creative expression in both criticism and production must continue to play an important role in postmodern art education. A good program, says Eisner (1994), has both instructional objectives, focused on the acquisition of skills and content, and expressive open-ended outcomes. Skills in studio and art talk are important as are expressive opportunities.

But what content, exactly, is to be addressed? The content of art education has changed radically in just the last decade. This change of focus has been facilitated by adopting the poststructural strategy of deconstruction. In essence, deconstructionists challenge all given forms of knowing, all orthodoxies, indeed all holistic and integrated philosophical systems. Carried to its extreme, this form of radical critique is nihilistic (Szkudlarek, 1993), denying the signifier-signified relationship, truth, and even meaning. The possibility of critique, of deconstructing and recontextualizing the reifications of philosophical systems presented as truth, however, has been very useful. The notions of art for art's sake, universal form, and the aesthetic point of view are particularly under challenge, and thus the Euromale perspective, itself, has been brought into question. First spearheaded by the civil rights movement, feminism, and ecological concerns of the 1960s, cultures and subcultures previously peripheralized have increasingly demanded and received cultural acknowledgment and empowerment. Consequently, content-based art education now increasingly focuses on multiculturalism. The decentering of the white male and the repositioning of the "other" (blacks, Hispanics, the physically challenged, women, those with alternative sexual orientations) toward the center allows more voices to be heard. Each of these voices represents a different culture or orientation, and brings to the chorus a different timbre and pitch representing differing values, mores, and beliefs. In this way, content-based art education is embracing vital plurality through multiculturalism.

Accepting and embracing multiple, competing, political value bases engenders the postmodern position that there is no one truth. Rather there are multiple *narratives* and accepting one to guide you, then, defines your world view. Promoting a world view, or narrative, as it engenders beliefs, values, and ways of doing things is the traditional role of the arts, executed through ritual, ceremony, and extrinsic functions. In a postmodern framework, art is once again about something beyond itself; it defines a particular narrative or world view. Through critically examining and making artworks, using this conceptual framework, students therefore may gain access to attitudes, mores, and cultural understandings of themselves as beings in their own culture and of the cultures of others. Obviously, this is valuable learning in a world growing increasingly smaller and more interdependent, and translates to valuable political capital in the educational system. Through focusing on works of art as culturally embedded

objects, content-based art education may yet realize the DBAE political agenda of centering art in general education.

# Conclusion

Postmodern critique has deconstructed the modernist belief in scientific objectivity, progress, the independent and rational individual, universalism, autonomous aesthetic art, and the aesthetic point of view. Social and educational reconstructionists have introduced or reintroduced the ideas of narrative relativism, linguistic and cultural embeddedness, the centering of society over the individual, and art with extrinsic functions beyond merely the aesthetic. Art education, as a social institution, is reflecting all of these changes in various ways. What I am suggesting is that each of these components from the traditional, the liberal tradition, and the postliberal era are layered like sediment in the rocks that make up the foundation of art educational consciousness. None can or should be eliminated. Instead they should be combined and built upon, the very synthesis being the bedrock of postmodern art education.

Modernism's faith in the independent and autonomous individual, resulting in autonomous and individualistic creative expression needs to be balanced by tradition's focus on the individual's responsibility to the group and by art's functions as a force for social cohesion, but not overpowered by traditional "determinism" (Szkudlarek, 1993). Thus modernism's faith in progress and therefore technology should serve as a moderating force for the conventionality and repressive orthodoxy of tradition. Yet the renewed sense of community advocated by many postmodern theorists must be seen as being equally as important as the individual's (artist's) right to creative free expression through innovation. Artists, critics, art historians, art educators curators, philosophers of art, consumers, and members of the general community should all have a voice in defining and valuing art with an eye toward a balance between rights and responsibilities.

This vision calls for models of content-based art education focusing on skills, concepts, and expressive outcomes directed toward recognizing how art is defined, valued, and utilized in multiple cultures and subcultures. The modernist universalist principle can be applied to the impulse to make things special worldwide. The postmodern advocacy of multiple competing narratives can be applied to understanding how the universal impulse takes multiple forms and meanings cross-culturally.

When art educators recognize that artworks do not stand above or apart from culture, but are in fact embedded in a cultural web; when we recognize that reality is socially constructed, rather than positivistically given; when we recognize that signs and meanings are arbitrarily and collectively assigned; and when we recognize that the definition, meaning, and value of art are as different as the differing cultures in which they exist; then multicultural, content-based art education becomes the model for the

postmodern age. Mining artifacts and performance for meaning (T. Anderson, 1995) and creating culturally aware expressions interculturally and cross-culturally should be the point of postmodern art education. The goal is to understand ourselves and others better, allowing more intelligent and meaningful action in the arena of life.

# References

Anderson, R. (1990). *Calliope's Sisters: A comparative study of philosophies of art.* Englewood Cliffs, NJ: Prentice-Hall.

Anderson, T. (1995). Toward a cross cultural approach to art criticism. *Studies in Art Education, 36*(4), 198-209.

Bell, C. (1981/1913). *Art.* New York: Perigee.

Bowers, C. A. (1989). *Elements of a post-liberal theory of education.* New York: Teachers College Press.

Cockcroft, E., Weber, J., & Cockcroft, J. (1977). *Toward a people's art: The contemporary mural movement.* New York: Dutton.

Collingwood, R. G. (1958). *The principles of art.* New York: Oxford University Press.

Derrida, J. (1978). *Writing and difference.* London: Routledge and Kegan Paul.

Dissanayake, E. (1988). *What is art for?* Seattle: University of Washington.

Eco, U. (1986). *Art and beauty in the middle ages* (H. Bredin, Trans). New Haven, CT: Yale.

Eisner, E. (1994). *The educational imagination: On the design and evaluation of school programs* (3rd. ed.). New York: Macmillan.

Fry, R. (1920). *Vision and design.* London: Chatto and Windus.

Gablik, S. (1991). *The reinchantment of art.* New York: Thames and Hudson.

Greenberg, C. (1961). *Art and culture:* Critical essays. Boston: Beacon.

Greer, D. (1984). Discipline-based art education: Approaching art as a subject of study. *Studies in Art Education, 25* (4), 212-218.

Lippard, L. (1990). *Mixed blessings: New art in a multicultural America.* New York: Pantheon.

Lovano-Kerr, J. (1990). Cultural pluralism and DBAE: An issue revisited. *Journal of Multicultural and Crosscultural Research in Art Education, 8*(1), 61-71.

Sarup, M. (1989). *An introductory guide to poststructuralism and postmodernism.* Athens, GA: University of Georgia.

Saussure, F. (1974). *Course in general linguistics.* London: Fontana & Collins.

Szkudlarek, T. (1993). *The problem of freedom in postmodern education.* Westport, CT: Bergin & Garvey.

# MULTICULTURAL ART EDUCATION: CHICANO/A ART AS CULTURAL NARRATIVE AND AS DIALECTIC

Elizabeth Garber

## Introduction

The focus in understanding art in the postmodern era has shifted from the modernist emphasis on formal elements and art about art to art as meaningful expression of culture. Indeed, postmodern thinkers cannot conceive of understanding art outside of culture. The postmodern era has also meant the end of single meanings and solitary truths, raising our awareness that cultural groups and individuals within them hold differing beliefs, practice different life styles, and make different styles of art, and that all of these are valid. I work within these two premises of postmodernism in this paper.

One of the areas concerning art educators is talking about art (art criticism). Issues of multicultural art criticism have concerned a number of these writers; a good knowledge of the cultures within which any artifact is made and within which it is discussed is considered by most, if not all, of these writers to be preliminary to any kind of meaningful art discussion. Sally Hagaman [Mc Rorie] (1990) points out that in the postmodern era, scholars have "rejected the notion of universal, objective truth and have pursued knowledge and meaning constructed in and through relationships among individuals, social structures, and cultural artifacts" (p. 28). She also discusses the trend in contemporary art criticism to explore artworks as narratives. It is within the context of postmodernism that this paper necessarily takes its place.

In this paper, I argue that art by the Chicano/a can be understood as a cultural narrative of Mexican Americans, and, moreover, that it can be understood as forming a dialectic with groups both within and outside Mexican-American culture. Although

the focus is Chicano/a culture, understanding some art as a dialectic has implications for art that is made by other counter-mainstream culture groups.

## Chicano/a Art and Cultural Narrative

One of the questions I have been concerned with is whether art can be considered a narrative. I have been looking at how literary critics understand works of fiction as cultural narrative and the question I have asked myself about Chicano/a fiction is whether it *can* be a *cultural* narrative. A novel or short story commonly, though not always, tells the story that we associate with a narrative, but a cultural narrative is not to be understood as fictional only. It becomes a piece of the cultural fabric, a cultural informant. (Arguably all narratives are cultural narratives, but not being a literary scholar, my concern has been with the importance of Mexican-American literature in relationship to Chicano/a culture and art.) Chicano literary scholar José David Saldivar argues that Chicano/a narratives of the border, "like Faulkner's modernist novels about Mississippi and the (post) modernist Latin American new narratives...all appear to be obsessed with New World history and myth" (1991, p. 179). Another literary scholar echoes this when he argues that "history is the subtext that we must recover [in Chicano/a narratives] because history itself is the subject of its [the novel's] discourse" (R. Saldivar, 1990, p. 5). Both scholars characterize Chicano/a literature as based in historical and mythological aspects of Mexican-American culture. Through Chicano/a literature, they tell us, we experience not only stories, but, as literary scholar Ramón Saldivar (1991) has noted, "cultural matrices" (p. 12) that reveal the heterogeneity of any culture (p. 13). How the culture functions, what forces are at play, the character of everyday experiences, and beliefs are part of what literature allows us glimpses into. In this sense, a novelist might be seen as an ethnographer and a native informant (J. D. Saldivar, 1990, p. 264; Quintana, 1991).

"But literature is not history or sociology," you might think, "literature is fiction." Saldivar confirms my reasons for including literature in the study of Chicano/a culture: he argues that Chicano/a contemporary fiction is "not so much the empirical events of the world as the self-inscription and symbolization in texts of those events and in our thinking about them" (R. Saldivar, 1990, p. 15). This is what Fredric Jameson calls "the narrativization [of the 'real'] in the political unconscious" (1981, p. 35). The texts offer individuals' responses to events and the beliefs and reasons behind these responses. This is, argues Saldivar, "the truth of the real world that Chicanos experience" (p. 5). The aesthetic act itself is, in this sense, ideological and the production of literature and art can be understood as ideological acts (R. Saldivar, 1991, p. 17). In other words, the bare facts are but part of the story; how they are experienced and understood being the greater story. Fredric Jameson (1981) argues similarly when he calls cultural artifacts (such as artworks and novels) "socially symbolic acts" (p. 18). The artifacts not only reflect the culture and its stories, but take an active part in the dynamic of the culture. Thus, literature is an important piece of the cultural material.

This brings me to the question I have struggled with concerning art: can artworks contribute to this narrative and be considered a cultural narrative in and of themselves? Politically speaking, the arts have been very important to Chicano/a politics. Anyone who knows the history of the Chicano/a Movement knows the centrality of the arts to the movement. Influenced by the political role and impact Mexican Renaissance artists such as Diego Rivera and David Alfaro Siqueiros played in Mexican culture and social reconstruction earlier this century, artists were leaders in the Chicano/a Movement from the beginning and art was understood to be important to the success of the movement. Luis Valdez, working with striking farmworkers from what was then known as the National Farm Workers Association (later the United Farm Workers), created satirical theatrical skits called *actos* or acts. Performed in the fields of the Salinas Valley of California to support the strikers, they were improvisational. Visual artists actively painted murals in communities, creating a public art that expressed anger or political convictions, pride and/or community, and hope. For example, Carlos Almaraz and youths from East Los Angeles painted *No Compre Vino Gallo* (Don't Buy Gallo Wine) to protest the heavy use of pesticides that is harmful to the health of field workers and the brutal breaking of strikes. Las Mujeres Muralistas, a group of women muralists, painted *El Mercado* (The Market) in San Francisco to express pride in the native heritages of most Mexican Americans. In the mural, we see cooperation and communalness, an offering of hope for the future. These are both murals, which, along with posters, were a favored format because their audiences were people in communities and on the street rather than art audiences. They reflect issues in the movement: political actions to protect laborers, the community focus of events, and cultural—including language and gender—affirmation.

Much of the information I have given you is reliant on information that cannot be gleaned from the artworks themselves—I remember the grape and lettuce boycotts of the 1970s (I still boycott grapes) and I've supplemented my information with discussions I've had with others and readings. So, can these pictures be considered narratives? If we look at artworks as texts, it is easier to accept them as narratives in and of themselves, as opposed to representations or outgrowths of narratives. Semioticians Jurij Lotman and Irene Portis Winner have worked with ethnic culture texts, an entity similar to the cultural narrative to which I have referred above. An ethnic culture text communicates the cultural self-identity of an ethnic group that distinguishes it from others (Winner, 1984; 1989). Both Lotman and Winner use a definition of text that can be either verbal or visual. Winner describes culture texts as composed of signs...that are organized by cultural codes and are conveyed in any modality. Texts are understood as both verbal and visual. (Winner even extends the definition of text to the study of individuals within a culture, calling these studies "human sign-texts.") Narrative is broadly defined by both scholars to include visual art forms as well as poetry, prose, theater, film, radio, television, music, advertising, politics, science, and communication between people. Winner and Lotman distinguish between montage-like and plot-like texts, with most visual texts being montage-like. Montage involves a

simultaneous juxtaposition of elements rather than the sequence of story events that characterize traditional plots. But a montage still acts as text and carries as well a contribution to the structure of cultural ideology and change. These definitions and conditions allow me to extend narrative to include at least some visual art and much Chicano/a art.

## Chicano/a Art and Dialectics

How might we see these expressions beyond their role as cultural informants? Texts, as I have argued above, reveal human perspectives on history, beliefs, and experiences. But Chicano/a narrative is not merely illustrative, representative, or a translation of Mexican-American experience or history, but an agent working to demystify the experiences and the history of its people. When Ramón Saldivar argues the importance of history as a subtext to Chicano/a literary narrative, he concludes that "History cannot be conceived as the mere 'background' or 'context' for this literature; rather, history turns out to be the decisive determinant of the form and content of the literature" (1991, p. 5). He argues this by looking at the ideological nature of Chicano/a narratives as "oppositional." As oppositional forms, they "signify imaginary ways in which historical men and women live out their lives in a class society" (R. Saldivar, 1990, p. 7). By this he acknowledges that they are both fictional creations and yet important political, cultural, and ideological tools—in part, at least, because they reveal the human response to lived experience, affirm the experience of Mexican-Americans and the strength of the culture, and underscore the need to resist oppression and degradation. But, moreover, he argues their importance as an active force in the creation of change. Chicano/a narratives are not just a mirror—they are predominantly critical and ideological and these are oppositional, or "resistant ideological forces," (1991, pp. 6-7), a term he borrows from Barbara Harlow (1987). "Their function is to shape modes of perception in order to effect new ways of interpreting social reality and to produce in turn a general social, spiritual, and literary revaluation of values" (R. Saldivar, 1991, p. 7). Chicano/a narratives, then—including art— should be understood as producing versus merely expressing ideological difference. Griselda Pollock (1988) makes a similar point about feminist art in her book *Vision and Difference.* Saldivar actually calls it an "aesthetics of resistance" (R. Saldivar, 1990, p. 193). Chicano/a texts should, as he argues, "be understood as different from and in resistance to traditional American literature, yet they must also be understood in their American context, for they take their oppositional stance deliberately" (R. Saldivar, 1990, pp. 8-9).

In this sense, we might be able to call Chicano/a art texts dialectical, not in the sense that they must form logical arguments, or that we try to arrive at a truth through the use of logic, but in the materialist sense, in that they interact with conflicting realities—most noticeably the conflicting realities of white mainstream culture and that of Mexican Americans, but sometimes between genders as well—on a materialist and

experiential basis. They provide a classic dialectical clash both between cultural-historical forces that surround a text and the text itself (R. Saldivar, 1990, p. 207). They also provide us with the formal elements of dialectics, the "paradoxical impulse toward revolutionary deconstruction and towards the production of meaning" (p. 7). This dialectics of difference is purposeful, and informally similar to the spirit of Winner and Lotman's idea of an ethnic culture text. But it goes beyond the affirmation of an ethnic culture text in that a dialectic implies opposition with the underlying need to facilitate positive change and growth.

But lest I lose your attention, let me apply this to an example. The Virgin of Guadalupe is the patron saint of Mexico. She is said to have appeared to Juan Diego, a Christianized Indian, during the winter of 1531 on the Hill of Tepeyac in the Valley of Mexico. She told him to inform the archbishop of her desire to see a church built in her honor on this hill. After two unsuccessful tries to convince the archbishop of the Virgin's apparition and request, the Virgin bade Juan Diego fill his cloak with roses growing on a normally barren spot of the hill (remember that it was winter). When Juan Diego unfolded his cloak in front of the archbishop, the out-of-season roses tumbled out, but moreover the image of the Virgin appeared on the cloak. The shrine was ordered built. Today, a basilica stands on the site and hundreds of thousands of visitors pour into it yearly to pray before that same cloak with the image of the Virgin on it, another miracle because the cloak fibers, now 450 years old, usually disintegrate after a score of years. The hill of Tepeyac had earlier housed a temple to the earth and fertility goddess Tonantzin (also known as Tonatzin), who like Guadalupe, was associated with the moon. That the Virgin of Guadalupe was readily adopted by natives during the 16th century was, according to several Spanish friars of the time including the chronicler Bernardino de Sahagún, due in no small part to the association of Guadalupe with Tonantzin. Although Christianity in the United States remained quite distinct from native religions, Catholicism in Mexico is mingled with indigenous practices and symbols. Today, the Virgin of Guadalupe is not only a symbol of Mexico, but, as one writer says, "a symbol which seems to enshrine the major hopes and aspirations of an entire society" (Wolf, 1973, p. 246). During the Mexican war for independence against Spain, her image preceded the insurgents into battle. During the revolution of 1910, Emiliano Zapata and his rebels fought under her emblem (Wolf, p. 246). She was another organizing symbol in the United Farm Workers' [UFW] struggle to unionize farmworkers in California in the 1960s. Her image accompanied the UFW eagle on the farmworkers' 300-mile march in 1966 from Delano, California, to Sacramento (Terzian & Cramer, 1978, pp. 100-101). Today, the image of the Virgin of Guadalupe is ubiquitous in the Mexican barrios or neighborhoods of the southwest: it adorns home and garden altars, roadside shrines, restaurants, buses, and so on. She remains an important icon for Chicano/as in their struggle for justice and self-respect (CARA, 1990, p. 238). Her image is very powerful to most people of Mexican descent, the profundity of which probably eludes most non-Mexican descended persons living in the United States. An emblem of their

Mexican heritage, she is known as "the brown virgin." The distinguishing factors of the Virgin are her starred blue cloak, the rays, and the moon and puti at her feet.

Because of her cultural importance as a traditional religious and personal icon, the Virgin of Guadalupe has become a focus in Chicana feminist critical reinterpretations. What's at stake for contemporary women in the depiction of Guadalupe? The Spanish invaders of Mexico used imagery as well as words to construct the idea of indigenous peoples as living in nature, waiting to be civilized by European culture and Christianity (Zamudio-Taylor, 1992, p. 15). How does the Virgin's depiction help construct an identity for Mexican-American women? It is both because of her importance as a cultural symbol and as an important icon in contemporary political movements that the Virgin of Guadalupe is a subject of Chicanas. The Virgin is a symbol of motherhood and, by transference, the symbol of ideal womanhood. She is beautiful, serene, passive, and virginal (the moon is symbol for immaculate conception). That ideal is characterized by the Virgin's passive stance and her position as protector of others, a role that seems to echo her subservience to others. The problem, of course, is that mortal women have a hard time living up to the ideal she sets. And in a culture where symbols of "evil" women are almost as powerful (for example, la malinche who helped Cortés conquer Mexico and la llorona who drowned her children to avenge her philandering husband) and the virgin/whore binary system remains intact, failing the ideal of the Virgin, the association with la malinche or la llorona strengthens. These and other female models have been scrutinized by Chicanas.

Yolanda Lopez's series *The Guadalupe Triptych* portrays the artist, her mother, and her grandmother as the Virgin. The use of family as subject is frequent in the art of Chicanas (Mesa-Bains, 1990, p. 132) and recalls the feminist slogan "the personal is political." What affects individual women often has broader implications, because the structure and content of individual lives is influenced by cultural constructs whose subtexts are political; the personal is further politicized by feminists working for change. Lopez's Guadalupes are portrayed as working-class Mexican Americans. As portraits of real women, they underscore the material reality—as opposed to the idealized construct—of women and their lives. Each woman is shown with the cloak of stars and the sun-ray body halo, the crescent moon and the puti that characterize depictions of the Virgin of Guadalupe. Each is also accompanied by a snake that stands for knowledge, wisdom, respect, and sex; it also represents consciousness and regeneration (Lippard, 1990, p. 15). The portrait of the artist shows her in running shoes (Lopez was a runner at the time), bounding out of the frame with confidence and energy. In the painting, the artist calls on the power of the Virgin's image as an ideal woman, subsuming it into her own image. At the same time, she replaces the Virgin's passiveness and aloofness with a living Chicana with distinct experiences and characteristics. She is active, alert, energetic. The image changes from a closed, inwardly focused one. As runner, Lopez as Guadalupe is the antithesis of a passive woman. In an artist's statement, Lopez notes that the Virgin "has no emotional life or

texture of her own" and expresses that living women "also deserve the respect and love lavished on Guadalupe," and this is why she has utilized the image (Lippard, 1990, p. 15 & pp. 40-42).

Lopez's portrait of her mother, Margaret Stewart, as the Virgin indicates Mrs. Stewart's occupation as family-supporting seamstress. She is a "valentine to working women," the artist says (Lippard, 1990, p. 5 & pp. 40-42). Stewart uses the domesticated snake as a pincushion and is shown in the act of fabricating the cape worn by the Virgin of Guadalupe. In the original story, the cape with the Virgin's image on it was a miracle, but in Lopez's painting, a working class Mexican American has the power to create something of great power. She is in the act of constructing her own identity, rather than being told who she is.

The portrait of Victoria Franco, Lopez's grandmother, portrays her as physically slight, but confident. She is strong, solid, and appears at peace with who she is. Franco has skinned the snake (says Lopez, "It's under control, and she has survived the Garden of Eden with serenity and dignity"). The image and Lopez's statement about it acknowledge the desires of the flesh that are antecedent to motherhood and grand-motherhood in the world of mortals. Given this acknowledgment, Franco remains dignified and self-confident. The skinned snake reinforces this: in skinning the snake, the grandmother possesses the knowledge, wisdom, and sexuality of the snake. She is not duped as Eve is when she takes an apple from the Garden of Eden. Unlike Eve, the grandmother is wise and good. She receives given respect. She acts consciously. She represents future generations of women possessing these self-determined qualities.

The three portraits Lopez has created symbolize alternative role models for women. These women are not powerful politically or in social status because of their gender, their race or class, or their job status; indeed the mother and grandmother decidedly occupy traditional female roles of nurturer and seamstress. They are shown and titled as portraits of specific individuals, that offer a challenge to art historical traditions in which pictured women are rarely named and usually pictured for their feminine beauty, the only other socially highly valued attribute of women besides their role as mothers and nurturers. Much as artist May Stevens has done in her series *Ordinary, Extraordinary*, in which she juxtaposes the brilliant Polish-German social theorist Rosa Luxemburg with the artist's own working-class housewife mother who was an institutionalized mute for the last 40 years of her life, showing us the ordinary and extraordinary aspects of both women, Lopez challenges both art historical traditions and traditions of class, ethnicity, and gender representation in picturing and naming her mother, her grandmother, and herself in the stead of the Virgin of Guadalupe. She challenges the virginal and passive traditions that are unattainable for most (if not all) mortal women and in doing so, helps Chicanas reconsider their self-images and cultural roles.

The paintings, in their combination of cultural heritage, contemporary women, and ideological beliefs, create new meanings and are part of the Chicana process of reconsidering women and revaluing cultural symbols, patterns, and beliefs. They were powerful enough that, I am told, Lopez was brought before the venerable society of Guadalupeños who protect the Virgin's image, to defend her art against the charge of heresy.

Thus, Lopez's images of the Virgin of Guadalupe do not merely reflect or critique practices and cultural beliefs that confine women to traditional places of subservience, they actively construct new roles, new possibilities for women, and underscore that these new roles are acceptable and worthy (Mesa-Bains, 1990, p. 137). This going beyond mere expression or reflection of extant ideology to the production of ideological difference is one of the roles of Chicana narrative that embodies an aesthetics of resistance. As Ramón Saldivar states, "Chicano narratives are not just a mirror—they are predominantly critical and ideological and these are oppositional...[They are] resistant ideological forces...Their function is to shape modes of perception in order to effect new ways of interpreting social reality and to produce in turn a general social, spiritual, and literary revaluation of values" (1991, pp. 6-7). Lopez's narrative forms a dialectic not only with mainstream culture and feminist culture in presenting Mexican-American women as active and self-confident, but also within her own culture. A dialectic works on a materialist and/or experiential basis and provides a clash between cultural-historical forces that surround a text and the text itself. Lopez orchestrates this clash by holding on to traditional symbols of the Virgin as underpinning of the culture, while simultaneously challenging the traditional configurations of those underpinnings. She presents us with representations of some of the material realities of women's lives—work, recreation, family, and sexuality, for example—that clash with the passivity and virginity of standard Virgin of Guadalupe images. The cultural-historical forces that surround the paintings clash with the visions Lopez presents. Lopez presents us with images closer to the material realities of living women such as Victoria Franco, Margaret Stewart, and herself. The tripartite presentation of the Virgin of Guadalupe as Franco, Stewart, and Lopez is also important in our exploration of the dialectical nature of the series, for there is no one truth of the female role or experience. The roles and identities of women are in flux and constantly changing. Finally, remembering that a formal element of dialectics is the "paradoxical impulse toward revolutionary deconstruction and towards the production of meaning" (R. Saldivar, 1990, p. 7), I point you again to her summons before the society of Guadalupeños. This paradox is also classical to feminism—Lopez does not throw out the icon of Guadalupe, but rather works to make her meaningful to contemporary women, offering a different model, one of growth.

Yolanda Lopez and many other Chicana artists are participating in this narrative about the material lives of women, helping to reconstruct Mexican-American culture through the imaginary. They are involved in a political project, trying to create

change. I mentioned earlier that the Spanish invaders of Mexico used imagery as well as words to construct the idea of indigenous peoples as living in nature, waiting to be civilized by European culture, and Christianity (Zamudio-Taylor, 1992, p. 15), and also the importance of artists such as Rivera and Siqueiros after the Mexican Revolution of 1910 in helping to create social change. These images are important sources of communication and potential change.

## Educational Implications

Over the years, a number of art educators have called for understanding artifacts in an expanded context of culture. These range from recent work by Freedman (1994) and Wasson, Stuhr, and Petrovich-Mwaniki (1990) to earlier work by Lanier, Marantz, McFee and Degge, and Chalmers. The point that flows from my discussion of narrative and dialectics cannot be understood without the foundation of the work of these art educators. Indeed, some of these scholars might agree that some art can be understood as a cultural narrative.

In discussing and coming to understand the art of culturally distinct ("minority") and counter-mainstream culture groups, it is productive to account for the critical and oppositional stance many artists take towards mainstream culture as well as intra-culturally. Werner Sollors suggests that "to look at American culture anew" we should focus on themes of *consent* and *dissent* as terms that help us "to approach and question the whole maze of American ethnicity and culture" (1986, p. 6). And importantly, and unlike some directions in postmodern scholarship that give us a new way of seeing the same canonical texts and studying issues that pertain to the same ruling and wealthy classes, we must include study of the working classes, women, people of different ethnic, racial, and religious backgrounds, people of different ages and different sexual preferences and the cultural artifacts they produce. This, concludes Sollors, "can tell us much about the creation of an American culture out of diverse pre-American pasts" (p. 6). Additionally, and again unlike some postmodern scholarship that deconstructs without reconstructing, we are presented with positive alternatives. The dissent should not be seen as a mere wish to tear down; the growth and realization implied by dialectics are important to appreciating social movements for change.

In identifying an aesthetics of resistance and growth in art by Chicano/as and other ethnic groups as well as some Euro-American political artists, we have an important tool with which to explore some cultural artifacts. Although the concept of a dialectic may be complex for many learners, the principles of studying conflicting realities within or between cultures; the clash between material and historical bases surrounding a text with those in the text; and the paradox of deconstruction and the production of meaning can be employed in the study of cultural artifacts. Through such study, students are exposed to the importance of art within culture; that art is not a frill, but an integral part of culture and cultural change.

# References

*CARA: Chicano art—Resistance and affirmation, 1965-1985.* (1990). Los Angeles: Wight Gallery, University of California, Los Angeles.

Freedman, K. (1994). Guest editorial. About this issues: The social reconstruction of art education. *Studies in Art Education, 35*(3), 131-134.

Garber, E. (1995). Teaching art in the context of culture: A study in the borderlands. *Studies in Art Education, 36*(4).

Hagaman, S. (1990). Feminist inquiry in art history, art criticism, and aesthetics: An overview for art education. *Studies in Art Education, 32* (1), 27-35.

Harlow, B. (1987). *Resistance literature.* New York & London: Methuen.

Jameson, F. (1981). *The political unconscious: Narrative as a socially symbolic act.* Ithaca, NY: Cornell University.

Lippard, L. (1990). *Mixed blessings: Multicultural art in America.* New York: Pantheon.

Mesa-Bains, A. (1990). El mundo femenino: Chicana artists of the movement—A commentary on development and production. In *CARA: Chicano art—Resistance and affirmation, 1965-1985,* pp. 131-140. Los Angeles: Wight Gallery, University of California, Los Angeles.

Pollock, G. (1988). *Vision and difference: feminity, feminism, and histories of art* New York: Routledge.

Quintana, A. E. (1991). Ana Castillo's *The Mixquiahuala letters: The novelist asethnographer.* In H. Calderón & J. D. Saldivar (Eds.), *Criticism in the borderlands: Studies in Chicano literature, culture, and ideology,* pp. 72-83. Durham, NC: Duke University.

Saldivar, J. D. (1990). The limits of cultural studies. *American Literary History, 2*(2), 251-266.

Saldivar, J. D. (1991). Narrative, ideology, and the reconstruction of American literary history. In H. Calderón & J. D. Saldivar (Eds.), *Criticism in the borderlands: Studies in Chicano literature, culture, and ideology,* pp. 167-180. Durham, NC: Duke University.

Saldivar, R. (1990). *Chicano narrative: The dialectics of difference.* Madison, WI:University of Wisconsin Press.

Saldivar, R. (1991). Narrative, ideology, and the reconstruction of American literary history. In H. Calderón & J. D. Saldivar (Eds.), *Criticism in the borderlands: Studies in Chicano literature, culture, and ideology,* pp. 11-20. Durham, NC: Duke University.

Sollors, W. (1986). *Beyond ethnicity: Consent and dissent in American culture.* New York: Oxford University Press.

Sorrell, V. (1990). Words and images in the margin: Chicano visual art and the canon. Essay in R. J. Kubiak & E. Partch (curators), *Body/ Culture: Chicano figuration* [exh. cat.], pp. 2-5. Rohnert Park, CA: University Art Gallery, Sonoma State University.

Terzian, J., & Cramer, K. (1978). *Mighty hard road: The story of Cesar Chavez.* Garden City, NY: Doubleday.

Wasson, R., Stuhr, P., & Petrovich-Mwaniki, L. (1990). Teaching art in the multicultural classroom: Six position statements. *Studies in Art Education, 31*(4), 234-246.

Winner, I. P. (1984). Theories of narration and ethnic culture texts. In J. Pelc, T.A. Sebeok, E. Stankiewicz, and T. Winner (Eds.), *Sign, system, and function: Papers of the colloquia.* Berlin, NY & Amsterdam: Mouton Publishers.

Winner, I. P. (1989). Segmentation and reconstruction of ethnic culture texts: Narration, montage, and the interpenetration of the visual and verbal spheres. In K. Eirmacher, P. Grzybek, & G. Witte (Eds.), *Issues in Slavic literary and cultural theory*. Bochum, Germany: Universitättsverlag Dr. Norbert Brockmeyer.

Wolf, E. R. (1973). The Virgin of Guadalupe: A Mexican national symbol. In L. I. Duran & H. R. Bernard (Eds.), *Introduction to Chicano studies: A reader*, pp. 246-252. New York: Macmillan.

*Yolanda M. Lopez works: 1975-1978*. (1978). La Jolla, CA: Mandeville Center for the Arts.

Zamudio-Taylor, V. (1992). Memory, identity, and progress: Perspectives on 1992. In P. Chavez, L. Lerma, & S. Orozco (curators), *Counter colon-ialismo* [exh. cat.], pp. 12-26. San Diego, CA: Centro Cultural de la Raza, Phoenix, AZ: MARS, MovimientoArtistico del Rio Salado, & Austin, TX: MEXIC-ARTE.

# POSTMODERNISM IN ARCHITECTURE: TOWARD AN ECOLOGICAL PHILOSOPHY

## Robert Bersson

One major value associated with postmodern architecture is alternately referred to as the "ecological" or "contextual"; the emphasis is on buildings that relate sensitively to their natural or built surroundings. Frank Lloyd Wright's famous "Falling Water," a modernist house built around a small waterfall, certainly made the case for architecture that was well integrated with its natural surroundings. Postmodernism builds on this legacy, extending it, as modernism did not, to the built environment. Postmodernists consciously seek to relate a building to its neighbors; this in contrast to most modern buildings, such as those of Mies van der Rohe, Le Corbusier, and Wright himself, which reflect little or no concession to the built environment around them.

An analogy for this difference in approach is the difference in behavior of two groups of Western persons arriving in an Asian or African country. The "postmodern" group of persons begins to learn the language and customs of the host culture, retaining their identity but respecting and seeking dialogue with the larger culture. By contrast, the "modern" group takes the attitude that their modern Euro-American "international style" way is best, that there is little to be gained from interchange with the provincial foreigners around them. They will thus speak only their language, dress and act the way they like, even if they thus defy the country's centuries' old customs. From the respectful perspective of cultural pluralism, the second approach represents a prideful ethnocentrism and isolating individualism that has led to disharmony between cultures as well as buildings.

Contextually sensitive postmodern architects, much as Western visitors who attune themselves to the language and respect the ways of the host culture, seek to design buildings in ecological harmony with their environs, accepting that the buildings are an interdependent part of a larger whole, and not islands unto themselves. For this reason, ecologically oriented postmodern structures, although clearly creations of

advanced industrial society, also represent an attempt to relate to their neighboring buildings and the larger neighborhood. This tie might be achieved through their scale, materials, shapes, symbolism, or historical styling. They do not stand out individualistically, heroic "fragments" out of synch with their surroundings. Cooperation and harmony, not competition and defiance, are their way. Their humble goals are communion and "completion," not revolutionary modernist upheaval. Such an ecological attitude is summed up by the postmodern theorist and designer, Leon Krier. "Cities and landscapes," he observes, "are the tangible realisation of our material and spiritual worth, for good or for ill." Krier (Bofil & Krier, 1985) puts it this way:

> Each image we draw, each structure we build is an integral statement on how we want or don't want the entire world to be. We either work on its construction or on its destruction. We complete or we fragment it. The first rule of ecology is that we cannot do one thing alone. (p.15)

Displays of ecological and nonecological attitudes toward architecture and environmental design are everywhere, but, for our purposes, a single block in a small city in western Virginia will do. Built in 1985, Harrisonburg's Baptist Student Center (Figure 1) is an exemplar of the postmodern orientation at its ecological best, seeking as it does a harmonious relationship with the older buildings adjacent to it. Its clean lines and clear-cut, unadorned geometry, combined with its use of advanced building techniques and materials, communicate its origins in the late 20th century, yet its

Figure 1—Rawlings and Wilson, Baptist Student Center, Harrisonburg, VA, 1985.

overall scale, shape, color, and composition show a respect for its neighbors and their turn-of-the-century appearance. "We wanted to be good neighbors," confirms the Center's director, "and we wanted the building to communicate that fact."

In utter contrast, a three-story rental apartment building at the other end of the block shows the most disturbing disregard for its surroundings. A prefabricated structure put up virtually overnight, the Duke Garden Apartments (figure 2) was erected at almost the same time but with far less concern for aesthetics or ecological ethics. In no way an example of good architecture in the modern style, it nonetheless points out several shortcomings of the modernist attitude. First, the emphasis in the Duke Garden Apartments is on functionality, that core principle of modernist architecture, yet here the modernist dictum of "form follows function" is taken to its negative extreme. Functionally, the apartments provide effective short-term rental space for university students as well as substantial profits for its owner. One could therefore claim that the building successfully fulfils its primary functions. (A close look, however, reveals that the structure is shoddily constructed, and its life as a rental property is probably limited to a few decades).

By paying excessive attention to short-term profit, the builders of the Duke Garden Apartment House have disregarded both art and ecology. From an artistic standpoint, it is "non-architecture," a building with few redeeming aesthetic qualities. From an ecological perspective, it is an individualistic fragment that sticks out like a sore thumb

Figure 2—Duke Garden Apartments, Harrisonburg, VA, 1985.

in relation to the carefully crafted beauty of its longstanding neighbors. The apart-
ment house relates to its neighbors only in that it is of similar height and width, which
were mandated by zoning requirements. One gets the feeling that if there were no
such laws in place, the developer might eagerly have pushed his building several more
stories skyward. This is a short-sighted, crassly commercial approach to architecture
and community design that pushes to a negative extreme the modernist values of
functionality, individuality, and defiance of the past. Self-referential and narcissistic, it
is the opposite of the ecological approach necessary for the physical survival and spiri-
tual health of our planet.

But there is more to postmodernism than its ecological orientation. What observers
often note first about such architecture is its eclectic historical character. In postmod-
ern buildings, the forms and symbolism of past styles of architectural and community
design are welcome. We see columns and pediments, proportions and compositions
that derive from earlier decades or centuries, all redolent with memory and meaning
that communicate to us in a familiar language. Looking toward a superior future,
modernism cast off the past and its language and values. Postmodernism accepts the
past and the imperfect present, and agrees to work with it.

As the architect Robert A. M. Stern (Werhane, 1984) writes:

Modernism in architecture was premised on a dialectic between things as they
are and things as they ought to be; postmodernism seeks a resolution between—
or at least a recognition of—things as they were and as they are. Modernism
imagined architecture to be the product of purely rational and scientific process;
post-modernism sees it as a resolution of social and technological processes with
cultural concerns.

Postmodernism seeks to regain the public role that modernism denied architec-
ture. The post-modern struggle is the struggle for cultural coherence, a coher-
ence that is not falsely monolithic, as was attempted in the International Style in
architecture or National Socialism [nazism] in the politics of the 1920s and
1930s, but one whose coherence is based on the heterogeneous substance and
nature of modern society: postmodernism takes as its basis things as they are,
and things as they were. Architecture is no longer an image of the world as
architects wish it to be or as it will be, but as it is. (p. 123)

Another building in the small city of Harrisonburg, Virginia, might be noted as an
example of the postmodern valuation of the present and past, its respect for cultural
heterogeneity, and its related ecological/contextual concerns. Together with the
Baptist Student Center the award-winning Campus Center of Eastern Mennonite
University (figure 3) is the finest example of postmodern architecture in this city of
30,000. The Campus Center fulfills all of Stern's and Krier's criteria. It relates well to

Figure 3—LeRoy Troyer and Associates, Campus Center, Eastern Mennonite University, Harrisonburg, VA, 1985.

its architectural context, the older styles of the adjacent red brick chapel and campus buildings. It achieves a successful resolution, as Stern emphasized, between things as they were and as they are. Its shapes or materials evoke memories and meanings from the past: of an earlier administration building destroyed by fire; of the nearby chapel and Mennonite country churches in general. At the same time, the campus center expresses the technological capabilities and geometric forms of the late 20th century. As a harmonious blending of the traditional and the contemporary, the subjective vision of the architect with the collective vision of the community, the Eastern Mennonite University Campus Center represents a satisfying postmodernist synthesis between progress and permanence, and between the individual and the group.

Perhaps a major shift is taking place in our society, one more firmly grounded in multiculturalism and the honoring of past traditions and characterized by an impulse to harmonize the public with the private. We hear that "small is beautiful," that we now live in a "post-industrial" society, and that, if we are to survive, as individuals and nations, "the me generation" must be replaced by the "we generation." In such a post-modern world, the role of the architect would naturally change. Robert Stern (Werhane, 1984) puts it this way:

The fundamental shift to postmodernism has to do with the reawakening of artists in every field to the public responsibilities of art. Once again art is being

regarded as an act of communication as opposed to one of production or revela-
tion (of the artist's ego and/or of his intentions for the building or his process of
design)...To the extent that contemporary artists care about the public life of
art, they are post-modernists. (pp. 122-123)

Whether we are currently in the process of creating a postmodern art and society
remains to be seen. Whatever happens, architecture, that most social of the arts, will
invariably reflect our deepest cultural values and help to shape our lives in the years to
come.

# References

Bofil, R., & Krier, L. (1985). *Architecture, urbanism, and history.* New York: The Museum of Modern Art.

Werhane, P. (1984). *Philosophical issues in art.* Englewood Cliffs, NJ: Prentice-Hall.

# MODERN AND POSTMODERN: QUESTIONING CONTEMPORARY PEDAGOGY IN THE VISUAL ARTS

R. L. Jones, Jr.

As we have seen throughout this anthology, *modernism*, a term that we have all grown accustomed to and, no doubt, have considered to be appropriate and putative forever may now be dangerously close to if not completely a shelved notion of the past. It appears that we now are or are becoming postmodern. The difference between modern and postmodern, however, is far more apparent within the galleries and art journals and in the conversations of artists than it is within the postsecondary classrooms and studios where there is an ostensible effort to educate, train, and prepare future artists and/or teachers of art. The world of art has and is changing but there remains, within academe, an insensitivity, an ignorance, or, worse yet, a refusal to let our instruction be sufficiently informed by the practice of the professional world beyond our studio walls.

In order to understand both the nature of this transformation toward the postmodern and its implications for what we professionally profess, I first shall briefly review modernism and its conventional instructional practice. Subsequent to that discussion, I shall explore the meaning and notions of postmodernism and conclude with the theoretical framework within which contemporary visual arts instruction might be shaped.

## Modernism

### History

The most commonly accepted date for the beginning of modernism is 1863, with the first showing of the painter Manet's *Dejeuner sur l'herbe* at the Salon des Refuses. Arnason, however, suggests 1855 and the artist Courbet's exhibition of the painting,

The Painter's Studio, or 1824 and Constable's Salon presentation of direct studies from nature, or even David's *Oath of the Horatii* in 1784. In any event the move into modernism is considered as a "gradual metamorphosis" spanning as much as 100 years (Arnason, 1975, p. 13). Put simply, modernity is the result of "shifts in patterns of patronage, in the role of the French Academy, in the system of art instruction, in the artist's position in society and, especially, in the artist's attitude toward artistic means and issues—toward subject matter, expression, the literary content, toward color, drawing, and the problem of the nature and purpose of a work of art" (Arnason, p. 13).

What seems to be at the very heart and soul of modernism is its internalization, its insistence upon being what Donald Kuspit calls "introspective" (1988, p. 82). In other words, modern art has a preoccupation with form. For art to be modern it must attend to itself, it must search for and confirm its own boundaries as delineated by its own inwardness. What explains a work of art, what informs a work of art, and what frames a work of art for judgment is its own canons, its own parameters of form and medium. Put simply, modern art is about itself, about its own form, and in its most extreme and idealistic sense about nothing else but form!

The condition of modernism has been described as one where "the artist becomes an expert (like the scientist) in an autonomous realm decentered from the larger cultural stream and split off from the realities and responsibilities of everyday communication" (Risatti, 1990, p. 9). In other words, modern artists can be thought of as isolated, as alone, and making art that is about itself and that does not care about anything else! It is precisely this internalization of the art that has led to modernism being characterized as "decentered." One contemporary critic wrote that "all in all, it (modern art) seemed to have as little to do with life in the street outside as the work of any other academic art" (Godfrey, 1986, p. 9). Thus, this negative condition of formalism and modernism, "decenteredness," leads the artist to an unknowingly separatist, isolationist stance where Rome could continue burning with neither the artist's knowledge or concern. After all, what does modern art have to do with life?

What is interesting here is that a philosophical definition of modern art, i.e., formalism, transformed art into a non-contextual, decentered human activity and this may have provided an appropriate and necessary impersonalism to art. The art critic Kuspit, for example, suggests that formalism may unconsciously be "an attempt to protect art from political, psychological, or cultural interpretations for such interpretations make art vulnerable to the kind of censorship represented by the Nazis" (1988, p. 96) and it might be noted that we have recently witnessed the obvious political consequence of Senator Jesse Helms, who negatively responded to "less-than-impersonal" Mapplethorpe photographic images as "immoral" and not worthy of government support.

Modernism, then, for all of its stylistic variations and "isms," nonetheless, is molded by a simple preoccupation with internalization. Above all else it is the intent of modernism to concern itself with the essence of the artistic act, the character of its medium, and the visual ambience of the encounter. Modern artists are not concerned with their art having a message or a point to it; rather, modern artists want their art work to look good, to cause visual pleasure. For well over a century now we have grown accustomed to exercises in color, line, space, and edge as being not only legitimate but profoundly and aesthetically essential adventures for artists and viewers alike. Modernists have come to accept isolation and a subsequent "impersonalness" as corequisites for both the making of as well as the experiencing of art.

## Educating the Modernist

It certainly goes without saying that virtually everyone holding undergraduate as well as advanced degrees in the visual arts has a full and first-hand understanding of the nature of visual arts education in postsecondary settings. Not only do we know our own collegiate art education experiences but I feel comfortable in holding the suspicion that we also know the nature of visual arts education for the previous generation. If any group has so rigorously proved the adage that we teach as we have been taught it is the professorate of art. We have assimilated modernism through our own education and we have perpetuated it through the courses we have taught. We, as teachers, are bound together by our belief in modernism, our comfort in modeled pedagogical behavior, and our resistance to or lack of awareness of a transforming world of art.

No studio is more of a microcosm of visual arts education than the course(s) commonly known as Foundations of Design, Fundamentals of Design, or Two-and Three-Dimensional Design. These courses, regardless of their titles, can serve here to illustrate the true nature of the educational process as it is orchestrated specifically for the preparation of artists and/or teachers of art. A quick overview of some of the major texts designed to accompany these courses will demonstrate both the suggested organization of the course and also the basic character of the material. Although the specific terms and sequencing differs, the vast majority of texts focus only upon the plastic elements and compositional principles.

Interestingly, but not surprisingly, the content of these texts and presumably the courses themselves, is only dated by the types of materials utilized and the quality of the printed illustrations. Nowhere is there a relationship between the exercises in the text and what is happening within our world. In fact, we would be shocked to discover references to our social, economic, political, and/or historical world for such would be quite outside the realm of concern and purpose of either the foundations studio or its accompanying text. As Risatti has put it, "form and formal elements in art were ele-

vated to the position of universals that transcended any historical, cultural, or ethnic considerations" (1990, pp. 9-10).

# Postmodernism

## History

With the '80s there came a very felt and dramatic change in both the visual and also philosophical nature of art. Anyone either visiting New York City's art district, SoHo, on a regular basis or seriously reviewing the major art journals, has noticed that since the early '80s a notable transformation has been occurring. Simply, contemporary art has become surprisingly representational, clearly narrative and content driven, figure dominated, and, most importantly, irreverent to what the twentieth century has held to be of formalistic importance. To some, this new contemporary art has become "ugly," it has demonstrated an adolescent-like rebelliousness to what we know to be and have grown to accept as "modern." Some even call it nihilistic.

From an art-historical perspective these changes might accurately be explained as both reactions to some of the art styles of the '60s and '70s as well as a reflection of the ongoing and dramatic political-social transformation of our world. For many, contemporary art within the modern, formal mode had become "Tinder dry from more than a decade of the ever more reductive purity..." of some styles (Hicks, 1990, p. 229). Some see this new art as a reaction to modernism, in other words, anti-modern. Echoing this attitude, one writer stated, "...artists of the 1960s reached ground zero—creating forms stripped down almost to invisibility—and the historical pendulum was set in motion. Modernism's unyielding optimism and idealism gave way to the broader, albeit darker, emotional range of postmodernism" (Atkins, 1990, pp. 131-132).

Beginning with the "New Image" show at the Whitney Museum in New York City in 1979, it has become increasingly more apparent that postmodernism is more than just a pendulum swing, more than a reaction to the cold, conceptual, and reductive nature of the modern, formal art of the '60s and the '70s. Rather, what we were and are experiencing is a new and different art. An art that, quite unlike modernism, is "combining and reconciling what heretofore had been antagonistic aesthetic directions: abstraction and representational imagery" (Smagula, 1989, p. 84). Postmodern art is a reaction to a century of modernism which distroyed itself (Kuspit, 1990, p. 115). In other words, modern art and the formalist way has destroyed itself...Modern art is dead and a new and different art has been given birth!

Equally obvious to the question of postmodernism's rise is the political-social and even economic context within which the '80s found and now the '90s find themselves. From China to the Russian republic the hermetic character of our world, like the

autonomy of modern art, has been disrupted, challenged, and perhaps even permanently transformed into new political, social, and economic orders that no longer can disregard history and context. As a world we have not become at odds with what was but we are, and I suspect we will always be, quite different as a result of all that is happening. The parallel we have witnessed in the beginnings of postmodernism cannot be coincidental. The urgency for meaning in our times, the necessity for context, the desperation heard in the global voice are all too apparent in the postmodern artwork for one to explain away this new art as simply "a reaction to the self-indulgent modernist art styles of the '60s and the '70s. This new art called *postmodern* is a part of a new world order through which we are all being refashioned.

Though not diametrically opposed to modernism, this new art of "compromise" and "reconciliation" is observably and philosophically quite different. What seems to be at the very heart and soul of postmodernism is its externalization, its inescapable effort to break free from its formal self and, like German Expressionism, manifest its proclivity to recognize and examine the world. Unlike German Expressionism, however, and for that matter unlike other styles that externalize themselves, postmodernism is quite comfortable with taking imagery from other sources—in other words, appropriating imagery, artistic as well as non-artistic, and incorporating it, juxtaposing it, and transforming it in such a manner as to call into question the meaning of history and "to reveal the underlying mechanism of social reality in order to change it" (Kuspit, 1988, p. 408). Laced with sufficient ambiguity so as not to be rhetorically banal, this art, unlike modernism, relegates form to the vehicle through which meaning, revelation, and visual discourse occur. Remember that modern art is done in isolation, it is about itself, and all that is important is its form. Postmodern, however, is done within our world and life context, it is about all of us, and all that is important to all of us.

The referential emphasis of postmodern work becomes inescapably apparent when one reviews the critiques and interpretations offered for such a work. Take for example, one writer's (Schor, 1990) major essay on the work of postmodernist artist Ida Applebroog. The article, also quoting two other art critics (Miller-Keller, 1987; Tannenbaum, 1986), combines the three individual critical insights and thus provides an excellent example of the non-anonymous attitude of postmodernism:

> Applebroog's subject matter is generally described in detail and her emotional message editorialized: "Ida Applebroog's work embraces a full range of man's follies, often with compassion and wit and sometimes with reproach and anger...She has a facility for animating some of the major issues of our time: alienation, disenfranchisement, violence, racism, ageism and feminism." It is commonplace and truthful to say "that she makes us see the undercurrent of cruelty and violence that lies beneath characters and situations, which on the surface may appear normal and benign." The indecipherability of a complete

narrative within the paintings is noted, but poststructuralist analysis does not follow, even though such discourse is the lingua franca of postmodern art writing. (Schor, p. 116)

And if it is necessary to provide additional illustrations, consider the description of a collaborative installation at the New Museum of Contemporary Art, a SoHo museum dedicated to postmodern art:

> *Eat Me/Drink Me/Love Me*, 1989, examined the pleasures of female sexuality through nonconventional imagery. In their arrangement of both intellectual and emotional data, the artists suggested the structure and passion of women in love, of lesbian communities, and of the feelings of being "other" within the norms and mores of a dominant culture. The generative idea for the piece was a 19th century poem by Christina Rossetti entitled "Goblin Market." It is a tempestuous story of temptation, guilt, and redemption through affection, as well as a labyrinthian passage through religious inspiration and homoerotic passion. (Phillips, 1990, p. 160)

There is an undeniable shift of attention in what we, for so many decades, have found to be comfortable. Within the postmodern posture, form appears to be incidental to the substance of art and, as one critic has argued that "only as a sign of something more than itself does [art] become itself fully" (Kuspit, 1988, p. 481).

Just as decenteredness was and is a consequent condition of modernism's internalized focus, centeredness is the essential predisposition of postmodernism. It goes without saying that an art that externalizes itself, therefore, would obligate a sense of membership in the "larger cultural stream." It is more than social consciousness, however; it is a membership with accompanying responsibility and expectations that obligates one to communicate within the context of our reality as defined by our everyday life. What distinguishes postmodernism from those saccharine-lensed social styles is the postmodernist's disillusionment with history and context. More than anything else, postmodernism "is concerned with the problem of the relationship between meaning and matter; and with the related question of how we are to live in a seemingly dislocated and secularized world" (Godfrey, 1986, p. 156). Postmodernism, then, displays a cynical, perhaps nihilistic, acceptance of the fact that it and we are a part of a larger sordid history than simply its own.

Writing from an obviously anti-postmodernist, i.e., pro-structuralist, pro-formalist literary posture, another critic (Shaw, 1990, p. 81) labeled as "notorious" the notion of deconstructionist Paul deMan that history is not actual but rather only what people decide to make it (1971). No better point-counterpoint can illustrate the postmodern interest in interpreting through a less-than-disinterested posture the socio-political-historical context of our "cultural stream." What sets apart the postmodern history is a

"loss of faith in technological progress" (Atkins, 1990, p. 131), an implication "that things have been used up, that we are at the end of the line in terms of the creation of images, and that we are all prisoners of what we see" (Grundberg & Gauss, 1987, p. 207). Needless to say, postmodern centering, therefore, is marked by an unquestionable cynicism, fatalism, pessimism, hopelessness, and despair.

Modernism assumed a certain objectification, a distancing of the artist as person from the art object. The postmodern, however, has not continued this impersonal condition for either the making of art or for the viewing it. This new style is one that "fulfilled a deep need for an expressive art that gave full rein to subjectivity" (Godfrey, 1986, p. 10). Illustrative of this new reverence for the self is the description of one artist's work as "...self-reflexive critiques of modernist codes, but are self-reflective investigations that have to do with how people can see themselves" (Yau, 1990, pp. 162-163).

For postmodernists, however, "seeing themselves" is less a purely inward, narcissistic self-examination than it is a response to the contextual self, the self as it exists within and apart from the socio-political world in which we live. Although specifically describing the work of the artist Baselitz, one critic's comments are quite appropriate generalizations concerning postmodernism: Baselitz's work gives us not the "ahistorical self, but the desperate posthistorical self that really no longer has any use for art as a way of repositing the questions of the world, but only as an offensive way of restating the offensive primitive self" (Kuspit, 1988, p. 119).

Postmodernism, then, with its center in a world of cynicism, hopelessness, and despair gives way to what has been called an "artistic attitude of howling and crudeness" (Adorno, 1984, p. 327). And paralleling the post-structural literary climate, postmodernism can be seen to be an act of unmasking, of "deconstructing" our psychic, social, and political world. This "deconstructive impulse has liberated the mystic self so as to free the artist and the viewer of art to explore, to interpret, and to address the pervasive nature of our collective condition" (Owens, 1990, p. 201).

## Educating the Postmodernist

Howard Gardner of Harvard's Project Zero has offered a framework for understanding creativity (1988). That model can serve as an effective lens through which not only to examine but also to diagnose the current relationship between a world of the 1990s, and art of the 1990s, and the pedagogical practice within the collegiate art studio of the 1990s. Taking the liberty to adapt his model to the broader issue addressed here results in a perspective that can clarify what I would consider to be a current condition of disturbing incongruity between pedagogical art practice and the socio-political-economic and art world in which and from which such practice occurs. Gardner suggests that the individual (in this case, the art student) addresses the field

(i.e., the social "context") which then refashions the "domain" (i.e., "the structure of an area of knowledge or human accomplishment" which, in this case, is the world of art) which then instructs the artist who then addresses the social context that shapes the world of art that, in turn, informs the art student, etc. (pp. 300-304). It is clear that there is (or rather, should be) an interactive, interdependent relationship between the character of our world, the nature of art, and what happens in an art studio that is concerned with preparing individuals for that interactive and interdependent condition.

If we briefly examine the social context within which we live—say the past five years—terms like *upheaval, transformed, dramatic,* and *global* certainly can be accepted as descriptors of the social climate of our world. For both ourselves and our students, this climate of change, of new world orders, of new hopes and despairs, constantly envelops us through both the electronic and print media. Students in Foundations or Fundamentals of Design, for example, cannot help but be conscious of this new and volatile world environment as they enter and work within the classroom studio.

If also we briefly examine the art domain of which I trust we all are at least peripherally a part—say for the past five years—terms like *transformed, centered, externalized,* and *personal* are certainly appropriate. If we examine the major journals of the art domain we find confirmation of the interactive, refashioning relationships between the social context within which contemporary art exists and contemporary art itself. Take, for example, some of the recent topics addressed in *Artforum:* Carol Squiers writes on the delusionary nature of the Bush presidency (1990, #6); Hoberman on the Berlin Wall and American Materialism (1990); Shottenkirk debases the Chinese government's negation of the "moral yearnings" of its Tiananmen youth (1990); Giusti examines, in part, the manipulation of television by revolutionaries such as Saddam Hussein (1990); a professor of justice studies writes on David Duke and the KKK (Goldberg, 1991); and Smith relates the art of Czechoslovakia with the social context of the 1990 revolution (1991). This is a new type of content for *Artforum* in particular, and contemporary art in general. Twenty years ago the formally entrenched art world would have been both shocked and insulted to encounter articles that were so centered, so external in their focus. How appropriate to the verbiage of the world of art now (and how inappropriate to the verbiage of the art world of the '60s) is Carol Squiers's *Artforum* statement, "there's nothing the majority of Americans seem to like better than to subdue some little nation inhabited by people of color and bring it to its knees in the name of democracy" (1990, #8, p. 21). Our postmodern art domain appears to be consistent with what Gardner suggests is the interactive nature of the field and domain.

If, however, we briefly examine the general nature of our curriculum, our pedagogical strategies, and the finished "projects" of the course we consider to be fundamental to the preparation of artists and teachers of art, i.e., Foundations or Two-and Three-

Dimensional Design, there are some surprising (or perhaps, not so surprising) discoveries. I would challenge the reader to test the following general suppositions concerning such courses against the specific character of the foundation course(s) at the reader's own institution. I would be surprised to discover a syllabus that exhibited a major focus upon artistic content and meaning, upon knowledge of current and recent events in our world, upon personal and emotional metaphorical reactions to situations and ideas, or upon grading systems that acknowledged the importance of such things as the narrative, appropriations, or personal myth. What we all know to be generally true about such courses is that they are extremely insular. Not only do they display a patently callous disregard for these defining moments in our current global history but they also stand equally separated from and insensitive to the art domain, the contemporary world of art.

Assuming both the tenability of Gardner's model and the acceptability of the suppositions mentioned above, there is real cause for alarm. The content of basic, foundational studio art courses is being informed by tradition rather than the discipline of art and such is not only an unacceptable practice but also an irresponsible and dishonest posture. The self-indulgent luxury of narcissistic modernism does not appear to be an option for the 1990s. The transformations of our world (of which postmodern art is a part) are demanding that we abandon the incestuous infatuation with modernism and assume the responsible pedagogical role of an informed instructor of art or art education. No less can be accepted if we intend to wear with pride the mantle of our profession.

## Recommendations

Suspecting that current pedagogical practice cannot and will not accommodate the needs of a postmodern education, the following four major suggestions are offered in order to initiate debate that focuses upon the process of effectively educating future artists and teachers of art.

1.) There must be an ambitious, energetic, and proactive effort to educate those who teach. The cycle of teaching the way we were taught must be broken and the satisfaction of instructors with the cannons of modernism must be interrupted and challenged. There is an alarming silence concerning postmodernism in the art education journals; only cursory attention is evident in the major journals that inform art teachers and art education professors( see, for example, Garber, 1990; Anderson, 1991). The Getty Center must also assume a proactive role in underscoring the urgency of becoming sensitive to and conversant about the primary forces within contemporary art. Studio texts must effectively be lobbied to revise their content in order to reflect the postmodern spirit of the art domain. And notwithstanding the reality of "schisms" that separate art and art education instruction, national, state, and regional organizations, agencies, and institutions must immediately develop and initiate marketing

strategies that will result in a dialogue among all of the professorate of art and art education.

2.) There must be a balanced holistic approach to the educational process of preparing artists and teachers of art. No longer can it be acceptable practice to focus narrowly, perhaps exclusively, upon outdated, minor, or randomly selected aesthetic ideas. The art and art education professorate must give students formal as well as instrumental experiences, affective as well as cerebral opportunities. In its implicit terms, art is the interaction of humans (defined by their balance of affective-conceptual propensity) with media (defined by their internal and external character). This condition of art, addressed more specifically elsewhere (Jones, 1979), can guide curriculum so as to prepare artists and art educators for the competing demands of formalism and postmodernism, of cerebral and expressivist pressures and drives. If our intent is to lift future artists and art educators to their highest levels of potential and ability, we must be attentive to the message contained in the following postmodern observation:

> While many artists appear to address major political and societal issues within their work, the roster of those who can manage to fluttering balance of social agenda and formal strategies remains quite small. Equilibrium is difficult to achieve: one objective usually rises to the diminishment of another. (Phillips, 1990, pp. 173)

Our task is not to make artists and teachers of our students but rather to equip them to fully and individually become artists and teachers. This charge, I would suggest, challenges the professorate to embrace the contemporary world within which a contemporary art resides. This charge mandates an informed pedagogy that is willing to design curriculum based upon the need to balance extreme and competing pressures within the art domain.

3.) Given a redefinition of art and artist, we must initiate efforts to dramatically redesign the art and art education major. If both the world and the domain of art have changed, then it only follows that the configuration of courses and experiences designed to prepare people for that world and that domain must also change. In order to educate within the context of an externalized, decentered art domain it may be, and probably is, essential that the BFA be abandoned. It is no coincidence that there is a national move to both increase the liberal arts offerings and also to underscore their importance to the college age population. The social context within which colleges as well as art domains exist is obviously characterized by a postmodern attitude that minimizes the importance of specific knowledge, art or otherwise, at the expense of broader understandings of culture and civilization. It is further suggested that, as courses in media and design are reduced, increased attention must be given to providing greater opportunities in art history, especially non-linear approaches (see, for example, Crow, 1990). And finally the restructuring of the major may necessitate the removal of the

most formal, the most modern, the least external and least decentered of the visual arts, graphic design. Notwithstanding the enrollment productivity of such an area, it can no longer be the role of collegiate education to ignore both the social context and the art domain that shape and inform its purpose and practice.

4.) Curriculum change must force wholesale modifications to the formalist content of art and art education courses. Courses, particularly studio courses that focus upon art production, must abandon the quasi-Bauhaus approach where the student-artist is solely absorbed in the interactive nature of materials and form. It is quite clear that the 1990s are funded by a full decade in which content, meaning, and narrative are more substantive concerns of the art world. The modernist's insistence upon the integrity of materials, the importance of novelty, and the centeredness of compositions must quickly be caused to cease dominating the collegiate studio. Criticism, that other activity so basic to the studio and art education classroom, must also change. If the world of art, in any way, informs our profession it is clear that the rational, formalist, and cold objectivity of modern criticism be tempered by a new appreciation and acceptance of the personal myth, the subjective, deconstructive tendencies of a post-modern era. In many ways the new criticism, as Kuspit (1981) so insightfully contends, causes the critic to actually be the artist. The studio, then, in terms of both its production and talk, must immediately respond to the call of another voice.

## Conclusion

For the rhetorical as well as for the arousal effect the four recommendations above have been couched in an atmosphere of polemics and hyperbolic urgency. The truth of the matter is that this does appear to be a period of bridging, a time of change, and, perhaps, a defining decade. As Thomas McEvilley of Rice has put it, Western civilization is "somewhat inchoately seeking a new definition of history that will not involve ideas of hierarchy, or of mainstream and periphery, and a new, global sense of civilization to replace the linear Eurocentric model that lay at the heart of modernism" (1990, p. 20). If we listen to the critic, here too we sense inconclusiveness. Lucy Lippard asks, "does this mean the '90s will forego the '80s sturm und drang" (1990) as she reviews the predominately formal, modern work of finalists in the 1990 Awards in the Visual Arts project of the Southeastern Center for Contemporary Art. And if we examine the economics of art, we discover again, some expressed hesitation in subscribing wholeheartedly to a notion that we are no longer "modern." *Art and Auction*, for example, has noted that "critical praise for at least some of the neo-expressionists has certainly waned in recent years" (Hicks, 1990, p. 229).

## References

Anderson, T. (1991). The content of art criticism. *Art Education, 44*(1), 17-24.

Adorno, T. (1984). *Aesthetic theory.* London: Routledge and Kegan Paul.

Arnason, H. H. (1975). *History of modern art.* New York: Harry N. Abrams.

Atkins, R. (1990). *Art spark: A guide to contemporary ideas, movements, and buzzwords.* New York: Abbeville Press.

Crow, T. (1990). Art history as tertiary text. *Art in America, 78*(4), 43-45.

deMan, P. (1971). *Blindness and insight.* New York: Oxford University Press.

Garber, E. (1990). Implications of feminist art criticism for art education. *Studies in Art Education, 32*(1), 17-26.

Gardner, H. (1988). Creative lives and creative works: A synthetic scientific approach. In R. Sternberg (Ed.). (1988). *The nature of creativity.* New York: Cambridge University Press.

Giusti, M. (1990). Ad lib. *Artforum, 1990, 29*(3), 147-151.

Godfrey, T. (1986). *The new image: Painting in the 1980s.* New York: Abbeville Press.

Goldberg, D. T. (1991). Democracy, inc. *Artforum, 29*(5), 23-25.

Gookin, K. (1990). Annette Lemleux. *Artforum, 28*(8), 168.

Grundberg, A., & Gauss, K. M. (1987). *Photography and art.* Los Angeles: Los Angeles County Museum of Art.

Hicks, A. (1990). Twilight of the gods? *Art & Auction, Nov,* 226-233.

Hoberman, J. (1990). Believe it or not. *Artforum. 28*(7), 17-18.

Jones, R. L. (1979). Phenomenological balance and aesthetic response. *Journal of Aesthetic Education, 13*(1), 93-106.

Kuspit, D. B. (1981, Summer). Art, criticism, and ideology. *Art in America.*

Kuspit, D. B. (1988). *The new subjectivism: Art in the 1980s.* Ann Arbor, MI: University of Michigan Press.

Kuspit, D. B. (1990). The only immortal. *Artforum, 1990, 28*(6), 110-118.

Lippard, L. R. (1990). Waiting to see. *Awards in the Visual Arts 9* (Exhibition Catalog). Winston-Salem, NC: Southeastern Center for Contemporary Art.

Miller-Keller, A. (1987). *Matrix 96* (Exhibition Catalog). Hartford: Wadsworth Alheneum.

Owens, C. (1990). The discourse of others: Feminists and postmodernism. In H. Risatti (Ed.). *Postmodern Perspectives: Issues in Contemporary Art.* Englewood Cliffs, NJ: Prentice Hall.

Phillips, P. C. Martha Fleming and Lyne Lapointe. (1990). *Artforum, 28*(7), 160.

Phillips, P. (1990). Perry Bard. *Artforum, 28*(8), 173-174.

Risatti, H. (Ed.). (1990). *Postmodern perspectives: Issues in contemporary art.* Englewood Cliffs, NJ: Prentice Hall.

Schor, M. (1990). Medusa Redux: Ida Applebroog and the space of post-modernity. *Artforum, 28*(7), 116-122.

Shaw, P. (1990). Devastating developments are hastening the demise of deconstruction in academe. *The Chronicle of Higher Education, 37*(13), B1-B2.

Shottenkirk, D. (1990). Dara Birnbaum. *Artforum, 28*(8), 168-169.

Smagula, H. (1989). *Currents: Contemporary directions in the visual arts.* Englewood Cliffs, NJ: Prentice Hall.

Smith, V. (1991). The Czech point: Finding a third way. *Artforum, 29*(5), 82-88.

Squiers, C. (1990). Carol Squiers on the future of delusion. *Artforum, 28*(6), 19-21.

Squiers, C. (1990). Special effects. *Artforum, 28*(8), 21-23.

Tannenbaum, J. (1986). *Ida Applebroog* (Exhibition Catalog). Philadelphia: Institute of Contemporary Art, University of Pennsylvania.

Weinstein, M. A. (1990). Robert Green. *Artforum, 28*(8), 167-168.

Yau, J. (1990). Jean Feinberg. *Artforum, 28*(7), 162-163.

Yau, J. (1990). Marilyn Minter. *Artforum, 28*(8), 168.

# INQUIRY IN CRITICAL THEORY: QUESTIONS FOR ART EDUCATION

## Sally McRorie

"When are there going to be changes in how those courses are taught? We don't live in a modernist world anymore, you know." Those comments were part of a heated conversation in the hallway between one of my colleagues and a graduate student at Purdue University, where I formerly taught and served as Chair of Art and Design. The student expressed her displeasure with how many studio courses, especially foundations courses, continue to be taught from a late modernist perspective, with an emphasis on formal issues (read the elements and principles of design) and media techniques. The professor concerned burst into my office when he learned that the student was enrolled in my critical theory class and practically accused me of poisoning young minds with postmodern claptrap. When I asked him how long it had been since he had visited any contemporary exhibits in museums or galleries, or read any art magazines or journals, his anger subsided. He, like many colleagues at that university and, I suspect, across the country, was last formally educated in the late modernist heyday of 1950-1970 and continues to ground his ontological and epistemological ideas about art, including appropriate pedagogy, within the late modernist paradigm. It is no surprise that the classes he teaches and supervises are shaped by his understanding of what art is or that he might feel threatened by the kind of inquiry that goes on in my theory class (discussed below). But, as the student pointed out, we are no longer in a modernist era—that realization coupled with the troublesome notion of what postmodernity means for teaching art posits him, and the rest of us, on the horns of a plurality of dilemmas.

Because so much contemporary work in critical response to art and in artmaking itself, relies heavily upon a range of interrelated theories based on diverse theoretical and philosophical ideas, it is not enough that art students know how to make formally acceptable objects. The postmodern art world, from galleries and museums to educational institutions and their constituents, is no longer strictly a formally based phenomenon. Postmodern art deals with economic, political, and social experiences as

well as aesthetic, psychological, ethical, historical, and institutional ones. The post-modern era has brought with it an increased awareness of the roles of language and language systems, like art, in constructing, or at the very least, mediating reality.

At Purdue University, graduate students, in what are anachronistically called the fine arts (painting, printmaking, sculpture, photography/film, ceramics, fibers, met-als), are required to take a seminar investigating such issues, inquiring into the nature and structure of art, society, knowledge, and self. Many of the students who take the class are relatively inexperienced in talking about specific works of art, their own or that of others. They typically have an even greater lack of experience in discussing the underlying critical issues of the visual arts, having rarely done so in the undergraduate programs from which they come and even less frequently having had any such critical inquiry experiences in K-12 art education. In this paper I will discuss the content and methodology of that course, a version of which I now teach at Florida State University, and attempt to draw broader implications for teaching and learning in the visual arts at all levels.

## Course Content

The course is grounded in readings in criticism and aesthetics, most of which are contemporary writings about contemporary art and ideas. As might be expected, there are extensive changes in reading assignments each semester, as readings tend to become as quickly dated as do much of the art upon which they are based. The foundational experience is a thorough reading and discussion of selected work of Clement Greenberg (1988), that scion of late aesthetic modernism, and related writers, such as Michael Fried (1967) and, more generally, Jurgen Habermas (1987). This exploration is foundational for a number of reasons. First, the modernist tradition is the one in which most of the students were educated as undergraduates (and frequently in their work with graduate studio faculty now). Yet, many of these students have limited understanding of the theoretical underpinnings of aesthetic modernism and how affected they have been by its ubiquitous post-1945 spread among art schools and art programs in universities and colleges.

Second, it is impossible to reach a high level of understanding of much contempo-rary art and the varieties of critical responses to it without a strong grasp of modernist tenets—the ground against which such work is contrasted. It is simplistic, of course, to attempt to portray modernist and postmodernist art and ideas as a bipolar dichoto-my, but understanding the contrasts between them is crucial to truly understanding contemporary art at all.

Third, many of these students wish to pursue teaching as a vocation (and many are employed as teaching assistants with considerable contact with beginning students). The typical importance of exploration of both media and design constructs (elements

and principles of design) within studio courses that these students either do or might teach, is a far-reaching effect of the influence of modernist ideas about what art is and should be, and how it should be taught.

This component of the course includes investigation of the pervasive importance of the late modernist ideal of formalism, as espoused most influentially by Greenberg, with its avoidance of social and political issues and concentration upon purely formal artistic problems (what we might call a search for the autonomy of meaning in art). As Risatti (1990) has pointed out, Greenberg did not ignore the question of content, but drew a marked distinction between content, the formal qualities which every object inherently has, and subject matter, ideas reflecting ideologies which he saw as "infecting" the arts, making them less universally understandable and hence less viable and valuable. A cursory understanding of this notion led to a perceived split between form and content, which in turn led many art and design programs to focus almost entirely on studio experiences to the neglect of content-laden courses such as those in the liberal arts, and to diminish attention to subject matter in studio experiences.

The remaining course content (comprising by far the bulk of the semester) is derived from exploration of various postmodern responses to aesthetic modernism and their effects upon understanding, evaluating, and making contemporary art. These areas of critical thought include feminist aesthetics and criticism, psychoanalytic criticism, poststructuralist theory and criticism grounded in those ideas, semiotic analyses and responses to contemporary art, and what might loosely be termed ideological criticism. All of this sounds very complex and indeed it is. However, the foil of comparing all these perspectives to modernist tenets (and, inevitably to one another) helps to provide a continuity of content that allows for a certain unity.

## Pedagogy

Despite the continuity of content just claimed, I admit to an initial (and sometimes continuing) degree of confusion in deciding how to deal with that content with diverse groups of students. (Like Daniel Boone, who when asked if he had ever been lost, replied "No, but I was once bewildered for two weeks," I have searched for a solution to that problem.) The one that has emerged and has proven generally quite effective is based on ideas from a number of sources, including feminist philosophy, linguistic research into the ontological and epistemological nature of conversation, the Philosophy for Children program (Hagaman, 1990), and ideas about learning from sociocognitive theorists such as Vygotsky (1978) and Bruner (1985). The crux of this solution lies in development of what Charles S. Peirce called a "community of inquiry," a group built deliberately around and through dialogue or conversation-based inquiry. This pedagogical approach both mirrors and shapes the nature of the course content, thus denying the split between teaching methods and subject matter which seems inherent in a didactic, professor-as-lecturer model (with the latter reflect-

ing a version of the modernist form/subject matter split discussed above). The pedagogy is grounded in many postmodern tenets: most directly its collaborative nature, but also a view of reason (and reasoning) as plural and partial, of objectivity as an impossibility, and of subjectivity as multilayered and sometimes contradictory.

This kind of collaborative effort requires a good deal from instructor and students alike. Reflection and dialogue within such a classroom community of inquiry requires a reciprocity of effort; a willingness to be challenged by the ideas of others (teacher and peers); a process of reconstruction of one's own ideas and judgments based on such factors as coherence, consistency, and comprehensiveness; together with a sensitivity to the particularity of each situation and each idea under investigation.

The role of peer interaction is absolutely critical to the successful development and growth of a community of inquiry. In this pedagogical approach, I begin by helping the group focus on the primary issues under discussion, responding to and participating in the conversation, and facilitating the inquiry through asking follow-up questions. Although the teacher, especially in the beginning stages of a classroom community of inquiry, is ultimately responsible for performing these tasks and keeping the dialogue at an inquiry level, student members of the group should soon begin to do the same. In fact, student-peer dialogue is an ultimate goal of this approach. I am always conscious, however, of my need to make sure the conversation is not dominated by a few students, does not digress too much, and remains at a kind, courteous level of interaction.

The second "secret" to success in this course is a reliance upon students' interests; that is, the students are required to come into class with a list of questions or points of interest into which they wish to inquire, based on the assigned readings [by Greenberg (1988), Rosemary Betterton (1987) or Craig Owens (1992), for examples]. I list these questions or points on the board, including the questioner's name in parentheses. This seemingly simple pedagogical ploy does several important things: it rewards the asking of questions; it generates a large number of questions or points, typically many more than can be addressed during the class; it establishes a sense of ownership for the student posing a question or raising a point; and it makes clear the frequency of certain underlying questions, whatever the range of critical perspectives under investigation might be.

Vygotsky (1978) has spoken of the importance of both teacher-student and student-peer interaction in the process of learning in the educational environment. He contends that we are capable of performing at higher intellectual levels when working in collaborative situations than when asked to work individually. His much-touted "zone of proximal development," which has to do with organizing classroom experiences so that the student utilizes "higher" levels of intellectual functioning, is "the distance between the actual developmental level as determined by independent problem

solving and the level of potential development as determined through problem solving under guidance or in collaboration with more capable peers" (Vygotsky, 1978, p. 86).

Vygotsky holds that when one establishes the right kind of environment, one of structured teacher guidance and collaboration with peers, students are able to produce something together, as in significant inquiry into feminist criticism or the influence of poststructuralism upon the work of certain artists, which they could not have produced alone. Thus, students must be helped by one or more others to function intellectually at a level beyond that at which they might otherwise be expected to perform.

Bruner (1985) explains it as "scaffolding," a vicarious form of consciousness, which functions until the learner is able to consciously and independently control the new function or conceptual system being utilized. This support system makes it possible for the learner to internalize both external knowledge and critical thinking skills and to convert them into tools for conscious intellectual functioning. If this interpretation of learning is correct, then the contention that it is inappropriate to expect visual art students to analyze and synthesize meaning from complex written texts on art theory and criticism is a faulty one; but the appropriate pedagogical structure or scaffolding must be provided. In the seminar I teach, that structure is built through the collaborative processes involved in developing and nurturing a community of inquiry. Because some students have better verbal skills and are less reticent about sharing their ideas aloud, they help provide a model for students who are less prepared or more reluctant to voice their ideas or who come from a culture in which such communication is seen as offensive or at least devalued. The notion of more capable also refers to students who tend to be less vocal, but who listen very carefully to the content and progress of the conversation and make relatively infrequent, yet insightful, comments.

## Some General Thoughts About Conversation

Recent scholarship, especially in feminist philosophy, suggests that previous models for critical inquiry through dialogue and criteria used to evaluate those models, will be of marginal help in constructing the conversations to take place in contemporary classes since they (previous models and criteria) were basically exclusionary. Significant portions of the population were either precluded or hindered from participating fully in the conversation. For example, as Gilligan (1981), Martin (1985), and others have pointed out, the conversation in which women and children have had equal access with men is an historical curiosity. It, that conversation, is just beginning to develop and the criteria for evaluating are not just emerging from the interplay of different voices in the conversation, but are, in fact, being invented by that interplay (Reed, 1992).

So, there is a rather marked contrast between the classical philosophical model of the debate as a means of inquiry and the model of a collaborative conversation advo-

cated here. There is something important about the amorphous, nonlinear quality of conversations that is especially appealing. In a conversation, things are not just introduced, incorporated, and then dropped. A conversation is decidedly not like a thesis or a lecture. Conversations thrive on redundancy and repetition. An idea is introduced and it is, so to speak, tried on by different speakers.

## Repetition

Repetition is a most important feature of this pedagogical approach—not to say that mindless repetition is encouraged by any means, but as linguists (Tannen, 1989, for example) have pointed out, repetition allows the speaker to set up a paradigm and slot in new information—where the frame for the new information stands ready rather than having to be newly formulated. Selective repetition enables a speaker to produce relatively fluent speech while formulating what to say next—thinking on your feet, you might say. Also, repetition and its variations facilitate comprehension by providing semantically less dense discourse. Redundancy in spoken discourse allows the hearer to receive information at roughly the same rate the speaker is producing it—just as the speaker benefits from some dead space while thinking of the next thing to say, the hearer benefits from the same dead space and from the redundancy while absorbing what is said. This is especially important for students for whom English is a second or third language and students with one of many types of learning disabilities. Given the common reading done by students in this seminar and the mutual experience of identifying questions and points of interest, this aspect of the community of inquiry works to deepen understanding and create wider webs of meaning among students. Such inquiry not only ties parts of the critical discourse to other parts, but also bonds participants to the discourse and to each other, linking individual speakers in a conversation and in relationships.

## Assignments

In addition to all this reading and discussing, seminar students write a short weekly paper (about three pages on average) which builds upon and extends their thoughts on topics under discussion. They also must do an independent project, singly or in groups, agreed to by me. I tell them to choose something which has a direct or indirect relationship to the topics we investigate (which is so broad-based a criterion as to be ridiculous, I admit) and which, more importantly, is something they always wanted to do, but which never fit in a course or plan of study. My reasons for making this assignment are multiple. First, I am committed to what might be termed a postmodern feminism which resists defining language as the only source of meaning and so links material practices and struggles with discourse. Second, despite the risk of advocating a modernist bent with any encouragement of individually conceived and completed projects (aesthetic or otherwise), I would assert the importance of grounding inquiry in the contexts of students' lives and work. Third, I am inordinately curious to

find how students respond to this assignment—how the inquiry of the class is processed by them and how they choose to act upon that—in short, how it shapes their determinations, the choices of things they "always wanted to do." In presenting their projects to the group, students explain their choices and how they satisfy the two criteria for selecting projects.

I find that students do a rather amazing range of things to fulfill this assignment; it seems to be truly energizing for many of them. Examples over the years include a printmaker who made an extraordinary and complex book of portraits which in turn made up a self-portrait—dealing with the issue of how the self is determined; a painter who made an animated film addressing the problematic issues of phallic prejudice in representation of women; a photographer who read and analyzed Foucault; a sculptor who wrote a series of poems, many of which were later published in a small press; a painter who did a performance piece which included use of a series of small collages with quotes from feminist art criticism on them, which she handed out at the opening of a grad show, asking people to pin them to their clothing or carry them around, and collect responses to the ideas there—this was especially fruitful and resulted in an exhibition in a NYC gallery; a sculptor and a painter who made a huge, collaborative piece with children in the community; a photographer who started a free photo class for economically disadvantaged kids—now still in existence with 'new' teachers some three years later; and a doctoral student in aeronautical engineering who collaged onto a copy of his dissertation a multitude of little drawings, saved over the years, of break-through ideas first conceptualized that way, mingled with the equations by which they were formally represented; to name but a few examples. It is, typically, a most reward-ing experience for the group as a whole. It is plural; it is an expression of a multitude of interpretations of the meaning, implications, and, not to be too melodramatic, the power of the inquiry that takes place throughout the semester.

Before we get to that point late in the semester when we share those kinds of pro-jects, however, a good deal of hair-pulling goes on, especially, I am told, when stu-dents begin their first reading assignment. They are often overwhelmed by the diffi-culty of the textual material, especially those students for whom English is not the first language. So, I hear lots of moans and groans at first. But, almost without exception, students find themselves engrossed in the conversation which ensues from the reading experience. It is the setting of the agenda by the students (and that agenda is frequent-ly similar to what I would have prepared myself) that provides an interest on the part of students, and as Dewey pointed out long ago, interest is the starting point of educa-tion. What I want students to do, and I believe many of them do, is not only remem-ber the works and ideas, but also have a good start on understanding and acting upon the implications of them.

Optimistic as that sounds, that is where the real frustration begins for many of these students. They now are aware of the modernist ideas underlying most of their

previous art educational experiences and are not satisfied with teaching from that perspective themselves—teaching yet another set of exercises using the elements and principles of art or techniques for using acrylics, charcoal, or clay. But how does one teach art without relying on such approaches? How does one evaluate work that is not grounded in such ideas? Does increased classroom talk merely dilute the production inquiries? Does discussion of content inevitably lead to some kind of censorship, based on criteria from who knows where? If school art doesn't look like school art, at any level of education, what kind of programmatic, intellectual, academic, or emotional dissonance will result? How many heated arguments will take place in hallways and in curriculum committee meetings? As usual, I have many more questions than answers, but I like the prospect of continuing inquiry into these queries. Such conversation, for students and teachers alike, is extremely important, for as feminist critics have pointed out, people tend to define themselves by and in the conversations of which they are a part (Martin, 1985).

# References

Betterton, R. (1987). *Looking on: Images of femininity in the visual arts and media.* London: Pandora Press.

Bruner, J. (1985). Vygotsky: An historical and conceptual perspective. In J. Wertsch (Ed.), *Culture, communication, and cognition: Vygotskian perspectives* (21-34). London: Cambridge University Press.

Foster, H. (1983). *The anti-aesthetic: Essays on postmodern culture.* Port Townsend, WA: Bay Press.

Fried, M. (1967, Summer). Art and objecthood. *Artforum,* 12-23.

Gilligan, C. (1981). *In a different voice: Psychological theory and women's development.* Cambridge, MA: Harvard University Press.

Greenberg, C. (1988). *The collected essays and criticism.* Chicago: University of Chicago Press.

Habermas, J. (1987). *The philosophical discourse of modernity.* Cambridge, MA: MIT Press.

Hagaman, S. (1990). The community of inquiry: An approach to collaborative learning. *Studies in Art Education, 31* (3), 149-157.

Hertz, R. (1985, 1993). *Theories of contemporary art.* Englewood Cliffs, NJ: Prentice-Hall.

Martin, J. (1985). *Reclaiming a conversation: The ideal of the educated woman.* New Haven, CT: Yale University Press.

Owens, C. (1992). *Beyond recognition: Representation, power, and culture.* Berkeley, CA: University of California Press.

Reed, R. (1992). *When we talk: Essays on classroom conversation.* Fort Worth, TX: Analytic Teaching Press.

Risatti, H. (1990). *Postmodern perspectives: Issues in contemporary art.* Englewood Cliffs, NJ: Prentice-Hall.

Tannen, D. (1989). *Talking voices.* Cambridge, England: Cambridge University Press.

Vygotsky, L. (1978). *Mind in society: The development of higher psychological processes.* Cambridge, MA: Harvard University Press.

# POSTMODERN THEORY AND CLASSROOM ART CRITICISM: WHY BOTHER?

Sydney Walker

## Introduction

Postmodern literature is frequently difficult and seemingly irrelevant outside of academia. Jargon and opaqueness proliferate, requiring a stretch to find any connection to elementary and secondary classrooms. My purpose here is to explore the possibilities of postmodern theory for conducting classroom art criticism. I believe postmodern theories have significance for understanding artworks and it is worth the effort to search out the basic issues and their implications for classroom art criticism. Current postmodern literature certainly extends well beyond this essay, but my intent is to continue a dialogue about postmodernism that has already begun in art education (Anderson 1991, 1993; Barrett 1990, 1994; Congdon, 1989; Fehr, 1993; Garber, 1990; Hagaman, 1990; Hicks, 1992; Walker, 1992; Wolcott, 1994).

## Postmodern Theory

Doubt is the by-word for the postmodern era. Postmodern perspectives assault traditionally held values, beliefs, and practices by questioning truth, authority, and social norms. Postmodernism is described as a major intellectual shift from a modernist paradigm premised in science to a model rooted in social theory. The scientific paradigm, evolving since Isaac Newton's universal law of gravitation in 1686 (Doll, 1989), privileges the logical, the rational, the universal, the stable, and the objective; while conversely, the postmodern model favors the heterogeneous, the multiple, the temporal, the local, and the contradictory (Best & Kellner, 1991; Lyotard, 1984).

To organize this discussion I am using three terms: *discourse, textuality*, and *deconstruction*. These terms derive from a linguistic philosophic perspective of postmodernism. This perspective differs from a contextual postmodern perspective which is more absorbed with ideological issues as multiculturalism, feminism, and sexuality,

each addressed elsewhere in this text. The linguistic philosophical perspective considers language and the primary questions: How is meaning constructed and how is meaning possible? Both perspectives have relevance for classroom art criticism. I am acutely aware that the theories I discuss about discourse, textuality, and deconstruction intertwine with issues that inform the postmodern contextual perspective. But within the limitations here, I have elected the linguistic philosophic perspective since it most directly considers the interpretive act.

## A Primer

"Discourse—n. 1. communication of thought by words; talk; conversation" *(American College Dictionary*, 1988 edition)

*Discourse* is a significant term in postmodernism, but it is not employed by postmodernists with the commonsensical dictionary definition. Social theorist Michel Foucault (1970) speaks of the discourse of science, the discourse of medicine, and the discourse of psychiatry. *Discourse* for Foucault describes particular social practices that are referred to as discourses because they are constructed through language. Foucault defines the structure of a discourse by asking what social rules permit certain statements and practices within the discourse while denying others. He further queries how the discourse identifies some statements as true and others as false.

The discourses of medicine or schooling are highly structured with readily identifiable institutionalized social practices. Other discourses as the discourse of family or the discourse of popular culture are more loosely structured, and although less formalized, these discourses have specific defining social practices and statements as well. In my own recent readings of postmodern literature I have come across wide-ranging references to discourses. These include the discourse of art history, the discourse of power, the discourse of modernism, and the discourse of postmodernism, among others. Hutcheon (1988) concludes about discourse and postmodernism: "Discourse becomes an important and unavoidable term in discussions of postmodernism, of the art and theory that also will not let us ignore social practices, the historical conditions of meaning, and the positions from which texts are both produced and received" (p. 184).

The postmodern concept of discourse seems removed from classroom art criticism. However, the concept of discourse places the making and interpreting of artworks within a social context. Identifying the discourses that inform an artwork opens the work to interpretation. Art objects contain numerous possible discourses and understanding of the art object is determined by the discourses one chooses to speak from when constructing meaning.

# Discourse and Classroom Criticism

What relevance does the postmodernist concept of discourse have for classroom art criticism? To help clarify the significance of postmodernism for art criticism classroom practice, I asked an art education graduate student at The Ohio State University, Jane Gooding Brown, why she is choosing "Postmodernism and Discourse" as her dissertation topic. She responded to me in writing:

At present poststructualist theory and particularly the writings of Roland Barthes, Michel Foucault, Jacques Lacan, and Jacques Derrida afford us opportunities to undo, disrupt, decenter, dislocate, or contradict modernist assumptions of fixed meaning, 'closures of knowledge', by locating discourses embedded in art texts in order to unpack and 'repack' postmodern multiple and unstable interpretations of meanings.

The implications for critical art theory and critical thinking at the high school level are important. If students are able to *understand* and recognize their own and others'positioning *in particular and different discourses,* they can examine their own interpretations through their relationship with the discourses embedded in art texts. By deconstructing discourses in art texts students can begin to see themselves as social beings with links to others in the world. (J. Gooding Brown, personal communication, August 20, 1994)

## A Classroom Example

Gooding Brown emphasized directing students toward an awareness of their own personal discourses as well. I asked Jane for an example of students interpreting artworks through personal discourse positions. She constructed a senario based upon her previous teaching experience with the work of Mexican artist Frida Kahlo and an advanced high school art class in a white middle-class school. She narrated:

I read to the art class from Kahlo's biography and from art criticism by critic Hayden Herrera. This provided the class with an understanding of Kahlo as a marginalized person: woman painter in the 1920s, feminist, Mexican, communist, and invalid. The class viewed and interpreted Kahlo's self-portraits in this context. I recognized that the students' interpretations were constituted by their personal positions to the discourses that informed Kahlo's works: Woman, Mexican, Medicine, and Pain. The female students, situated in the discourse of Woman, viewed the anti-conformity represented in Kahlo's works as vital to her identity as a person. Some male students saw her work as typically "difficult" in a female way, that is, aggressive, confrontational, and hysterical. Other students interpreted Kahlo's paintings through their discourse positions in religion referring to practices of self-sacrifice and martyrdom.

As I developed the students' awareness of the influence from their own discourse positions, they reexamined their interpretations. The students returned to Herrera's criticism and identified the critic's discourse positions.They not only recognized a feminist position in her writing, but from words like "muralism," and "idiosyncratic talent," they recognized the discourses of art history and art criticism.

I then instructed the students to write interpretively about Kahlo's *Broken Column*. The students analyzed their writing for words and phrases that revealed their particular discourse positions.

As students continued further interpretive work with other artists' works and discourse positions, some students began to understand that their interpretations of meanings about any area of life, not only artworks, are constituted by their particular discourse positions. They realized that new knowledge was always reinterpreted through the personal. The students began to grasp the notion that examination of one's discourse positions allows for exploring concepts of difference. (Jane Gooding Brown, personal communication, September 1994)

Jane's example demonstrates the potential value for developing deeper more considered student interpretations through instruction about discourse positions. She raises the concept of developing multiple interpretations for artworks. In the following section, I further explore heterogeneous interpretive views.

# Textuality

## Text and Discourse

Postmodernists use the term "text" to refer to understanding objects from multiple social perspectives. Social discourses provide the framework for interpreting objects as texts. A text may be physically limited: a sculpture, building, book, television program, newspaper, or person. Or it may be a less concretely defined object as a social event: marriage ceremony, courtroom trial, cocktail party, or political rally. It is not the specific object or event that produces a text, but it is the interpretive approach that determines textuality.

For the postmodernist a text is distinguishable from a work because a text is always in the process of becoming and never in a state of finality. By contrast, a work is limited, singular, and complete. In his seminal essay "Death of the Author," Roland Barthes (1977) offers a postmodern conception of text:

"We know that a text is not a line of words releasing a single 'theological' meaning...but a multi-dimensional space in which a variety of writings, none of them

original, blend and clash. The text is a tissue of quotations drawn from the innumerable centers of culture." (p. 146)

If considering artworks as textual objects links them to any number of cultural discourses that offer boundless interpretive possibilities where does the art instructor open interpretation for students?

## Interpretive Structures

Culler views a study of the structures and systems that make interpretation possible as highly productive for literary studies. He recognizes that "it is clear that practically, in studying literature, people do not just develop interpretations (uses) of particular works but also acquire a general understanding of how literature operates—its range of possibilities and characteristic structures" (Culler, 1992, p. 118).

Culler particularly critiques Stanley Fish's reader-response theory of interpretation because Fish negates the value of structural knowledge about literature. Fish, according to Culler, does literary students a disservice by denying them the opportunity to study the structures that allow literary works to produce meaning. He cites Fish's admonition that "actually, there isn't anything here one could be right or wrong about; there isn't such a thing as the nature of literature or of reading; there are only groups of readers and critics with certain beliefs who do whatever it is that they do'" (p. 119). Culler views this as a wrong-headed notion. Culler's argument that students should study the structures of literature offers a useful direction for developing classroom art criticism approaches for interpretation. If art instructors and art students understand the general structures that produce meaning about artworks, they will be better interpreters.

## Critics' Discourses[1]

Certain discourses and concepts are consistently used by art critics and historians to explain artworks. These offer a general framework for interpretation. In an analysis of

| gender | critical reception | culture | | technique |
| | | art historical context | | |
| | | | | |
| morality | | | | philosophy |
| | | postmodern theory | | |
| | | | | |
| science | artist's biography | | politics | nature |
| psychology | | | | popular culture |
| performance | | art world systems | | ethnicity |
| rationality | | | | irrationality |
| | | feminism | | |
| formalism | | pornography | | museum systems |

---

[1] The heading, "Critics' Discourses," is followed by unconventionally spaced text to graphically emphasize the notion that art critics write about artworks from multiple rather than singular perspectives. In an subsequent section, the heading, "Deconstruction" and "Decentering the Text," is also followed by unconventionally spaced text to visually illustrate the idea that deconstruction practice decenters fixed meanings.

16 critics' writing about eight contemporary artists, I found the most frequently used discourses were: *social/cultural issues, artist's intent, art historical,* and *critical reception of the work.*[2] Knowledge that art critics engage a conceptual structure of this nature offers art teachers guidance for classroom art criticism. Significantly, these areas require knowledge that is not directly perceivable in artworks. Students most likely would require additional knowledge about these areas before they could utilize them interpretively.

# Limitations of Structure

## Intent

Poststructualists critique the boundaries and closures that structure imposes upon meaning. For instance, Eco (1992) argues for the 'intention of the text' proposing that interpretation should be guided by questions that text insists upon. This method provides Eco with a structure for interpretation. As a poststructualist Culler (1992) counters that indeed it can be very important and productive to also ask questions the text does not encourage one to ask. He comments, "Many of the most interesting forms of modern criticism ask not what the work has in mind but what it forgets, not what it says but what it takes for granted" (p. 115). Culler's wish to displace the intention of the text as an interpretive foundation reflects a poststructualist desire to displace and dislodge structure.

Considering the text's intent is similar to seizing upon the *author's intent* for interpretive grounding. As a poststructualist Barthes (1977) had some decided negative opinions about criticism which uses the author's intent for interpretation. In "Death of the Author" he banishes the author from the interpretive scene. "To give a text an Author is to impose a limit on that text, to furnish it with a final signified, to close the writing" (p. 147).

## Art Historical Relations

The art historical structure fares no better than the author's intent with Barthes (1977). According to Barthes, historical relations provide familial ties that close off meaning and predetermine a text's meaning. Historical connections produce meaning through an abstract evolutionary process of development, not from a specific cultural context.

---

[2] The critics' writings for this analysis were selected from a range of contemporary artists' work— Conceptual, socio-political, two and three-dimensional media, minority and mainstream artists, and essay-length pieces (only one writing was review length).

Without structure students are limited in their abilities to interpret artworks, but concomitantly such structures as the text's intent, the artist's intent, or art historical relations can close off further meaning by becoming the 'right' interpretation. An alternative is to offer students a number of interpretive structures and encourage them to explore artworks for meanings rather than a single meaning. Under this pedagogical model artworks become "textual" objects.

## Interpretation and Closure

However, if artworks as textual objects have unbounded interpretive possibilities, how does or does the art instructor bring closure to the interpretive activity? There is a point in interpretive activity when criticism needs conclusions and syntheses to avoid a continuous state of fragmentation. An answer: Instead of considering closures as embracing finality, they can be temporary and students and critics may return to the artworks for further inclusions, excisions and reconfigurations. Temporary closures and re-openings of interpretation offer distinct pedagogical possibilities for deepening interpretive levels and seeking multiple understandings without producing interpretive chaos.

# Deconstruction

## Decentering the Text

Umberto Eco (in Rosso, 1983) remarks that "postmodernism is born at the moment we discover that the world has no fixed center" (p. 3 - 4).

Deconstruction is a facet of postmodern theory that critiques meaning and interpretation. It does not seek to add new meanings to objects, but asks the philosophical question: How is meaning possible? In deconstructive analysis, one searches for marginalized meanings that dominant meanings suppress. Jacques Derrida (1976, 1981), originator of deconstruction theory, proposes that every meaning is always problematic and never certain. That is, every meaning we construct is a candidate for deconstruction.

In her introduction to Derrida's (1981) *Dissemination*, Barbara Johnson describes the deconstructive reading of a text not as a destruction of the meaning of the text, but as an analysis that seeks to "undo" the signifying systems in the text. She asserts that "If anything is destroyed in a deconstructive reading, it is not meaning, but the claim to unequivocal domination of one mode signifying over another."

## An Example

Art educator Hicks deconstructs the patriarchial representation of female images from a 1990 exhibition at the University of Maine, *Woman Figured by Man: A Re-Reading of 20th Century Visual Representations*. She challenges the stereotypical passive, submissive, emotional representations of the female figures. Hicks argues that these supposedly neutral images—constructed by artists, art historians, art educators and art institutions—conceal specific social roles that "the male-dominated art world finds acceptable" (p. 23).

A Picasso linocut, *Tete de Femme* (A Woman's Head), from this exhibit is interpreted traditionally as an example of Picasso's analytic cubist style. Hicks displaces this dominant reading by asking questions as: "What visual cues help you see that this is a woman? (example: tears and eye lashes). Why are these symbols used to tell us this is a woman? What do these symbols communicate about women? How would you describe the woman? (example: She's scared or lost. Definitely evil. Ugly and pitiful)" (p. 27). Raising these types of questions about *Tete de Femme*, Hicks decenters the dominant interpretation to expose other suppressed meanings.

## Deconstruction and Classroom Criticism

What relevance does decentering and deconstructing meaning have for classroom criticism? Deconstruction is a difficult concept to practice because it is a systematic attempt to locate those places in which a text contradicts itself and does not say what it means to say. Deconstructive activity does not seek meaning in the traditional sense of interpretations asking "what does this statement (image) mean?," but instead queries "what are its assumptions and presuppositions?" This type of activity assumes that one must understand the systems that structure the text's meaning before one can challenge them. Deconstructive activity must be carried out rigorously and systematically.

Deconstruction is further problematized, as Melville (in Brunette & Wills, 1994) recognizes, by the fact that "every object must appear as an occasion for the reinvention of deconstruction: Every object is different(ly). Within Derrida's work this demand is embedded in his own practice of renaming his enterprise and its key terms with each new text he reads" (p. 41).

This obviously is not an approach for elementary students or even appropriate for all middle or high school students. But I believe it is a method that could benefit some high school students and all college students, especially future teachers and thus eventually be applicable to schools. It is a method that motivates one to search for the overlooked, to find those areas that have been pushed to the edges and margins.

Postmodern deconstruction and textuality raise a number of questions for classroom art criticism practice as: Are there ever conclusive meanings about artworks? Will meaning change with every viewer? How are artworks given social meaning? Where are the parameters and boundaries to interpretation?

## My Position

I consulted my colleague Terry Barrett who writes about art criticism, to ask questions about meaning and if meaning is even necessary for artworks. I concur with Terry's response that meaning is central to teaching about art and is both unavoidable and desirable. As Terry, I too am put off by nihilistic tendencies in postmodern theory, but engaged by postmodernist explorations of meaning itself and "what it means to mean."

Postmodern notions of textuality enrich interpretive meaning by encouraging students to place artworks in a richly connected interpretive context. I agree with Barbara Johnson (1981) that deconstructing and decentering a text is not a "form of textual vandalism designed to prove that meaning is impossible" (p. xiv), but displaces the domination of one mode of meaning over another. Engaging students in displacing and decentering accepted meanings for artworks can usefully instruct them to search for the unsaid and the not-so-obvious. My pedagogical judgment is, however, that students must develop an understanding of textuality and multiple meanings for artworks before they can work deconstructively.

As an art educator who conducts art criticism with university students and assists art education students with instructional design for classroom criticism, I find the use of structures for art criticism indispensable. My method is multiple: seek the intentions of the text, consult the interpretive strategies of art critics, encourage textuality by interpreting artworks within a social context, and consider the role of the viewer's personal responses.

I've raised postmodern interpretive issues in this essay that are significant to furthering classroom art criticism practice. These issues are incomplete without additional knowledge of contemporary artworks. The content of much contemporary art is informed by the postmodern theories I presented: discourse, textuality and deconstruction and ideological issues from the contextual postmodern perspective as well. Classroom art criticism practice could be deepened by art instructors who are knowledgeable about both postmodern theory and contemporary art. There is ample room for innovation and multiple approaches to classroom art criticism from a postmodern perspective; however, substantive changes to interpretive practice require understanding of the basic notions that drive postmodern thought.

# References

Anderson, T. (1991). The content of art criticism. *Art Education, 29* (1), 28 - 37.

Anderson, T. (1993). Defining and structuring art criticism. *Studies in Art Education, 34* (4), 199-208.

Barrett, T. (1994). *Criticizing art.* Mountain View, CA: Mayfield Publishing Co.

Barrett, T. (1990). *Criticizing photographs.* Mountain View, CA: Mayfield Publishing Co.

Barthes, R. (1977). Death of the author. (S. Heath, trans.). In R. Barthes, *Image. music. text.* (pp. 142-148). NY: Noonday Press. (Original book published 1977).

Best, S., & Kellner, D. (1991). *Postmodern theory: Critical interrogations.* New York: The Guilford Press.

Congdon, K. (1989). Multi-cultural approaches to art criticism. *Studies in Art Education, 30* (3), 176-184.

Culler, J. (1992). In defense of overinterpretation. In S. Collini (Ed.), *Interpretation and Overinterpretation,* pp. 109-124. Cambridge, England: Cambridge University Press.

Derrida, J. (1981). *Dissemination.* (B. Johnson trans.) Chicago: University of Chicago Press. (Original work published 1972).

Derrida, J. (1976). *Of grammatology* (G. C. Spivak trans.). Baltimore: Johns Hopkins University. (Original work published 1967).

Doll, W.E. (1989). Foundations for a postmodern curriculum, *Journal of Curriculum Studies, 21* (3), 243-253.

Eco, U. (1992). Overinterpreting texts. In S. Collini (Ed.), *Interpretation and Overinterpretation,* pp. 45-66. Cambridge: Cambridge University Press.

Fehr, D. (1993). Mona Lisa's milestones: The modern gods of criticism. *Art Education, 46* (1), 68-70.

Foucault, M. (1970). *The order of things: An anthology of the human race.* New York: Pantheon.

Garber, E. (1990). Implications of feminist art criticism for art education. *Studies in Art Education, 32* (1), 17-26.

Hagaman, S. (1990). Feminist inquiry in art history, art criticism and aesthetics: An overview for art education. *Studies in Art Education,* (1), 27-35.

Hicks, L. (1992). The construction of meaning. *Studies in Art Education, 45* (2), 23-32.

Hutcheon, L. (1988). *A poetics of postmodernism.* NY: Routledge.

Johnson, B. (1981). Translator's introduction. In J. Derrida, *Of Grammatology,* pp. vii-xxxiii. Chicago: University of Chicago Press.

Lyotard, J. F. (1984). *The postmodern condition: A report on knowledge.* (G. Remington & B. Massum trans.). Minneapolis, MN: University of Minnesota Press. (Original book published 1979).

Melville, S. (1994). Color has not been yet named: Objectivity in deconstruction. In P. Brunette & D. Wills (Eds.), *Deconstruction and the Visual Arts,* pp. 33-48. Cambridge, England: Cambridge University Press.

Rosso, S. (1983). A correspondence with Umberto Eco. *Boundary 2, 12* (1), 1 - 13.

Walker, S. (1992). *A study of relational meaning in the writings of three professional art critics.* Unpublished dissertation, The Florida State University.

Wolcott, A. (1994). Whose shoes are these anyway?: A contemporary approach to interpretation. *Art Education, 47* (5), 14-16.

# End Notes

The critics' writings for this analysis were selected on the basis of including a range of contemporary artists' works—Conceptual, social/political, two-and three-dimensional media, minority and mainstream and essay-length pieces (only one writing was review length). The analysis was limited to locating those discourses which appeared to be central to the critic's explanation of the artist's work. Discourse was not strictly defined or delimited, but referred to Foucault's sense of discourse as a category of statements commonly linked through social practices. Some discourses in the analysis as art historical, psychological, or postmodern theory are fairly formalized. A discourse of the artist's biography or intent does not have the same formal structures, but, nevertheless, contains a particular set of accumulated statements and practices that function as an accepted discourse about an artist's background or intent. Even loosely structured discourses have implied rules for permitted and nonpermitted statements and practices within the discourse. For instance, the authorizing voice in the discourse of the artist's intent is the artist's voice and statements, not those of others; or in the discourse of the artist's biography, narrative and story-telling as ends in themselves are not dominant practices since biographical information functions to establish rational explanations of the artworks' content or credibility through references to education, training, and artworld relationships. A complete analysis of the permitted and nonpermitted practices and statements informing the major discourses of art criticism writing would be instructive for teaching about art criticism.

# INTERACTIVE HYPERDOCUMENTS: IMPLICATIONS FOR ART CRITICISM IN A POSTMODERN ERA

Karen Keifer-Boyd

The 'style' of the present is eclectic. It admits of even the most incongruous combinations. This eclecticism, indeed, has led to much talk of art having come to an end in the sense of having exhausted its potential for real innovation and creativity. The orderly divisions of the modernist epoch, then, have given way to much more fragmented and shifting ways of ordering and expressing the world. We have entered a postmodern age (Crowther, 1993, p. x).

The hypermedia art criticism project discussed in this article rejects the rigid categories and division of disciplines established by modernism. Instead, this postmodern approach to art criticism embraces complexity, pluralism, anti-authority, respect for difference, diversity, and transience. An underlying assumption of the model is that there is not a singular meaning or quality in any work of art. The maker's background and intent and how these relate to diverse viewers' life experiences all influence the meaning, value, and judgment of an artwork or event. Using hypermedia we can present meaning or judge excellence from our personal relation to a certain work and learn from various other interpretations of the same work. Interpretation of meaning and excellence is a dynamic process involving the context of the art object or event, the maker, and the viewer.

*Hypermedia* refers to the combination of more than one medium that has been digitized for use with computer technology. *Interactive hyperdocuments* refers to computer technology that enables humanly manipulated computer actions to produce multiple effects in the computer's presentation of linked information. Figure 1 is an example of a hyperdocument card demonstrating the concept of linked information. Each box is a button that when activated takes the participant to a new card. The new card may be linked to all other cards, each with their own set of buttons linking that card to other cards. Therefore, the path that each participant takes determines the information that

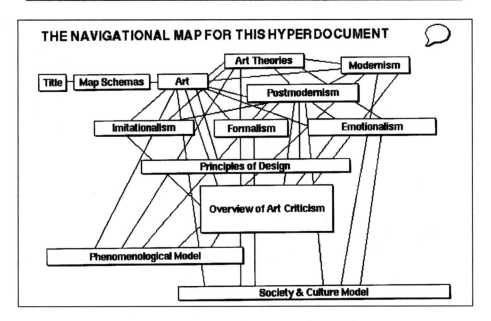

Figure 1—Hyperdocument card demonstrating linked information.

is derived. The participant may add buttons to lead others elsewhere, or add text and images that offer another perspective. In this article I present the theoretical orientation of the multivocal art criticism project, a description of the project including a pilot of it in an undergraduate art education course, and the direction of the project's development.

## A Postmodern Art Criticism Approach

Judgments of excellence, no matter what criteria used, are based on understanding, not on facts. An educational anthropologist, H. Wolcott, concluded that "validity stands to lure me from my purpose by inviting me to attend to facts capable of verification, ignoring the fact that for the most part the facts are already in...Any understanding I may achieve will occur largely in answer to questions that are not matters of fact" (1990, p. 147).

Understanding is an on-going process. The use of only one model of art criticism amplifies some aspects of an artwork while it obscures others. To choose an interpretative strategy for a particular work of art, we might consider who sponsored its creation, what audience it is intended for, who made it, using what process, and with what intentions. What does the artwork reflect, challenge, or describe? Knowledge of the culture in which an art work was created or valued helps us to understand it, and

vice versa. An artist's statement of intent sheds light on interpretation. To determine what criteria with which to interpret art, we might consider why we value it, and the maker's intention, goal, function, or purpose. If the maker does not identify the work as art, or if the maker's culture does not distinguish aesthetic aspects of objects as a separate category designating them as art, then multiple criteria and methods may help us to conjoin disparate points of view.

Potentially, a multivocal art criticism model, created and presented with interactive hyperdocuments, can present different perspectives. The concept of multivocal art criticism derives from Victor Turner's anthropological definition of a multivocal symbol as a "single perceptible vehicle" or "outward form" carrying a "whole range of significations, not just a single meaning" (Turner, 1978, p. 573). The concept, therefore, refers to how a single object, event, or artwork conveys multiple meanings. Multivocality does not simply mean that everyone sees something different, but rather that multiple meanings are allowed to co-exist and are taught.

While cultural identity is valuable to reveal underlying assumptions and develop self-worth, one must also recognize that there is as much difference within cultural groups as there is between cultural groups. Each of us is a cultural mosaic belonging to several groups simultaneously. We construct knowledge from the categories we create to understand the world. Each individual will differ in their culturally-derived categories, and how they see the fixity, congruence, or fluidity of those categories. "Knowledge, then, is not the discovery of truth, but the construction of it" (Weeks, 1990, p. 241). Interactive hyperdocuments allow for the construction of knowledge by linking a web of interpretations derived from the diverse ways that individuals encounter and respond to art. Multiple perspectives should be taught and respected along with teaching/learning environments that emphasize dynamic concepts that are contextually defined. A multivocal art criticism approach enables active learning techniques where students work cooperatively and collaboratively on hypermedia projects. Students can experience other points of view without compromising their own cultural heritage.

Zurmuehlen (1987) states: "Like art, the past is not merely a passive object of investigation but exists as a multitude of possibilities for meaning, to be transformed again and again" (p. 134). An interactive hypermedia art criticism format that students create can present different interpretations and judgments of works linked with the context, strategy, and rationale from which each interpretation was conceived. This view of art criticism is congruent with changing views of art from universal standards to art interpreted according to contexts of human actions with respect for valuing variable meanings. "Contemporary criticism places new importance on theoretical discourse. With a focus on theory has come a blurring of what was once clearly defined academic disciplines" (Smagula, 1990, p. v). In a multivocal approach meanings derive from political, environmental, historical, philosophical, sociocultural, and

psychological orientations. The disciplines merge as the critic forms an interdisciplinary synthesis or interpretation.

Art criticism based on linear and prescriptive models does not stimulate student generated investigations. Student-constructed art criticism with interactive hypermedia could: (a) present multiple perspectives, (b) reveal assumptions and self-analysis by tracking navigational paths, (c) present visual analysis in visual formats, and (d) enable the transformation of existing images in order to rethink ideas and values that are embedded in images.

A hypermedia art criticism format addresses two very crucial needs in education today. One key is the need to incorporate technology into the classroom in creative ways that will differ from the linear, singular objective truth, and primarily verbal models of traditional education. Schools rarely use computers in ways that explore the potentials of computer technology. Traditional emphasis upon numerical and written analysis and presentation of findings tends to stifle the development and acceptance of other forms of analysis and reportage. However, it is also possible that these values will change as new technologies, such as hyperdocuments, become more accessible and researchers explore and demonstrate viable alternative approaches.

The hypermedia art criticism approach allows for visualization of problems, the collection and organization of information in nonlinear and nonhierarchical ways, and meets the needs of diverse learning styles and abilities. As a model of an innovative way to use technology in arts education, it also respects and teaches diverse value systems of a multicultural society. Tolerance and respect for diversity will strengthen society's ability to listen to the range of aesthetic opinions that exist in most communities. This multivocal art criticism project will empower students to solve problems free from the domination of one group of people or ideas. Art educators can teach skills and provide opportunities for students to experience participatory democracy.

The potential for critical thinking in the area of art criticism will be enhanced if students construct the direction of their exploration which is possible in the interactive hypermedia format. Specific critical thinking traits that are developed in the multivocal approach include examining the richness of disparate data, discovering relationships, synthesizing ideas to form new understandings, imagining new possibilities by transforming existing images, and especially recognizing the plausibility of more than one correct answer or response. Visual analysis requires manipulation of multiple linked images. Multiple linkages are more directly presented with Digital Video Interactive (DVI) hyperdocuments. Interactive hypermedia, a presentational format which depends neither on linear nor hierarchical structures, allows for multiple linkages that incorporate moving and still images with text. Only recently has DVI technology become widely available in an economic range to facilitate use by the general

public and in public education. Consequently, potentials for analysis and presentation with hyperimages has not been explored in many areas.

A second key educational goal of the multivocal art criticism project is to facilitate connections between school and society. Students have an opportunity to engage in real world issues using an interactive critical method of interpreting art. By learning to critique art from various perspectives, students gain insight into how art relates to life throughout time and among diverse cultures. In a partnership between Texas Tech University's Art Education Program and Lubbock High School's Art Department, the art criticism hypermedia project is being implemented in a way that engages students in aesthetic-expressive discourse. Via the high school's television interaction room, which is connected to other schools, City Hall, and the school district's central office, students gather interviews, data, and discussion concerning current national, regional, and local controversies in the designed environment and public art acquisitions. Various perspectives can be compiled as hypermedia presentations for public hearings and community meetings to encourage student and community involvement in making aesthetic decisions that affect their lives. Through experiences in an art education curricula in aesthetic-expressive discourse, a term borrowed from Habermas (1983), students gain communicative competence and are empowered to work for cultural policy that enables their voices to be heard.

## The Multivocal Art Criticism Project

During a pilot of the hypermedia art criticism project, undergraduate art education majors explored diverse theories of art, read and discussed feminist perspectives on interpreting art, and engaged in several models of art criticism ranging from formalist and phenomenological strategies to sociocultural and deconstruction approaches. Figure 2 represents an interactive page from the hyperdocument. Students had explored these art criticism models in the course. In the hyperdocument they could activate one of the buttons in order to follow the strategy of a specific model.

Throughout their involvement with art criticism these students individually kept a log of questions that they felt were the most important to interpret art. After the class had submitted and discussed suggestions, students selected one art work to apply their questions to in a hypermedia format. In this way both the questions and art work had significance to the students, based in their specific sociocultural backgrounds.

Initially, this multivocal art criticism model was organized in an interactive hypermedia format according to various existing art doctrines and art criticism models. (See Figure 2.) I adapted these existing models of art criticism to the hypermedia application as a way to facilitate student definition of their own investigation strategies. A class of 11 art education majors interpreted one work of art using the diverse models in the hypermedia nonlinear document and then worked at responding to the ques-

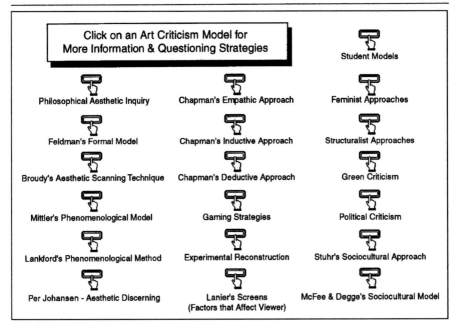

Figure 2—Interactive page from hyperdocument.

tions they had developed over a period of 3 months. Students collaboratively decided upon the graphic and interface design as they developed a presentation of their diverse interpretations in the hyperdocument.

The purpose was to use hypermedia to generate and present multiple perspectives on art. Students expressed their ideas and reactions to specific works of art, thereby recognizing their cultural and individual values while being exposed to other views. Students can use this computer art criticism process for self-evaluation of their own art and for feedback from other students. Students learned to design nonlinear navigational paths that connect information in ways not easily expressed in traditional written or verbal reports. To engage others to interact with their hypermedia productions, students learned to present and link disparate data.

Hypermedia is particularly suited to manipulate visual information for analysis and it allows one's interpretations to remain in a visual format. One of the ways in which students can manipulate images is by transforming them to evaluate their qualities and expose the values embedded in these images. To transform images students may either scan images, digitize slides, or use a digital editing system to capture video. Students may manipulate the still video, scanned or digitized image with a vector graphic drawing program or a bit-map drawing program prior to importing them into the hypermedia application.

# The Project's Direction and Future Development

As teachers with multicultural art education goals, we need to provide students with alternatives to existing ideologies and some grounds for challenging prevailing values and assumptions. This project will provide opportunities for students to apply multiple interpretations of visual information in their world and to engage in critical thinking, interdisciplinary research, and multimedia presentation of their art investigations. Preservice teachers will learn multiple models of interpreting and responding to art which will enable them to be more responsive to diverse cultural values.

The hypermedia products created by Lubbock High School and Texas Tech University students will be available to others as resources on various art works. They will remain interactive with the potential to grow in their dialogue about art as people from different parts of the world add their interpretation and understanding of the art.

As principal facilitator of the project, I am developing assessment tools that reveal pre- and post-levels of student tolerance for diverse perspectives and the students' ability to recognize underlying theories concerning the nature of art that are inherent in aesthetic valuing. The assessments will help guide future art criticism pedagogy for a multicultural society.

A variety of formats need to be developed and instructionally implemented according to the needs, abilities, and interests of teachers and students. Student-developed formats for art criticism, using hypermedia to present various questioning strategies and diverse perspectives and to track navigation paths of interests, will provide educators with student-driven models of instruction for responding to art.

There has been very little research about how individual differences influence what skills can be learned in regard to visual literacy or art criticism. A commitment to a partnership concerning the multivocal art criticism model was developed between Lubbock High School art teachers and the Texas Tech art education faculty in February 1995. The culturally diverse high school students at Lubbock High School, teachers, and preservice teachers at Texas Tech will provide a rich data base to conduct research concerning the types of formats that these three distinct groups will develop and how differences within the groups influence responses to visual information.

Questions of interpretation, quality, and standards can be answered only through an examination of cultural assumptions and values. Students involved in the project are asked to record the naturally occurring art criticism in the community in order to provide data for the investigation of the role of vernacular responses to the visual environment within the classroom.

I witnessed an example of vernacular (i.e., unstructured or unsolicited) art criticism while I was videotaping a group of non-sighted gallery visitors. Issues of context and gender arose from their tactile experience of the art. While a tactile observer was touching a bronze sculpture of a woman holding a fish in the center of several sculpted men's heads that were springing back and forth on rods, someone asked whether Morgan (the first name of the artist) was a woman or a man. When informed that Morgan was a man, she said, "Well that changes my whole interpretation in an instant." Of course, issues of context (social, physical, and/or psychological) of both the maker and viewer affect sighted and non-sighted interpretations. This exchange provided an opportunity for a provocative discussion concerning what this sculpture might mean if made by different people (i.e., male, female, heterosexual, or homosexual), and how stereotypes of gender and sexual orientation influence interpretations. This video segment will be digitized and imported into the hypermedia art criticism document to further dialogue about divergent meanings and aesthetic value systems. In this case the process of understanding the meaning of an artwork encouraged the rethinking of socially accepted ideas and values. The meaning of an artwork is interpreted not only by the contextual issues surrounding the maker's life experiences and reasons for producing the artwork, but also by the viewer's gender and unique life experiences.

After developing several student-driven hypermedia art criticism formats with responses from a range of people, a second important area of research in which high school students, teachers, preservice teachers, and I will engage will be the act of art criticism itself, its origins, and the use of particular critical approaches. By reviewing the questions that students developed, the vernacular critiques, and the navigational paths created in the hyperdocuments, we will examine assumptions concerning art and artist, and how these influence the way that we look at art. We will investigate how some formats illuminate some aspects of art and obscure others.

By changing the contexts of how things are displayed in the environment, museums, and galleries through redesigned worlds using hypermedia, students and teachers will explore how judgments and interpretations are affected. In this way the multivocal hypermedia art criticism explores how context affects interpretation, questions underlying assumptions of art and artist, and encompasses diverse aesthetic perceptions. It also addresses the need to make theory and terminology both relevant and accessible to students of varied cultural heritages. Students examine their own biases and attitudes about art and recognize, discuss, and hopefully learn to respect the diversity of values and aesthetic persuasions. The multiple linked presentational format of hyperdocuments eliminates the necessity of placing ideas in a hierarchical and linear order that the use of books for educational practices has necessitated. The authority of a single author erodes with multivocal hyperdocuments. The multivocal art criticism model addresses high priority educational goals such as research involving interdisci-

plinary connections, diversity of learners, multicultural content, and innovative uses of technology in education.

# References

Crowther, P. (1993). *Critical aesthetics and postmodernism.* Oxford: Clarendon Press.

Eaton, M. M. (1983). *Art and nonart: Reflections on an orange crate and a moose call.* London: Associated University Press.

Habermas, J. (1983). Modernity: An incomplete project. (S. Ben-Habib, Trans.). In H. Foster (Ed.), *The anti-aesthetic: Essays on postmodern culture* (pp. 3-15). Port Townsend, WA: Bay Press.

Smagula, H. (Ed.). (1990). *Re-visions: New perspectives of art criticism.* Englewood Cliffs, NJ: Prentice Hall.

Turner, V. (1978). Encounter with Freud: The making of a comparative symbologist. In G. D. Spindler (Ed.) *The making of psychological anthropology* (pp. 558 - 583). Los Angeles: University of California Press.

Weeks, P. (1990). Post-colonial challenges to grand theory. *Human Organization, 49* (3), 236 - 244.

Wolcott, H. (1990). On seeking—and rejecting—validity in qualitative research. In E. W. Eisner & A. Peshkin (Eds.), *Qualitative inquiry in education: The continuing debate* (pp. 121-151). New York: Teachers College Press.

Zurmuehlen, M. (1987). Context in art: Meaning recovered and discovered. *Journal of Multicultural and Cross-cultural Research in Art Education, 5* (1), 131-143.

# Readings that the Students Discussed in the Art Criticism Course:

Alpert, L. (1990). Feminist art criticism: Issues, assumptions, & lived experiences. *Controversies in Art & Culture, 3*(1), 1-13.

Blandy, D. (1987). Art, social action, and the preparation of democratic citizens. In D. Blandy & K. G. Congdon (Eds.), *Art in a democracy,* pp. 47-57. New York: Teachers' College Press.

Blandy, D., & Congdon, K. G. (Eds.), (1991) *Pluralistic approaches to art criticism.* Bowling Green, OH: Popular Press.

Chadwick, W. (1990). In and out of the mainstream. In *Women, art, & society,* pp. 297-347. New York: Thames and Hudson.

Chapman, L. (1978). *Approaches to art in education,* pp. 64-90. New York: Harcourt, Brace, Jovanich, Inc.

Conner, J. (1990). *History, theory and practice of art criticism in art education.* Reston, VA: National Art Education Association.

Corrin, L. (1993). Mining the museum 1. *In Discipline-based art education and cultural diversity,* pp. 72-75. Santa Monica, CA: The J. Paul Getty Trust.

Dissanayaake, E. (1988). *What is art for?* Seattle, WA: University of Washington.

Feldmon, E. (1971). The critical performance. In *Varieties of visual experience.* (pp. 466-485) Englewood Cliffs, NJ: Prentice-Hall.

Gablik, S. (1991) The ecological imperative: A new cultural coding. *The Reenchantment of art,* pp. 76-95. New York: Thames and Hudson.

Garbor, E. (1991). Implications of feminist art criticism for art education. *Studies in Art Education, 32*(1), 17-26.

Hammond, H. (1984). Feminist abstract art: A political viewpoint. In *Wrappings,* pp. 19-28. New York: Time & Space Limited Press.

Hicks, L. (1992). The construction of meaning: Feminist criticism. *Art Education, 45*(2), 23-31.

Johansen, P. (1982). Teaching aesthetic discerning through dialog. *Studies in Art Education, 23*(2), 6-13.

Lanier, V. (1983). *The visual arts and the elementary child.* New York: Teachers College Press.

McFee, J. K., & Degge, R. M. (1980). *Art, culture, and environment: A catalyst for teaching* (2nd ed.). Dubuque, IA: Kendall/Hunt.

Mittler, G. A. (1989). *Art in focus.* Mission Hills, CA: Glencoe.

Nadaner, D. (1985). Responding to the image world: A proposal for art curricula. *Art Education, 38*(1), 9-12.

Risatti, H. (1987). Art criticism in discipline-based art education. *The Journal of Aesthetic Education, 21*(2), 217-226.

Smagula, H. (Ed.). (1991). *Re-visions: New perspectives in art criticism,* pp. 1-14. Englewood Cliffs, NJ: Prentice Hall

Smith, R. A. (1986). *Excellence in art education: Ideas and initiatives,* pp. 13-37. Reston, VA: National Art Education Association.

Wilson, F. (1993). Mining the museum 2. In *Discipline-based art education and cultural diversity,* pp. 76-77. Santa Monica, CA: The J. Paul Getty Trust.

Wolcott, A. (1994). Whose shoes are they anyway? *Art Education, 47*(5), 14-20.

# POSTMODERNISM, FEMINISM AND ART EDUCATION: AN ELEMENTARY ART WORKSHOP BASED ON THE WORKS OF NANCY SPERO AND MARY KELLY

Yvonne Gaudelius

## Introduction: Feminism, Postmodernism, and the Visual Arts

Presenting challenges to modernist understandings, the postmodern critique has brought into question ideas such as the notion of individual genius, the distinctions between "low" and "high" art, and the neutrality and objectivity of the canon of great works of art. As such, postmodern theory can generate new ways of thinking and new ways of approaching art. In art education, the questions of postmodernism are manifested in a number of ways. We find them in the art that is produced, in the way we look at art, write about art, and interpret art. Postmodern theorists also raise questions such as: How do we establish criteria for determining great works of art? Are these criteria equitable to all groups of people? Should they be? Does aesthetic experience exist other than as a learned reaction? What assumptions and ideas do our interpretations of works of art rest on? On what ideas do we base our studio production?

While these issues can be approached through postmodern theory, we must also be aware that much of the questioning inherent in postmodern theory has been paralleled and, in some instances, initiated by feminist theory. Yet feminist inquiry differs from and extends postmodernist thought by placing women and their lives and experiences at the center of inquiry. As Stacey and Thorne (1985) describe it, "this strategy makes women's experiences visible, reveals the sexist biases and tacitly male assumptions of traditional knowledge, and...opens the way to gendered understanding" (p. 303). Without the insights provided by feminist and other critical theories, postmodernism

can easily be diverted from questions surrounding patriarchal systems of silencing and merely serve to question modernism within an extremely limited focus.

The danger of exclusion imbedded within postmodernism was pointed out by Craig Owens (1983) as "a blind spot in our discussions of postmodernism in general: our failure to address the issue of sexual difference—not only in the objects we discuss, but in our own enunciation as well" (p. 61). His essay, "The Discourse of Others: Feminists and Postmodernism," widely read in the art world, exemplifies much of the problematic nature of the relationships between modernism, postmodernism, and feminism. For example, Owens discusses the proclivity of postmodern theorists to construct general theories of culture. These theories, already problematic in light of their claims at universality, are undermined by the exclusion of gender and sexual difference as a category of inquiry and understanding.

Feminist theory does not just add the question of gender to postmodern discourse—it locates gender and sexual difference as primary questions through which inquiry is organized. In this sense, feminist scholars have contributed to, extended, altered, and challenged the postmodern debate by questioning both the categories through which postmodern thought is organized and the structure of metaphysics and discourse upon which it rests. In the visual arts, feminist theory has brought to light questions surrounding the way that art carries meaning and the underlying values and ideologies that support this system of meaning.

For feminist art historian Griselda Pollock (1987), the struggle over meaning can be described as follows:

Feminism's struggle is . . . not a campaign to raise quotas of women in exhibitions or to find spaces for the expression of women's experiences, although these are parts of the tactical activity of the movement. It is a struggle about meanings, a fight against dominant and established systems of meaning and the positions and identities which they attempt to secure. (p. 118)

To Pollock, the positions that are available to women determine what women are able to say. Furthermore, these positions are limited and defined by patriarchy. As is implicit in Pollock's comments, struggles over meaning and identity are connected. Without access to dominant systems of meanings, and therefore no control over the ways in which these meanings are constructed and used against them, we have no power to change dominant systems of meaning.

In an exploration of the ways in which artworks carry meanings, I describe two elementary art workshops based on the work of artists Nancy Spero and Mary Kelly. Spero and Kelly are two feminist artists whose works are exemplary in their questioning of the inscription of gender identities by dominant systems of meaning. Their

works are important for they go far beyond an analysis of representations of women in terms of "good" versus "bad" models, or simple reversals of the roles of men and women. Instead, like many postmodern artists, Spero and Kelly present strategies for creating works of art that open new systems of meaning. These artists, by the very nature of their questioning, demand that we understand gender as one of the primary cultural categories through which we order our lives. Spero's work is composed of multiple images of women, images which use multiplicity to challenge singular, patri- archal definitions of "woman." Mary Kelly rejects the use of images of women's bod- ies, presenting instead images that write women's subjectivities and desires through other signifiers.

These positive representations or markings come about through a subversion of both linguistic and symbolic codes and through an understanding of the multiplicity of interpretations that emerge from a close reading of textual and visual ambiguities. In this sense these works must be understood and approached as situated strategies which combat culturally inscribed meanings of femininity and patriarchy.

## Description of the School Setting

The activities that I will be describing in the rest of this paper took place over a period of two years as part of a university-sponsored "Arts Day" program. These class- es were held in an urban, K-6 school located in a medium-sized city in the northeast- ern United States. The classes of 5th graders were largely composed of African- American students; out of 20 students approximately 85% were African American. All instructors of these Arts Day classes were either art education undergraduate students or university professors.

Because these classes were not a part of the regular curriculum for these children, the activities were, through necessity, devised so that they could be completed during one 45-minute class period. In addition, the activities had to be devised to fit within the very limited budget of the school. This meant that supplies and time were both at a premium.

## Nancy Spero, Gender, and Appropriation

In the visual arts, an attempt to subvert dominant systems of representation can be clearly seen in the work of artist Nancy Spero. Spero's images of women are collages of art history. She recovers past images of women, combining them in such a way that they celebrate women's multiplicity of meaning. Rather than placing women within one system of representation and meaning, Spero's multiple images create multiple systems of meaning. By doing this, she defies an essential, singular definition of "woman." In her work she moves women to active roles, repositioning images of women so that they become positive representations.

Nancy Spero is a feminist artist. In her earlier works Nancy Spero had used images of men as well as women, but by the 1980s she moved away from this in an attempt to locate women in a position of subjectivity. As Lisa Tickner (1987) points out, "Spero had decided to return to images of women—indeed to use *only* images of women—in an attempt to displace the position of the male as the generic human subject" (p. 7). At this point Spero began to combine her images with text and to use the scroll format that has characterized much of her later work. The scroll format that Spero chose allowed an element of narrative to enter her work. It also made the work more difficult to categorize and to summarize. With scrolls that stretched 11 feet across the wall, no single point of view would be enough to understand the work. Indeed, by combining images and text with the longitudinal scrolls, Spero forces the viewer to move towards and away from the work simultaneously. We are drawn in to read a passage, then forced backwards to connect the images. This represents the beginning of Spero's use of multiplicity as a strategy operative in her work. The image is no longer unified, no longer readable as a single entity. While in these works they represent a narrative device, in Spero's later works this format will take on meaning as a feminist strategy, for she will use it to represent the multiplicity of women and to break the boundaries of a single definition of women.

In works such as *Notes in Time on Women II, Female Symbols II*, and other works of the 1980s, Spero presents woman as incredibly complex and varied. Continuing her borrowing of images, Spero wanders through history reclaiming man-made figures of women and giving them active roles.

Spero's strategies—identified by Tickner (1987) as quotation, repetition, stylistic disunity, the use of unfamiliar sources and "emblems of femininity that are often abbreviated and remote"(p. 10)—allow her to reposition the images of women which have been produced by men. In this way, she undermines the problems which arise when trying to place the image or representation of a woman as a subject within an art world system that has historically allowed women only the position of object.

Beginning around 1980, a distinct change begins to appear in Nancy Spero's work. Her earlier images had been dark; showing women as victims of torture or of social codes and structures. With works such as *To the Revolution* of 1981, Spero's representations of women begin to change. Although she still appropriates figures from other sources, the figures now begin to move; they leap through the space of the page, escaping the boundaries of the image.

Spero refuses to define woman, and instead offers us words and images which play from and with the boundaries of masculine and feminine. Spero uses historical images of women which have been produced by a patriarchal society to create a form of feminist painting. What Spero is doing is opening a space for women, a social space where they can speak.

Spero has stolen men's images. In this way her images cannot fail to be subversive for she is taking representations of woman created as object to the position of subject. Spero presents us with one strategy with which to negotiate our collective history and cultural schema.

It is of equal importance for students in the elementary classroom to learn to negotiate their collective histories and the cultural schema in which we all participate. This is what the work of an artist such as Spero can model for our students. The lesson that I engaged in during this Arts Day program used Spero's strategy of cultural interrogation as a starting point for students to begin their own critical examination of the schema through which their beliefs and collective histories are presented.

This particular lesson began with a discussion of the work of Nancy Spero. In this discussion with the students a number of points were brought forth. The students immediately recognized the narrative quality of Spero's work, probably because of the scroll format that she uses. The scrolls present us with a form of story that we have learned to read through popular culture devices such as comic strips. Building on this idea of narrative, the students were asked to arrive at a possible interpretation of Spero's "story." Not being familiar with the images that Spero was quoting from art history, the students did not recognize the specific nature of Spero's critique of the patriarchal structure of the art world. However, they quickly realized that all the figures were those of women. This then lead to a discussion of the role of gender in the work of an artist such as Spero, and from there to a discussion of the way gender and other narratives (such as of race and class) affect the students' lives.

After this discussion period, the students engaged in a printmaking activity. The work of an artist such as Spero is particularly suited to the rather crude printmaking techniques that were available because Spero is an artist whose work playfully engages with a visually rough form of printing. Her works are intellectually sophisticated but are not dependent on a graphic slickness that could never be achieved by students in an elementary classroom.

The students first decided upon a narrative that they would like to express. Keeping in mind the issues of gender that Spero has chosen to deal with, the students were asked to "tell a story" that dealt with a similar sort of issue that had an effect upon their lives. They then had to decide how they would describe their narrative in a visual form. Finally the students printed their narrative upon scrolls of paper. The actual printmaking technique was very simple; we used styrofoam trays that the students engraved. These were then rolled with ink using a brayer and printed upon the scrolls of paper.

This lesson concluded with a short discussion of the narratives that the students had created, the majority of which explored some facet of gender construction and

identity. Students explained their narratives and discussed the images that they had chosen to represent their ideas. In this discussion other concepts connected to post-modern art education arose. One example of such a concept is that of appropriation. This is a technique used by Spero and many students also chose to appropriate images for their narratives. While they did not appropriate their images from art history sources, this could easily be included as a part of this lesson.

## Mary Kelly and Clothing as Subject

The second lesson that I discuss here was developed from an artwork by the artist Mary Kelly. The artwork that I will be using is Kelly's *Interim*, an installation piece whose scope of inquiry is very large. Mary Kelly's work is located within a psychoanalytic framework, and draws heavily on the work of the French psychoanalyst Jacques Lacan. However, what Kelly accomplishes through her work is an analysis and rewriting of Lacan. Kelly speaks of what Lacan's system leaves out, that is, the lived experience and point of view of women.

Mary Kelly approaches many of the same questions as Nancy Spero in her work; however, Kelly's approach is radically different in form from that of Spero. In direct opposition to an artist such as Nancy Spero, Kelly believes that the female body can never be shown, in images or in performance, without being subject to and co-opted by the male gaze. However, her work shares with Spero's its central questions, namely "How can women become visible and effective? How can they encode their subjectivity into discourse—become present in the world?" (Tucker, 1990, pp. 23-24).

*Interim* is a large-scale installation work by artist Mary Kelly. Begun in 1984, this piece is divided into four sections, *Corpus, Pecunia, Historia,* and *Potestas.* The first section of Kelly's installation and the section upon which this lesson was based, *Corpus,* deals with the female body and its representation through clothing. There are five parts to *Corpus,* each composed of three pairs. The five parts—"Menacé," "Appel," "Supplication," "Erotisme," and "Extase"—take their names from the photographs of J. M. Charcot, a 19th-century French neuropathologist. Kelly challenges Charcot's photographic inscriptions of hysteria with texts and articles of clothing. For example, in "Extase" she presents Charcot's photograph, with pieces of women's clothing and handwritten texts of women's desires.

Mary Kelly uses the paired items of clothing and text to challenge each of the "Attitudes Passionelles." For example, in the "Extase" section we read of a woman's desire for a happy ending, her dress becoming part of her plot to escape the constraints of her life. The texts are drawn from the words of a variety of women and are "first-person accounts which explore how older women experience the body shaped socially and psychically by the discourses of popular medicine, fashion, and romantic fiction"(Tucker, 1990, p. 19). As we read the words we become aware of the gap

between Charcot's image and the transcribed voices of the women. The former presents us with a constructed sexuality while the texts describe the experiences of desire by women and thereby challenge this construction. This opening of social space enables women to begin to exist.

This signifying space is the creation of a social space in which women can begin to express their desires, and through this, their subjectivities. This is the space that Mary Kelly is opening up in *Interim*. The women who come into being in *Corpus* become feminist subjects, that is, women aware of their estrangement from the symbolic order and the construction of gender yet able to begin to articulate a subjectivity. Griselda Pollock (1990) thinks that this is because "the work's objects and texts function as a screen onto which Mary Kelly projects the traces of the historical, personal, and theoretical processes that turned the feminine subject into an object of feminist analysis, and thus produced the possibility of the feminist subject" (p. 49). By the juxtaposition of text and articles of clothing Kelly moves the viewer away from Charcot's definitions.

One half of each pair is the article of clothing, while the other part is the transcribed text. However, the three texts differ from each other. They do not all tell the same story even though each speaks of a woman's desire. Of paramount importance in Kelly's work is the multiplicity of women's voices. She is careful to maintain the differences between women and to let individual differences speak.

It is perhaps Laura Mulvey's comments which come closest to capturing the force of *Interim*. Mulvey (1989) reminds us that an *Interim* is "an intermediate time during which the 'something' that might be pending can be transformed by changed understanding and perspectives so that it can be opened up to unexpected eventualities" (p. 149). Kelly has opened social spaces in which this transformation might take place, and she has created a potential for change and for women's subjectivity.

The Arts Day activity that I engaged in with these elementary students was based upon readings of clothing as they form part of our cultural schema. As in the lesson based upon Nancy Spero, the students began by looking at and discussing the work of Mary Kelly. The students could easily decode the messages sent by various articles of clothing and quickly grasped the ways in which Kelly's photographs of clothing and the accompanying narratives worked against the grain of patriarchal meanings. They also understood how Kelly was articulating a particular critique of gender as it is constructed in relationship to clothing through her work. This discussion also gave students the opportunity to discuss other articles of clothing, such as shirts with team logos as compared to business suits. As might be expected the students were able to decode these articles of clothing. What might not be so obvious, however, is the way in which students were able to construct other meanings, meanings against the grain, for these items of clothing.

After this discussion, students were given the opportunity to construct their own dialogues based upon photographs of various articles of clothing. Prior to the lesson, I had selected and photocopied a variety of photographs of clothing. I tried to eliminate the human figure from these photographs so that the emphasis was placed upon the clothing as the site of meaning. Students were given a choice of which images they wanted to work from and were asked to construct a narrative that would explain the possible meanings of the clothing that they had chosen to the viewer. The students also embellished the photocopies with colored markers and text and images from magazines. This activity concluded with a discussion of the various meanings that were uncovered in the narrative constructed around the images of clothing that the students had chosen to work from.

## Conclusions

In art education the artworks that we study with our students can bring us and our students to new meanings and understandings. For example, the act of interpretation requires that we move beyond merely examining the formal elements and principles of an artwork to an understanding of historical genres and styles, or the biography of the artist. Interpretation, when defined in this way, is not a model but rather a practice which seeks to uncover meaning by engaging the artwork and the viewer in a dialogue.

Because art is not produced in isolation, we, as art educators, have a responsibility to teach students to enter into dialogue with larger artistic traditions. We should also teach students to respond to the issues that the artwork reflects and which lie behind the production of the artwork. Such issues include the formation of gender identities and the way in which binary thought structures our ways of looking at art.

Contemporary visual artists suggest approaches for a contextual, interpretive approach to art that encourages both questioning established systems of understanding and suggesting new ways of meaning. As educators we need to recognize the way in which differences— of gender, race, class or ethnicity—construct our students' experiences and knowledge. Contemporary visual art can offer new means of inquiry and new, empowering strategies to art education: in the studio, when we teach about the creation, interpretation and evaluation of artworks; in the classroom, when we teach about the relationship of art to society and culture and when we ask our students philosophic questions about the nature of art and interpretation; and in our research, in the way we frame our inquiries and develop research problems.

First, and perhaps most obvious, is the need to communicate ideas about women's subjectivity to prospective teachers of art in both the elementary classroom and the art classroom. While "creative self-expression" may no longer be the focus of art classrooms, I think that many teachers still use the arts to work with students in exploring

ideas related to self-identity. Unless this includes a recognition that the "self," as it is currently constructed, is limited to a subject presumed to be male, female students will continue to have little or no access to subjectivity. The best that they could hope for under these conditions is to exist pretending that they are male.

In teaching about women's achievements in the arts it is necessary to include an understanding of the ways in which patriarchal systems of meaning in the visual arts have defined and constructed woman. This level of teaching also involves an exploration of the manner in which women's access to the arts has been restricted and how this restriction has served to make speaking the feminine impossible from the position of woman-as-other.

Art education will remain at fault until we examine why women, among others, have been excluded, to a large extent from the art world and "a hundred other systems" (Nochlin, 1988, p. 55). Education and our institutions are not somehow free or separate from societal conceptions of women, and we need to acknowledge the role that institutions such as schools play in forming and maintaining these constructions of women.

Instead of this arbitrary addition of gender as yet another factor to mix into the research equation, I echo Janet Wolff's (1990b) call for an art education different from the one we now have. She states:

> At the very least...an education in the arts should incorporate the self-reflexivity of an historical and sociological understanding of both art and education. ...Arts education...must incorporate this kind of perspective, which goes beyond...attempting to encourage girls to try sculpture, and which subjects to a necessary critical scrutiny the orthodoxies and assumptions of contemporary arts education. (p. 204)

A feminist, postmodern approach to the teaching of art can provide the contextual basis which Wolff is calling for. Such an approach also asks educators and students to consider the visual arts as both a self-reflexive tradition and as a part of a larger social, cultural, and political whole. We need to teach students how art influences the way people feel, think, and act; how we determine values-- aesthetic, ethical, moral, spiritual, cultural, societal or environmental; and how the visual arts communicate our differing collective and personal existences. As long as we ignore these issues and present instead a unified understanding of works of art, we will silence those who do not already have access to these systems. As Cixous (1986) reminds us, "only those people who already have a relationship of mastery, who already have dealing with culture, who are saturated with culture, have ever dared have access to the discourse that the master gives" (p. 139). With our students, we must begin to break down this discourse of mastery that only the few have access to. Using postmodern artists in the ele-

mentary classroom and discussing with our students those issues and questions raised by postmodern artists and critics is one strategy that displaces this mastery.

In this paper, I have argued that it is of crucial importance that we create a space for women's subjectivity and for women's voices to speak. Examining and teaching based upon the works of Nancy Spero and Mary Kelly can suggest and uncover ways through which this space might be opened in the visual arts. Spero's work, with its numerous images of women brings to mind the multiplicity of women. This very multiplicity defies definition. Spero is an artist who has begun to create plural visions; her works tell multiple stories told in many voices. The narrative embodied in her long scrolls gives us a different sense of history. Her reappropriation of images from art history reveals the mythical nature of art history. Like most myths, art history tells us a story. It also constructs the possible stories we might begin to tell. What Nancy Spero does by defying the myth is allow new stories to begin to be told.

Mary Kelly challenges patriarchal constructions of woman. Her work speaks the unspoken and can enable us to do so with our students. Kelly (1990b) writes that "*Interim* proposes not one body but many bodies, shaped within a lot of different discourses. It doesn't refer to an anatomical fact or to a perpetual entity, but to the dispersed body of desire" (p. 55). She enables us to represent the body, desire, and subjectivity in such a way so as to avoid co-optation by the patriarchal gaze. In this manner, Kelly escapes the confines of patriarchal definitions.

For art educators, the works of these artists represent possibilities that challenge our dominant ways of seeing and knowing about art. They lead us to ask questions concerning the representation of women in the visual arts and suggest possibilities of approaching the question of women's subjectivity that might open new doors for our students. Above all, the works of Spero and Kelly indicate the importance of multiple ways of knowing.

What educators must begin to do is subvert the "truth" about woman. Rather than accepting patriarchal definitions and restrictions as to what woman is (and by extension what an educated woman is), we must begin to challenge the ways in which our education forms our subjectivity and the ways in which that subjectivity is gendered. In addition, these types of challenges help to understand the terms of women's oppressions.

Simone de Beauvoir (1989) reminds us,

No single educator could fashion a *female human being* today who would be the exact homologue of the *male human being;* if she is raised like a boy, the young girl feels she is an oddity and thereby she is given a new kind of sex specifica-

tion. Stendhal understood this when he said: "The forest must be planted all at once"(p. 725).

No single educator perhaps. However, the recognition that subjectivity is gendered leads me to the understanding that in my teaching I must open spaces for other subjectivities to exist. Nancy Spero and Mary Kelly have shown that speaking is not reserved for the "great men," and in their artworks they have spoken the feminine and subverted patriarchal definitions. By placing the questions of subjectivity and sexual difference at the center of inquiry and teaching, we can create a space for the other to exist.

# References

Cixous, H. (1986). Exchanges. In Hélène Cixous & Catherine Clément. *The newly born woman.* (Betsy Wing, Trans.). Minneapolis, MN: University of Minnesota Press.

Collins, G.C., & Sandell, R. (1987). Women's achievements in art: An issues approach for the classroom. *Art Education, 40*(3), 12-21.

de Beauvoir, S. (1989). *The second sex.* (H. M. Parshley, Trans., ed.). New York: Vintage Books. Orginally published, 1953.

Dobie, E. A. (1990). Interweaving feminist frameworks. *The Journal of Aesthetics and Art Criticism, 48* (4), 381-394.

Huyssen, A. (1986). Mass culture as woman: Modernism's other. In *After the great divide: Modernism, mass culture, postmodernism.* Bloomington and Indianapolis, IN: Indiana University Press.

Huyssen, A. (1990). Mapping the postmodern. In L. J. Nicholson (Ed.) *Feminism/Postmodernism* (pp. 234-277). New York and London: Routledge.

Kelly, M. (1990a). *Interim.* New York: The New Museum of Contemporary Art.

Kelly, M. (1990b). That obscure subject of desire. Interview by Hal Foster. In Mary Kelly, *Interim* (pp. 53-62). New York: The New Museum of Contemporary Art.

Mulvey, L. (1989). Impending time: Mary Kelly's Corpus. In *Visual and other pleasures.* (pp. 148-155) Bloomington and Indianapolis, IN: Indiana University Press.

Nochlin, L. (1988). Why have there been no great women artists? In *Women, art,and power and other essays.* (pp. 145-178) New York: Harper & Row.

Owens, C. (1983). The discourse of others: Feminists and postmodernism. In H. Foster (Ed.), *The anti-aesthetic: essays on postmodern culture* (pp. 57-82). Port Townsend, WA: Bay Press.

Pollock, G. (1987). Feminism and modernism. In R. Parker & G. Pollock (Eds.), *Framing feminism: Art and the women's movement 1970-1985* (pp. 79-122). London and New York: Pandora Press.

Pollock, G. (1990). Interventions in history: On the historical, the subjective, and the textual. In Mary Kelly, *Interim,* 39-51. New York: The New Museum of Contemporary Art.

Stacey, J., & Thorne, B. (1985). The missing revolution in sociology. *Social Problems, 23* (4), 301-316.

Tickner, L. (1987). *Nancy Spero: Images of women and la peinture féminine.* In *Institute of Contemporary Art exhibition catalogue.* London.

Tucker, M. (1990). Picture this: An introduction to *Interim.* In Mary Kelly, *Interim,* (pp. 17-25). New York: The New Museum of Contemporary Art.

Wolff, J. (1990a). *Feminine sentences: Essays on women &culture.* Berkeley and Los Angeles: University of California Press.

Wolff, J. (1990b). Curriculum inquiry in the arts. *Studies in Art Education, 31* (4), 198-206.

# JUST LOOKING OR TALKING BACK? A POSTMODERN APPROACH TO ART EDUCATION

Anne G. Wolcott and Betsy Gough-Dijulio

Often in the past the educational system inadvertently communicated that the arts relate to emotions rather than intellect and one did not need to know anything about art to understand it (Rice, 1991). However, according to Radford (1992) just looking at art is a complex, culturally loaded act, as art does more than merely describe "concrete objects or events" (p. 57). He acknowledges that while much art is representational, it also is concerned with the response of the viewer and the artist, feelings and ideas, and personal elements of the experience. Art asks us to "talk back." In so doing, it may be used to transform the viewer, to communicate ideas, and to provide deeper and wider frames of reference. Art gives insight and shape to human experience, helping to inform our responses and actions. Thus, art can be used to inform and persuade in different ways and may be directed at different audiences. Especially in the art of recent years, these capacities have become more overt with the result that most viewers of contemporary art find themselves challenged to question and think about such things as morals, values, and other social issues in addition to the very nature of art.

In this respect, as educators we need to plan curricula focused on helping students develop their abilities both to create and to understand meaning in their own works of art and in that of other artists. In doing so, we need to provide students with the skills and abilities necessary to interpret, analyze, and evaluate art. In addition to these responsibilities art educators need to make art more relevant to students—that is, we must strive to bring the art world and the student's world together for better understanding. How can contemporary art assist students in understanding their changing society? How can art educators make experiences of art relevant to a student's world?

In this paper, we address how contemporary art can provide teachers with content which effectively accommodates postmodernist thinking in the realm of art education theory and practice. Contemporary art provides particularly engaging means of help-

ing students understand their changing society while giving meaning to their life experiences through the context of the art world.

## Postmodern Art World

As others in this text have discussed, postmodern theory and practice is challenging both the art forms and the critical models of the modernist period. Postmodernism is still evolving, as are its theories of art and criticism. Still we know that art has become critical of both culture and society. Works of art have become a means of discourse: art contemplating art, politics, society, religion, or culture. The language of modernism was enclosed within the artwork, whereas postmodern art seeks to be understood in the broader context of a dialogue between artwork and society. It has become necessary to learn the language of the world of art and the critics in order to gain insights into contemporary works of art. "We may have to come to understand the artist's language through a variety of means of experience. To understand fully the experience that the artist is trying to convey, we may have to share something of that experience itself" (Radford, 1992, p. 61). Today, a work of art might be looked at as a document: what does it have to say? As educators, we might consider what implications this has for our curriculum.

## Contemporary Art Education Theory and Practice

Postmodernist thinking in being accommodated within art education theory and practice in several ways. First, many art educators are acknowledging the cognitive dimension of art and consequently are questioning what should be taught. In many instances, curriculum emphasis is moving from studio-based to concept- or discipline-based, incorporating multiculturalism, art history, art criticism, and aesthetics into content and methodology that can be linked to other disciplines in the general education curriculum. Ideally, art teachers should introduce students to "skills, issues, and subjects they are unlikely to encounter elsewhere in the curriculum and ... to ways of seeing, knowing, responding to, and representing the world that are unique to art" (National Board for Professional Teaching Standards, 1994, p. 11). Creating connections to other disciplines across the curriculum enables students to understand art in a broader, more holistic context. Second, the study of works of art is becoming more central to the content of art education, and new models for teaching are being developed based on works of art (Clark, Day, & Greer, 1987). Third, teachers are paying less attention to the dissimilarities between high art and low art and particular attention to minority and gender issues (MacGregor, 1992). And fourth, for many art educators, the classroom is becoming an arena for generating questions about meanings in works of art, thus challenging students to think more critically about art, themselves and their world.

Teachers should educate students about the construction of meaning in artworks rather than merely training them to master certain skills. Approaches to teaching should focus on art appreciation and art production as complementary ventures, not wholly separate endeavors. Art production lessons should more often draw upon the kind of thinking that is required in art appreciation activities. One need not take away from the other; both will enrich a student's experience and final product. Further, art education ought to be a primary site for "talking back," for today's "art...seeks to challenge and change the world, not just contemplate it" (Sherlock, 1995, p. 5). And as Foster (1985) contends, contemporary work does not necessarily "bracket art for formal or perceptual experiment, but seeks its affiliations with other practices" (p. 99).

## Just Looking

Therefore students need to be engaged participants, reading meanings and messages in the signs and symbols of contemporary art in addition to contemplating the aesthetic qualities in an art object. Students should be taught to interact with works of art as both visual structures and structures of meaning which are inextricably linked. In order to understand a work of art as a visual structure, the student must attend to the artist's use of design elements and principles: line, shape, color, texture, balance, rhythm, and so on. Such analysis seems straightforward, based as it is on tangible evidence. But, engaging in a formalist analysis—particularly in a group setting like a classroom—will reveal to students the subjectivity implicit in what was once thought to be a purely objective accounting. In a postmodern curriculum such as Doll (1989) has begun to define, this kind of complexity is to be desired. He writes, "Complexity assumes reality to be web-like with multiple interacting forces. We as observers are inside, not outside, the web. Thus, knower and known are interactively entwined. There is no God's-eye view here, and objectivity takes on a new subjective dimension. We are limited in our perceptions and evaluations by our own places in space and time" (p. 247). In other words, description—far from being an objective enterprise—is an interpretive act, shaped by the entire range of our experience and knowledge.

The issue of meaning, then, is not wholly separate from formal concerns. In addition, it encompasses two other complex realms: the artist's intention and personal associations. Artistic intent is problematic for a number of reasons. One reason is a phenomenon known as "intentional fallacy," which refers to the fact that an artist may intend what s/he does not achieve and may not intend what s/he does achieve. Similarly, a work of art is always more than what can be said about it. Furthermore, especially with recent art and newcomers to the art scene, little information may be accessible to viewers regarding artistic intent. In the absence of adequate information about the artist's intent, are teachers and students faced with a work's non-meaning?

No, they need not, because as M. A. Radford (1992) observes, audiences "may 'graft on' meanings of their own" (p. 54). Therefore, he continues, "The meaning of

the work may then be seen as something separate from the intentions of the artists, something imposed, discovered, or invented" (p. 58). A case in point is a work entitled "Odd Glove" by Millie Wilson. In a recent lecture, when a group of high school students were asked to interpret the meaning of the piece, one student said he thought it was a reference to the O. J. Simpson murder trial currently in the media. Having been created in 1990, the artist could not have *intended* to deal with this murder, which occurred in 1994. Yet, no one familiar with the details of the murder trial, especially the lone bloody glove found by Los Angeles police on Simpson's property, can help but look at Wilson's piece within the context of the murder trial. This interpretation is given further weight by virtue of the word "well" written on the bottom of the table supporting the glove and reflected in a mirror on which the table stands, as in "Well? What about this glove?" This example illustrates the phenomenon by which works of art accrue meanings that may be "independent of the artist's intention. Once the work of art is part of the public domain, it becomes subject to public interpretation, and it can clearly come to mean different things to different people" (p. 61).

## Talking Back

A postmodern approach to art education would seize this kind of ambiguity, using it as a means to help students grapple with the problem of meaning as it relates to what anthropologists call *phenomenal absolutism*, that is, "the tendency most people have to assume that everyone else sees and thinks exactly the same way that they do" (Rice, 1991, p. 135). According to Rice, "[John] Dewey's pragmatist focus on experience underlines the fact, corroborated by anthropologists, that signification in art is not universal ... not all art means the same thing to all people at all times" (p. 129). A number of art educators advocate a curriculum based on Dewey's pragmatism and the relativity of experience as opposed to one based on classical idealism with its belief in a timeless, static ideal form. Pragmatism allows for reassessment and re-evaluation (Lanier, 1987; Holt, 1990). These practices are at the heart of a postmodern curriculum. As Doll (1989) describes it, " a postmodern curriculum would involve the class—teachers and students working as a community" (p. 251). Further, he writes, "Learning, in Dewey's and Piaget's visions, becomes a by-product of inquiry, not a direct and exclusive goal in itself. Mutual inquiry rather than the transmission of knowledge or production of specific behaviors is the general framework in which this relationship would be placed" (p. 252). Mutual inquiry involves both teachers and students in a dialogue with and among themselves. Radford (1992) highlights the importance of verbal communication about works of art among groups of students by discussing the relationship among language, experience, and knowledge. Language, he posits, helps structure our experience by providing a means of organization:

> It may be that it is the language that is conferring organization on the experience for the child. This is not to say that language determines the experience for the child, although it might be that the language the child uses leads to his "see-

ing" the experience in a certain way. Language helps the child to interpret his experience for others. It is no doubt the case that the language is given sense by the experience, but the process is not all one way. The experience is given sense for the child by the language he uses to communicate it to others. (p. 54)

Concepts become manageable when we can name them. Understanding gels when we can give it verbal form. Things observed become concepts understood through the structuring influence of language. While it is true that "not all that we know, we can say" (Eisner, 1991, p. 15), it is also true that "our language in part determines our beliefs, desires, and the like. I am as much a product of my language as my language is an expression of me" (Radford, 1992, p. 55). Sharing perceptions and understanding about works of art can encourage both teachers and students to look more closely within themselves, to see through the eyes of others, and in so doing to better comprehend the human condition (Beck & Gough-Dijulio, 1993).

Mutual inquiry, as a teaching methodology, has philosophical underpinnings in Doll's tenets of a postmodern education: a child-centered or progressive approach as opposed to an essentialist perspective. McFee (1991) describes the differences as being a concern for "students' individual differences and cultural backgrounds, as opposed to a concern that they learn correctly what they need to know" (p. 73). Said differently, the first approach begins with the child, the second with the subject to be learned (Eisner, 1987). The child-centered approach "becomes a process of development rather than a body of knowledge to be covered or learned, ends become beacons guiding this process, and the course itself transforms the indeterminate into the determinate" (Doll, 1989, p. 250). This process is consistent with the aims of inquiry-based teaching in that both accommodate diverse "backgrounds, interests and levels of sophistication" in a group of learners (Gartenhause, 1992, p. 2). Gartenhause has likened the ultimate aim of inquiry-based teaching to a dinner buffet. "Watch people at dinner buffets. They slow their usual pace, survey the range of offerings, investigate alternatives, and actively pursue every intriguing morsel...Skillful questioning requires learners to observe purposefully, develop ideas, make discoveries, examine responses and attitudes, and postpone decision-making" (p. 2).

## Contemporary Art as Content

When developing curricula, broad areas of content can be organized, structured, or presented by utilizing contemporary art and artists. Contemporary art can form a framework to develop activities that help students to understand the context of the artist's world and of their own world. Works of art can be selected and presented that are within the contexts of students' daily lives, allowing them to go beyond the classroom walls to be more aware of the human condition and to express their own ideas more powerfully.

What does this mean for the classroom teacher and student? Ideally, as teachers we must decide which works of art to select for study. Far from being arbitrary, selections are critical as to what is learned. As Eisner (1991) contends, "Different forms of art put me into the world in different ways. They speak to different aspects of my nature and help me discover the variety of experiences I am capable of having" (p. 16). Thus selecting diverse works of art invites access to different aspects of people's psyches, a process which happens less effectively when the range of works studied is too narrow. Though pre-modern and modern art is not excluded from curriculum content, we might look particularly to contemporary artists such as Barbara Kruger, Carrie Mae Weems, Raymond Saunders, or Roger Brown, each typical of the contemporary art world. These artists confront us with issues that are sometimes difficult to deal with and not always easy to understand. Therefore, if art educators select such works of art to be used in the classroom, they must present them in a more studied context. Not unlike critics, teachers should try to "get into" the work, understand it, before they attempt to engage students in a dialogue about it (Feldman, 1994). Teachers will be better prepared by knowing something about the history of art, the art world, and art theories in order to be able to teach about and from contemporary works of art. Even in the absence of such information, students' personal associations during interpretation can be valid and valuable. Although some art educators do not stress the cognitive aspects of art, others value both the experiencing (emotive) and the understanding (cognitive) of art (Efland, 1990). By utilizing contemporary art in the classroom, teachers can adequately address the emotive and cognitive aspects of art via interpretation and studio activities and build relationships to the student's world.

As a case in point, we might look to contemporary artists Barbara Kruger and Roger Brown. How would we teach about and from their artworks and connect the art world perspective to a student's perspective? Barbara Kruger works in a variety of media: photographs, photo-text collage, and descriptive language producing books, posters, t-shirts, and billboards. Presently, what has become her trademark "look" is work that consists of sharp black and white images selected from instruction manuals, old photographic annuals, and magazines, overlaid with bold-faced text enclosed in red enameled frames. "Her words are explicit, impertinent, and declarative" (Miers, 1990, p. 18). Kruger claims that her work reflects "the capacity of signs to affect deep structures of belief," and as a result she is both a social commentator and a political agitator (p. 12). Her art focuses on concepts rather than medium; and she inquires into the ways in which "our identities are constructed by representations in society" (p. 12). She views her art as political and conceptual, primarily focusing on issues of media manipulation, power, and stereotypical representations. In much of her work, Kruger deals with social relations in everyday activities. She attempts to involve the viewer both psychologically and physically as an active participant in her artwork. In this sense the viewer is not a contemplator of the aesthetic, but a participant engaged in constructing and interpreting the work's messages.

Such works as *I Shop Therefore I Am* (1987), *Who Follows Orders?* (1989), *Who is Beyond the Law?* (1989), and *Do I Have To Give Up Me to Be You?* (1988) are just a few examples of images that can be used in the classroom. These images elicit personal associations from the viewer and lend themselves to provoking discussion not only about the artist's intentions, experiences, and contexts, but also about the student's. The look of the visual images that Kruger uses should not be foreign to students. Most students should be familiar with the presentation format if not the artist. How often does one see this very look on television, particularly MTV, for such ads as Levis or Coke? With the proliferation of films, television, magazines, and videos in our society, many students are adept at looking rather than reading. As Kruger has noted, "the control once achieved through language has yielded to the picture—and, most recently, to pictures of electronic origin" (Miers, 1990, p. 29). Hence our society tends to favor sight over other senses, and society is increasingly controlled by the media. As McFee argues, people need critical skills to decode imagery and education to make critical choices. Students need to be able to compare issues and to comprehend the ways symbols and design are used to distort information. Contemporary artists such as Kruger can be used to do just that; they speak the same visual language. In the classroom we can ask: "How do these images relate to the student's world of experiences?" "Are there questions and issues that the images elicit that have direct impact on student's lives?" The texts used by Kruger are often ambiguous. Terms such as *I, you, me*, and *we* confuse the speaker and the addressee and the referent often changes. When students put themselves in the place of *I* or *we*, what associations do they make from their own lives? What issues do they bring up? What other subjects are brought into the conversation? Kruger's work allows students to make connections to their worlds and to compare and contrast ideas and beliefs among themselves and the artist.

As for studio activities, teachers need to structure activities that allow for personal expression which connect with prior learning. Dewey (1934) argues for understanding of art to be focused on the experience rather than the object, believing that "artness" is located in the maker and viewer. Hence, not all art means the same to all people; therefore, personal associations and individual interpretations should be emphasized. This is why contemporary art education needs to encourage individual exploration— spiritually, intellectually, and emotionally. Teachers must encourage students to ask questions at different stages of their development, such as, "Who am I? How do I feel?" Through a variety of instructional activities, teachers can provide students with abilities to build relationships with the art world by connecting art production and appreciation to the student's world. "Art making is work that reveals people, ranging from their greatest frailties to their most superb mastery" (Korzenik, 1993, p. 144). Various activities can use contemporary artists and art to build on and relate to personal histories, social experiences, and cultural issues. In the classroom, art activities should build on what artists have created: the concepts and issues with which they are dealing; the kinds of media they use to express these ideas; and how they go about it versus copying or merely translating the artwork. Too often, art lessons tend to rely

heavily on teacher's directions and certain desired ends. At all levels of education, students need to communicate their experiences through the visual arts. For example, Marilyn Zurmuehlen (1991) asked her students to write "personal histories to cohere their identities as artists...and to establish shared communities of memory" (p. 10). Such reflections give validity and identity to art and the artist. We must consider, *What do children learn from art? What makes art worthwhile and connected to their lives?*

The works of artist Roger Brown are other examples which encourage students to construct meaning, make personal associations, and reflect on contemporary society. Roger Brown has been called an American scene painter, not, however, to be confused with the scene painting or so-called American regionalism of the 1930s which was wholesome in a way similar to the television show "The Waltons." Roger Brown's America is more like that of David Lynch's "Twin Peaks" with its subtexts of violence and alienation, or Tim Burton's "Edward Scissorhands," with its treatment of conformity and alienation. Brown's narratives of American life become the context for these issues which may be remote, yet paradoxically prevalent, for many sectors of American society. Jon Yau (1987) writes that Brown's work: "can be said to explore the foundations of our socially conditioned perceptions. In doing so, he has revealed the disturbing extent to which various states—horror, irony, and boredom—mesh. Another condition his work addresses is how society's mechanisms, particularly the mass media, trivialize all events by reducing them to dramatic occasions. Meaning and emotion are codified" (p. 15).

Exploring these kinds of connections between television, film, visual art, and feelings—as well as the undercurrents of contemporary life—are the very stuff that makes art relevant to students' lives outside the classroom, for the influence of the media on students' lives can hardly be overstated. The work of Kruger and Brown could be the focus of a unit on the influence of both print and electronic mass media on contemporary art. Discussions might deal with how the media influences the way students think about themselves and the events and dynamics of the contemporary world, as well as how the media influences the students' tastes and values. Studio projects, then, would not deal with student versions or translations of the works of these artists— "Kruger-esque" or "Brown-esque" compositions—but with projects in which the student is required to think carefully about the way the media intersects with his or her life and then to determine how best to express that phenomenon. Similarly, Brown's narrativity could be used to encourage students to tell their own stories through their art, both personal narratives and those of their contemporary world.

Brown has been called a "fierce appropriator" (McGreevy, 1987), borrowing as he does from such diverse sources as Italian and Oriental painting, Oriental carpets, Navajo blankets, native or outsider art, American regionalism, early American Modernism, comic strips, and painted tin toys, to name the most common (McGreevy, 1987; Yau, 1987). This kind of pluralism and blurring of the distinctions

between high and low forms of art, partially influenced by his affiliation with the Chicago imagists of the 1970s, as well as his content—cityscapes, landscapes, horrific news events, political commentary, biblical themes, and personal narrative place him squarely in the postmodern—as opposed to modern—tradition (Lawrence, 1987). In fact, Yau (1987) writes that Brown rejects modernism on moralistic grounds. And he continues:

> The emergence of independently minded strong artists in Chicago, northern California, and elsewhere started the art world on the path to pluralism. Now, with modernism's enterprise seriously in doubt, New York's position diminished, and formalist criticism's failure to maintain a hierarchy of values and tastes, the received canonical interpretations of late twentieth century art are being seriously challenged. Roger Brown's accomplishment—his idiosyncratic transformations of a wide range of sources—suggests that a major re-evaluation of postwar American art and art history is sorely needed. (p. 14)

Brown's paintings, with their intentional layers of meanings, which assertively connect contemporary content, narrative bias, and affiliation with previous historical art movements and "low" art forms, are excellent choices for teachers who desire to expand the content of art discourse in the classroom and accommodate postmodernist thinking in their curriculum.

## Summary

A frequent explanation of the fine arts is that they reflect the natural world around us. "In the arts the uneasy relationship between the inner and outer worlds of human experience are given recognition and resolution" (Smith, 1992, p. 82). Today, nothing could come closer to this truism than contemporary art. Contemporary art challenges us on every issue, taboo and otherwise. In an effort to accommodate postmodern thinking and art into art education, students should be taught to construct meaning in works of art by attending to formal qualities, artist's intention/context, and personal experience. Educators must give students the sense of connecting internal and external realities, enabling them to give form to ideas and feelings. We must develop and extend their consciousness through a variety of methods and artworks that lend themselves to such endeavors. Through artistic expression—whether it be making, writing, or verbalizing about art—art educators have the responsibility to help students "extend the range and capture the quality of experience, that is, to formulate and substantiate [meaningful] meaning" (Smith, 1992, p. 82). In other words, art educators must encourage their students both to look and to talk back.

# References

Beck, L., & Gough-Dijulio, B. (1993). Audience-based thematic art tours. *The Docent Educator, 3* (1), 4 - 5.

Clark, G., Day, M., & Greer, D. (1987). Discipline-based art education: Becoming students of art. *Journal of Aesthetic Education, 21*, (2), 130-193.

Dewey, J. (1934). *Art as experience.* New York: G.P. Putnam's Sons.

Doll, W. E. (1989). Foundations for a postmodern curriculum. *Journal of Curriculum Studies, 21*, 243-253.

Efland, A. (1990). *A history of art education: Intellectual and social currents in teaching the visual arts.* New York: Teachers College Press.

Eisner, E. W. (1987). *Discipline-based art education: What forms will it take?* Los Angeles: The J. Paul Getty Trust.

Eisner, E.W. (1991). What the arts taught me about education. *Art Education, 44*, (5), 10-19.

Feldman, E. B. (1994). *Practical art criticism.* Englewood Cliffs, NJ: Prentice-Hall.

Foster, H. (1985). *Recodings: Art, spectacle, and cultural politics.* Seattle, WA: Bay Press.

Gartenhause, A. (1992). Teaching with questions. *The Docent Educator, 1*, (3), 1-3.

Heartney, E. (1987). The hot new cool art: Simulationism. *Artnews, 86,* 130-137.

Holt, D. K. (1990). Post-modernism vs. high-modernism: The relationship to DBAE and its critics. *Art Education, 43*, (2). 42-46.

Korzenik, D. (1993). Arnheim and the diversity of American art. *Journal of Aesthetic Education, 27* (4), 143-153.

Lawrence, S. (1987). *Roger Brown.* New York: George Braziller, Inc.

Lanier, V. (1987). A* R* T*, A friendly alternative to D.B.A.E. *Art Education, 40*, (5), 46-53.

MacGregor, R. (1992). *Post-modernism, art educators, and art education.* Los Angeles: Getty Center for Education in the Arts.

McGreevy, L. (1987, September 15). Brown images: Fortitude backed by irony, humor, skill and guts. *Portfolio,* 10-11.

Miers, C. (Ed). (1990). *Love for sale: The words and pictures of Barbara Kruger.* New York: Harry Abrams, Inc.

McFee, J. K. (1991). Art education progress: A field of dichotomies or a network of mutual support. *Studies in Art Education, 32*, (2), 70-82.

Moore, J. (1991). Post-modernism and DBAE: A contextual an alysis. *Art Education, 44*, (6), 34-39.

National Board for Professional Teaching Standards. (1994*). Early adolescents through young adulthood/art.* Reston, VA: National Art Education Association.

Radford, M. A. (1992). Meaning and significance in aesthetic education. *Journal of Aesthetic Education, 26*, (1), 53-66.

Rice, D. (1991). The art idea in the museum setting. *Journal of Aesthetic Education, 25*, (4), 128-136.

Sherlock, M. (1995). Inappropriate pictures for unaccompanied children. *Art Papers, 19*, (2), 3-10.

Smith, N. (1992). Classroom practice: Creative meaning in the arts. In J. J. Hausman & J. Wright (Eds.), *Arts and the schools* (pp. 81-115). New York: McGraw Hill.

Yau, J. (1987). Roger Brown and spectacle. In *Roger Brown.* New York: George Braziller, Inc.

Zurmuehlen, M. (1991). Stories that fill the center. *Art Education, 44*, (6), 6-11.

# Notes

# Notes